CARVING BLOCKS

—— Printmakers & Their Stories ——

GINGKO PRESS

CARVING BLOCKS

—— Printmakers & Their Stories ——

First Published in the USA in 2023 by

GINGKO PRESS

Gingko Press, Inc.
2332 Fourth Street, Suite E
Berkeley, CA 94710 USA
Tel: (510) 898 1195
Fax: (510) 898 1196
Email: books@gingkopress.com
www.gingkopress.com

ISBN 978-1-58423-783-9

By arrangement with
Sandu Publishing Co., Ltd.

Copyright © 2023 by Sandu Publishing Co., Ltd.
First co-published in 2023 by Sandu Publishing Co., Ltd.

Sponsored by Design 360° — Concept & Design Magazine
Edited and produced by Sandu Publishing Co., Ltd.

Executive Editor: Joann Chung
Copy Editor: Kim Curtis
Design: Pan Yuhua
Works on Cover: Harriet Popham, Jennifer Zee, John Pedder,
Lili Arnold, Nicole Revy, Rachael Louis Hibb

info@sandupublishing.com
sales@sandupublishing.com
www.sandupublishing.com

Printed and bound in China

CONTENTS

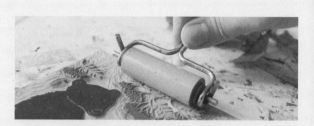

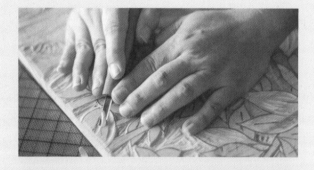

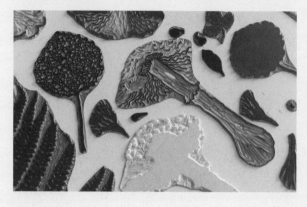

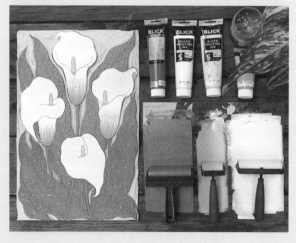

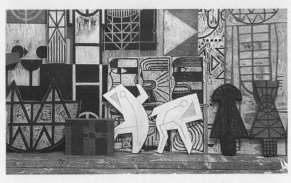

PREFACE

For me, carving is like meditation. When the design is transferred to the block and I let the carving tool glide through the soft rubber, I lose track of time. Sometimes hours have passed and I have hardly even noticed.

My very first carving was a small hedgehog and I remember how excited I was when seeing the final print. From that moment, I was hooked and I haven't stopped carving since. That one stamp became hundreds and I now have a whole cupboard filled to the brim.

Carving is all about negative space. We carve away on our chosen material and apply colors to what is left. The printing surface remains unscathed. We think about shapes instead of lines and it is quite different from drawing, where you build a picture by adding one line after another. And once you have made your mark with the carving tool, there is no going back. But with every mistake you make, you learn something new.

This book is filled with motifs made from negative space and even if the technique at first can seem limited, especially when it comes to color, it has so many possibilities. To me, that's the exciting part. It is fascinating to see how differently we apply our marks and bring out our personal styles. Behind every motif in this book there are countless hours of practice and drawers filled with prints and sketches.

I am always fascinated by how different the final print looks from the original sketch. The lines and contrasts are so much stronger, and I really enjoy the color limitations you face when printing. It

challenges me personally to spend more time on my designs and I constantly think about how I can do things differently and what to improve.

It is also an antidote to the digital work I often do and I love the process of working with just my hands. The special thing with carving and printmaking that sets it aside from other art forms that I have worked with, is the way the result is revealed at the very end when you apply ink for the first time. Before then, you can only guess the outcome. But when the ink brings out the details, you know if you have succeeded—or not. It feels like magic when you make the first test print and you see the finished picture when you peel off the paper or lift up the stamp. And from the very first print I made, that love has kept me going. I want to experience that feeling over and over again.

That love is something I believe all of us artists in this book share. And I hope our dedication to this wonderful art form shines through when you look through these pages, the pure love for carving and handmade art.

Viktoria Åström

All About Printmaking

Printmaking is an art form with a long history and a wide variety of techniques. The artist uses tools such as knives and pens to draw on the layout of different materials, applies ink, and then transfers the pattern to paper or fabric by applying pressure. Traditional printmaking materials are wood and stone. With the development of technology, the range of materials has gradually expanded to hemp glue, copper, zinc, etc., and carving or etching is carried out according to different materials. This art form is also known as "reproductive art" because it can directly print multiple original works. As the earliest print, woodcut was born in China in the 5th century and was used to print patterns or characters on paper. Up to now, prints have shown the wonderful creativity of ancient and modern artists.

Printmaking can be traced back to the Tang Dynasty (618-907) in China. As a way to spread Buddhist culture, it greatly laid the foundation for the evolution of printmaking art. The development of paper-making and ink-making technology in this period made the art of woodblock prints reach a certain height and had a basic and fine painting style. In the Ming Dynasty (1368-1644) and Qing Dynasty (1636-1912) with the efforts of many literati and skilled workers, a multiple of excellent prints were produced. In the vast land of China, many schools of prints with local characteristics were born. Prints were not only used as a single painting, but also became book illustrations and "painting books" for painters.

In a neighboring East Asian country during the same period, Japanese ukiyo-e prints also began to appear. They mainly existed in the form of woodblock prints, recording the scenery, beautiful women, history, and folklore in Japan at that time. The colors were bright and intuitive. This style vividly depicted the human customs

of the Edo period in Japan. Coincidentally, on the other side of the Eurasia, the spring breeze of the Renaissance came, and this new cultural movement drove the development of European culture and art. The emergence of movable type printing in the 15th century made woodblock prints more widely spread throughout Europe and this was also the initial period of European woodblock printmaking. Later, with the emergence of various painting genres, the field and definition of printmaking were gradually clarified. As a unique and charming reproductive art form, printmaking entered the halls of modern art and began to achieve uncompromising artistic achievements in the 20th century.

In terms of different techniques, prints can be divided into letterpress (woodblock prints, hemp prints), intaglio (engraving, etching), lithography, and stencil printing (screen printing, Risograph).

Letterpress printing is when ink is applied to the original surface of the substrate, leaving engraved or displaced grooves free of ink. It includes woodcut, linocut, rubber stamping, and metal cutting, among others. Linocut, woodcut and rubber stamping artists and their stories are highlighted in this book.

Linocut, also known as lino print, lino printing or linoleum art, is a variant of woodcut in which a sheet of linoleum (sometimes

Linocut
©Olga Ezova-Denisova

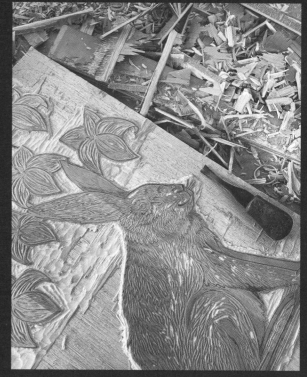

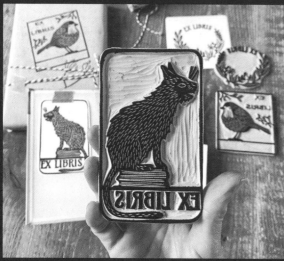
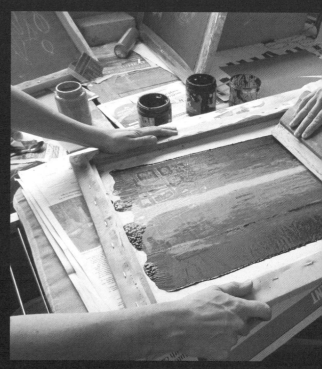

↑ Intaglio Printing ©Vassil, Wikimedia Commons
↑ Lithographic Printing ©Koreller, Wikimedia Commons
↑ Rubber Stamp, Ex Libris ©Esther Elzinga
↗ Woodcut, Hare ©JustAJar
→ Screen Printing ©North Tyneside Art Studio,
 Wikimedia Commons

mounted on a wooden block) is used as a relief surface. A design is cut into the linoleum surface with a sharp knife, V-shaped chisel or gouge with the raised (uncarved) areas representing a reversal (mirror image) of the parts to show printed.

Rubber stamp, also called stamping, is a craft in which some type of ink made of dye or pigment is applied to an image or pattern that has been carved, molded, laser engraved or vulcanized onto a sheet of rubber. Unlike wood or linoleum, the rubber is often mounted onto a more stable object such as wood, brick or an acrylic block. Increasingly, the vulcanized rubber image with an adhesive foam backing is attached to a cling vinyl sheet, which allows it to be used with an acrylic handle for support.

The other three kinds of printing have their own characteristics and techniques. In intaglio printing, the ink is forced into grooves or cavities in the surface of the substrate. Intaglio printing techniques include lithography, engraving, etching, graphic arts, and watercolor painting. Lithographic printing in which the substrate retains its original surface is specially treated and/or inked to allow the transfer of the image. Lithographic techniques include offset printing, monochrome printing, and digital techniques. Stencils, inks or paints are pressed across a prepared screen, including screen printing, vertical, and textured.

Printmaking has a long history. Printmaking is made by reversing the layout, which is an art that pays great attention to the production process. In today's rapidly changing society, printmakers usually need quite a long time to realize their own or others' ideas on the board with a sharp carving knife. This book will start with "letterpress printing" and lead readers to experience this most classic and modern form of printmaking.

Print Tutorial

By India Rose Bird

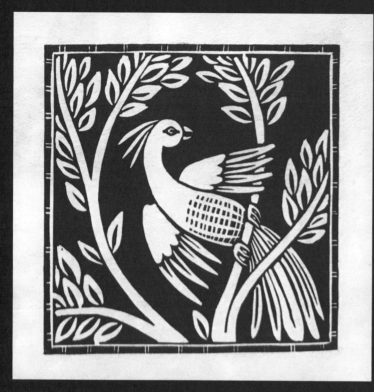

Lino is a good introduction into relief printing as it is cheap and easy to use. Once you feel you have gotten used to the technique, you can try moving on to wood.

You will need:

- Lino block
- Lino cutting tool (I use Power Grip gouge tools)
- Pencil and pen
- Drawing paper
- Water based relief ink
- Printing paper (a lightweight paper would be best—I use Japanese washi paper)

- Wooden spoon
- Ink roller (also known as a brayer)
- Ink knife
- Sheet of Perspex or glass to roll ink onto
- Cleaning supplies—gloves, soapy water, old rags

* Most art stores often sell beginner sets where you buy lino blocks, tools, and ink together.

Step 1: Start by testing out your tools. Try carving on a small piece of lino first. You could try out different tool sizes and techniques to get used to using lino. See what types of lines and shapes you can create.

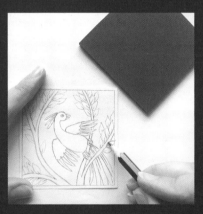

Step 2: Using a pencil, start by drawing your desired image onto paper. The simpler, the better to begin with—you can experiment with more complex images and finer details the more you practice. Start with something easy like shapes, patterns, animals, or flowers.

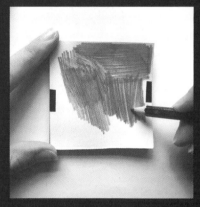

Step 3: To transfer the drawing to lino, place the paper facedown onto the lino block. Keep the drawing in place by lightly taping the edges. Using a graphite pencil, fill in the back of the drawing. This process will transfer the image. You could also use tracing paper or graphite paper for the same effect.

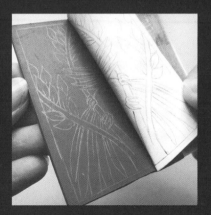

Step 4: If you peel the paper away and hold the block up to the light, you should be able to see the tracing of your drawing on the lino.

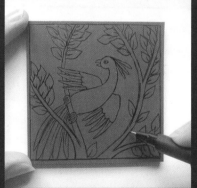

Step 5: Make the drawing bolder by going over the transferred image with a black pen or biro, adding any elements or extra details that didn't transfer from the drawing.

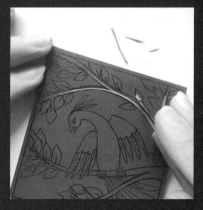

Step 6: It's time to carve!

Carving Tips:

1. Always cut AWAY from your body and be very aware of where you place your fingers when carving.

2. You may find that carving at a shallow angle will still create a good impression and there is no need to gouge your tools too deep into the block.

3. Take your time! Be careful not to rush as you could slip and either ruin your carving, or worse, cut your hands.

4. Different tools have different outcomes—a tiny "v" gouge creates sharp lines, a "u" gouge will be good for clearing areas of white space.

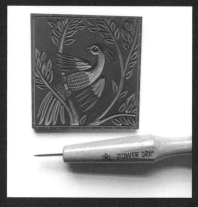

Step 7: When you have finished carving, brush any bits of lino away from the block. You can now go ahead and make your first print.

Step 8: Start by applying a small amount of ink in the color of your choice to the Perspex or glass. Using an ink knife, you'll need to mix the ink to warm it up and make it more spreadable, and to make sure there are no inky lumps. Then, drag it neatly across your Perspex/glass. Evenly coat your roller/brayer by dabbing it onto this line of ink.

Step 9: Roll out the ink that's on the brayer. I like to spread my ink out into a square shaped pad to work from. If the ink sounds too sticky and is tacky on the glass, you need to roll it out until it's less thick. You want to roll it for a good few minutes until the sticky sound is more faint. Use gloves during this part of the process if you want just to make sure your fingertips don't get inky.

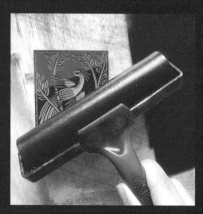

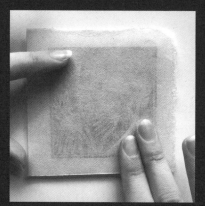

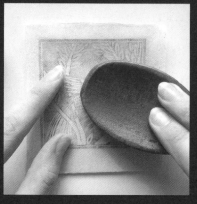

Step 10: Place your lino onto newspaper, so that you don't accidentally get ink onto your work surface. Once the ink is at the right consistency, roll the brayer across the lino block back and forth to distribute the ink, making sure you get plenty of coverage from all angles. If you need a bit more ink, you can go back to the ink pad with your brayer.

Step 11: Making sure your fingertips are clean, position some printing paper onto the lino and gently press it down, so that it sticks to the block, taking extra care not to apply too much pressure or shift the paper.

Step 12: To make your first print, use the back of a wooden spoon and firmly, but gently press onto the paper. I like to use small circular motions to create an impression. Take your time—if you're using a lighter paper, you'll be able to see the image transferring as you go over it. Once finished, peel the print off the block and put it somewhere safe to dry.

You now have your first lino print!

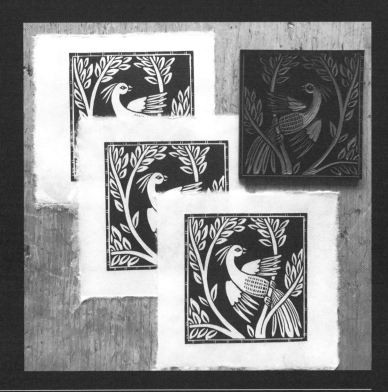

Cleaning up!

Water-based relief ink is easy to clean, and you can use soapy water and a rag to do so. I like to mix warm water and washing-up liquid into an old spray bottle. Spray the cleaning solution onto your glass surface, brayer, ink knife, and lino block, and wipe off with an old rag. Once they are clean, allow them to air dry.

Tips

- If your image is very faint, you either need to apply more ink or apply more pressure when printing. Play around and see what works best.

- If your image is too inky, you probably have applied too much ink to your block and will need to roll your ink out so that it's a bit thinner. Wipe your lino block clean and re-apply the thinner ink.

- Remember, printmaking is about experimenting! It might take a couple of tries to figure out the best amount of ink and the best amount of pressure for your print.

- If you want to work back into the lino to add any more details or clear areas of white space, clean the lino and let it dry before making any adjustments.

LINOCUT

Russia

Olga Ezova-Denisova

Olga Ezova-Denisova, an artist and printmaker based in Ekaterinburg, found her way into the art form in 2012 after an illustration course at the British Higher School of Art and Design in Moscow. In addition to linocut printing, she also enjoys working with various handmade techniques such as stencil, monotype, embroidery, collage, book illustration, and design. Her work is deeply connected with plants and animals from the forest, suffusing a serene and lovely vibe in whole or in part.

LINOCUT

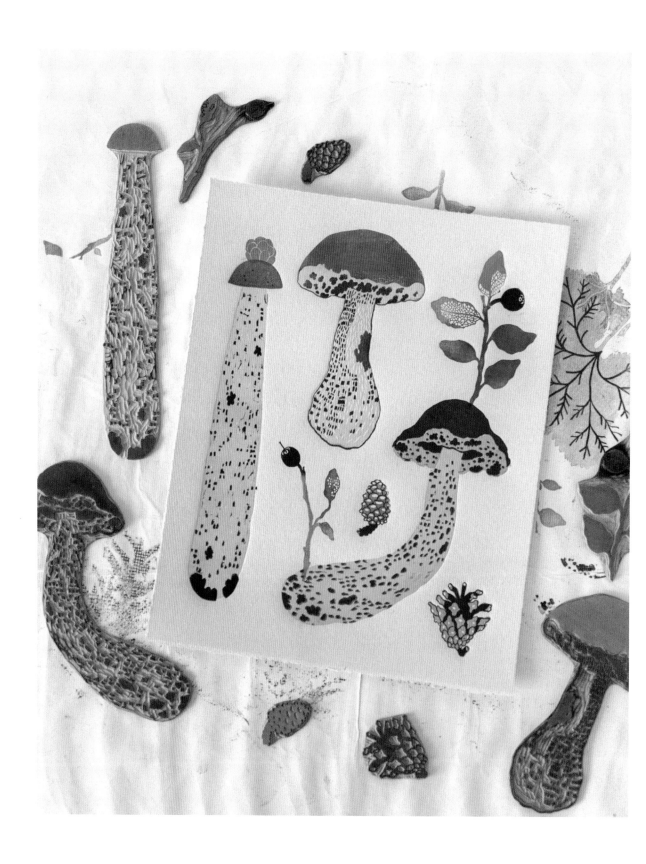

OLGA EZOVA-DENISOVA

020

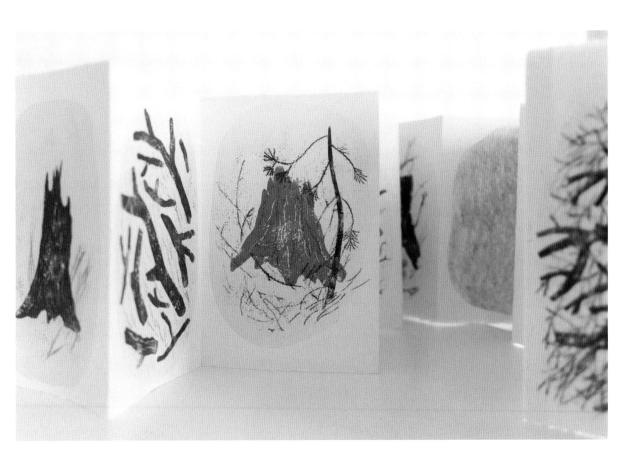

← Mushrooms (2020)
↑ Artist's Book Stumps and
 Twigs (2017)
→ the series On the Swamp
 (2021)

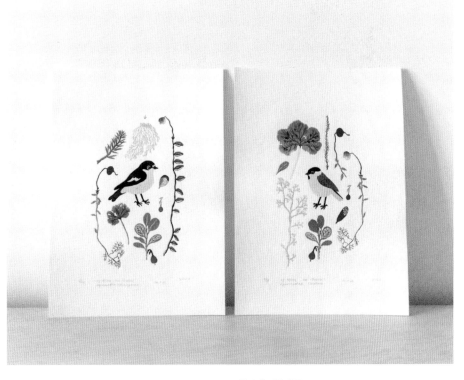

LINOCUT

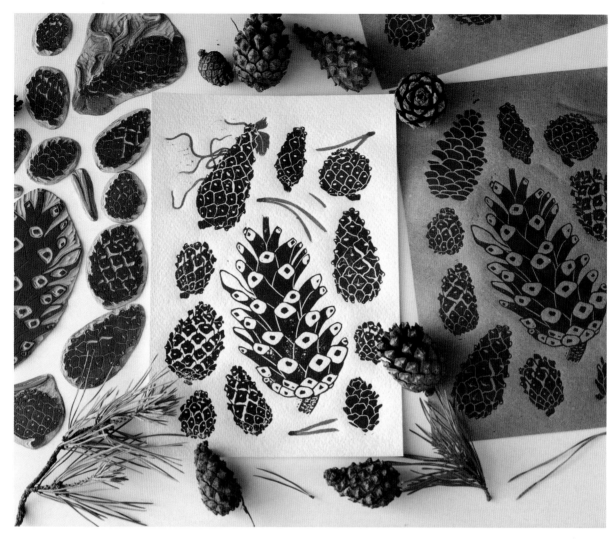

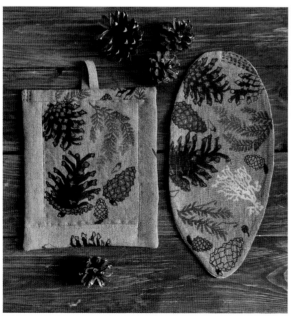

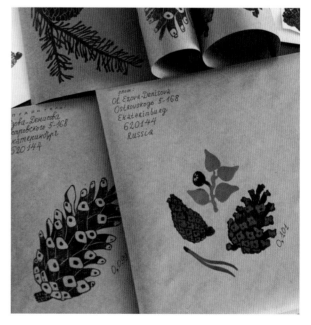

OLGA EZOVA-DENISOVA

022

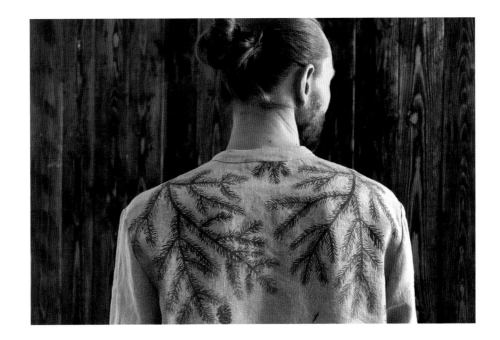

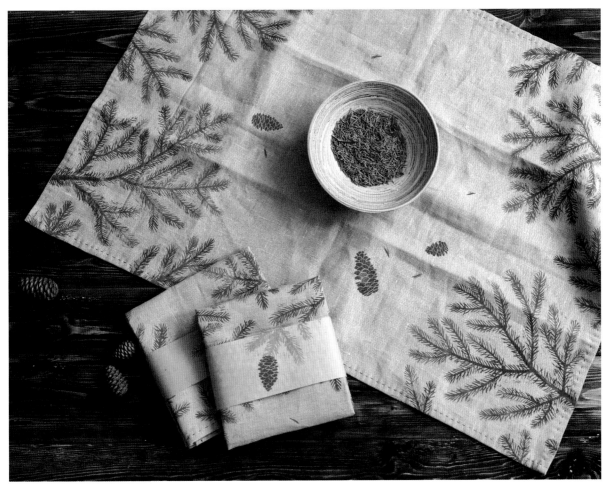

Q: You began your journey in art in 2012 after taking the illustration course at the British Higher School of Art and Design in Moscow. What drew you to be a printmaker?

A: I first tried carving and printing linocut in the illustration course at the British School and this technique went straight to my heart. I felt that the order of printmaking practice is for me: first, a long preparatory work and then the reward for it—I lift the sheet of paper from the printing plate and the image is ready. When I create the picture in any other technique step by step, I see how it gradually develops and, in printmaking practice, the final picture appears in one moment, which fascinates me.

Q: From drafting, carving, and inking to printing, how long does it take you to make a print? Which part is the trickiest?

A: The most difficult part is laying out the sketch on different printed plates by color in order to get one colored image from several plates. This is such an intellectually difficult part. In this process, I even feel how everything is moving and creaking in my head. There is a part that just requires a lot of time and focused routine work, but for me it is not difficult—carving the small details. Sometimes it takes two or three hours to get a simple piece of print from the sketch to the finished print. I do the complex artwork for several days, alternating cutting with other work, giving rest to my hands and fingers.

Q: You said you didn't have an academic degree in printing art. So, how did you hone your printing skills?

A: Yes, I don't have a degree in printing art. I honed my skills through trial and error, gradually learning different printing methods, techniques, and materials. I started my work by making prints with a tablespoon. I had been printing this way for several years and created a lot of amazing prints and artworks. It seems incredible to me. I had to put a lot of physical effort into each print. When I had access to special printing inks, I bought a small pressure press and this significantly improved the quality of the resulting prints. Now, I work on a professional printing press with excellent inks.

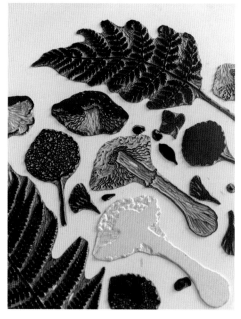

OLGA EZOVA-DENISOVA

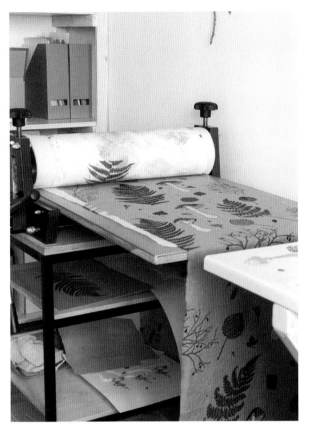
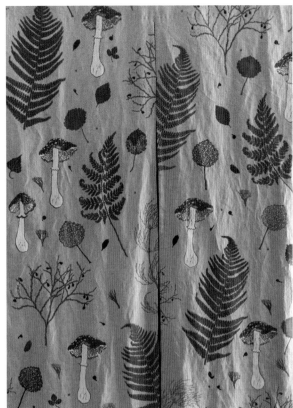

Home Collection "The Autumn Forest" and printing process (2021)

Q: What difficulties did you come across or what was the biggest challenge while shaping up your printing art?

A: The biggest challenge was to understand logically how to sell my art, how to evaluate it, can I call it "art," can I print new copies of the prints after I have finished one edition, etc. These questions are essentially about how to fit into the art market and they caused me a lot of stress. Now, I understand that I took it too seriously due to inexperience and not knowing how it works.

Q: Trees, mushrooms, berries, and small animals are the common themes of your prints. Why do you enjoy depicting them?

A: I think because they are beautiful. Perfect simple beauty is in abundance in the place where I live and I can admire and share my delight with others.

Q: Besides printmaking, you also love to work with other handmade techniques, such as embroidery, painting, and book binding. What is best about creating by hand?

A: I love all the techniques that I use! Periodically, I feel the biggest wave of love for a particular type of creation. For example, embroidery now feeds me very much. I try to mix printing and embroidery, it inspires me to make applied things for the home and clothes.

Q: In recent years, you have organized a couple of workshops on printmaking. What is your workshop like?

A: Yes, I do classes in my studio. I have the printing press, a large table for six to eight students, a high table for standing work, a paper cutter for cutting books, storage for paper, inks, rollers, etc.

LINOCUT

United Kingdom

Rachael Louise Hibbs

Rachael Louise Hibbs (RLH Prints) is a relief printmaker who is inspired by the natural world. Her block prints depict botany, wildlife, and otherworldly imagery in her own visual language of intricately carved linocuts. She creates her carvings from her small home studio in South London. She also works as a print technician in the studio of a university.

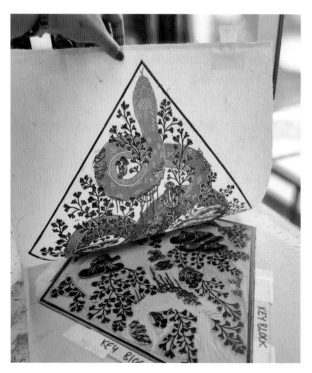

"You become more natural with using the tools and you settle into a rhythm of working that becomes second nature."

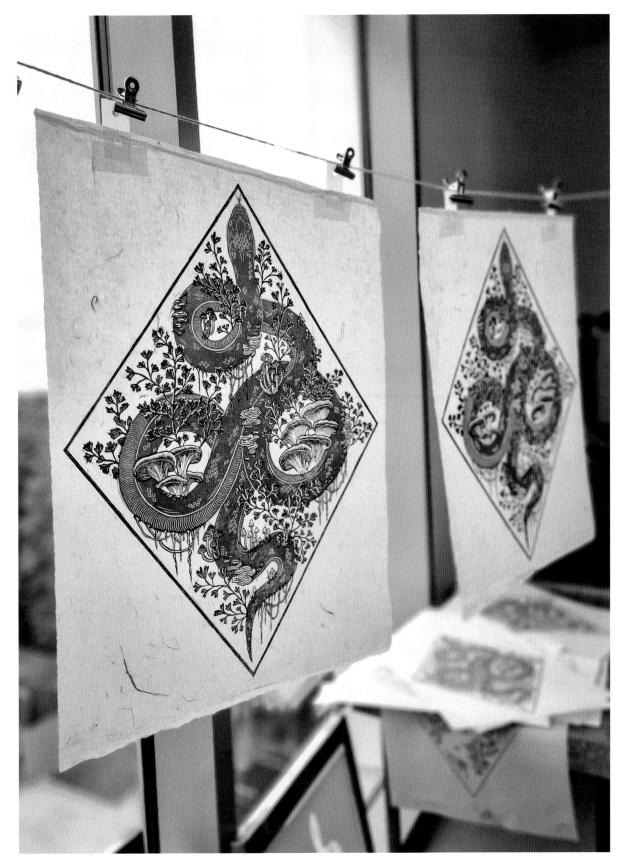

LINOCUT

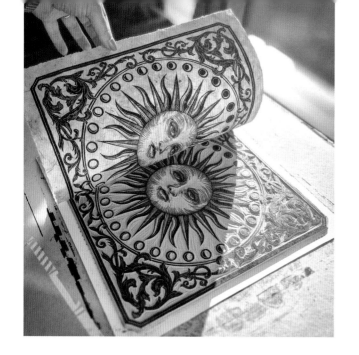

"I am fascinated
with how the ecosystem
works, so that definitely
feeds directly into
my work."

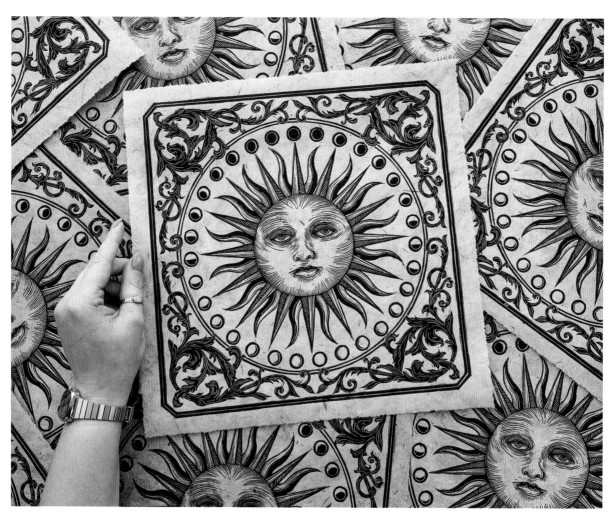

RACHAEL LOUISE HIBBS

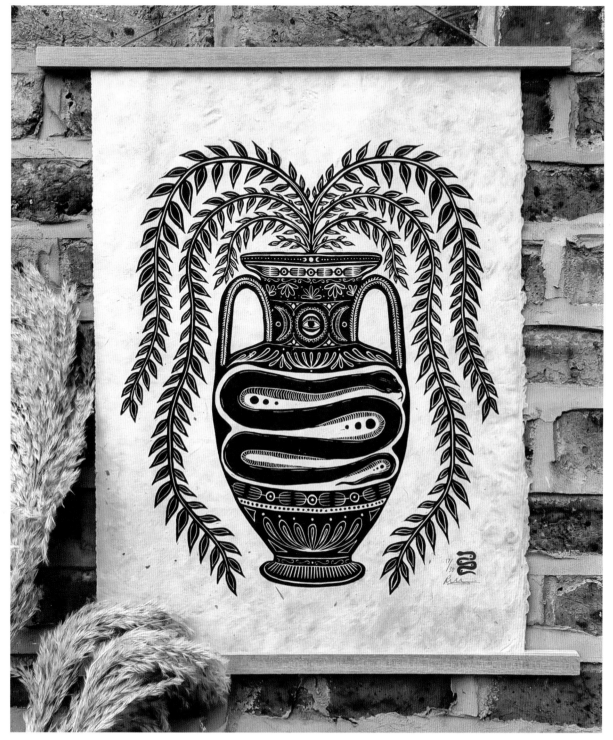

← Celeste (2021)
↑ Uncharmed (2021)

LINOCUT

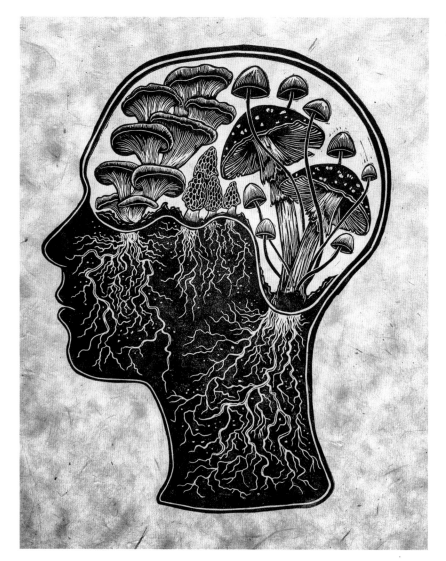

← Mindcelium (2021)
→ Selene (2020)

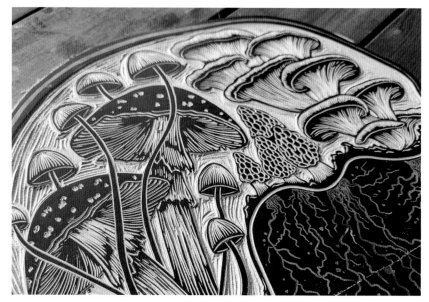

RACHAEL LOUISE HIBBS

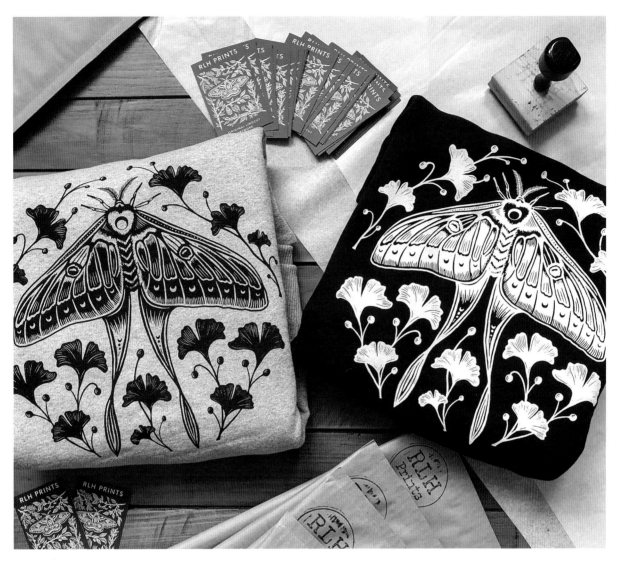

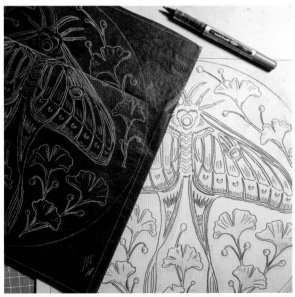

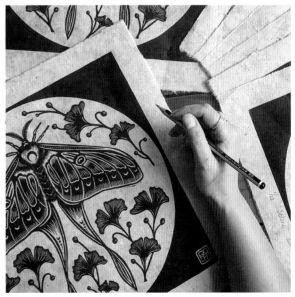

031 LINOCUT

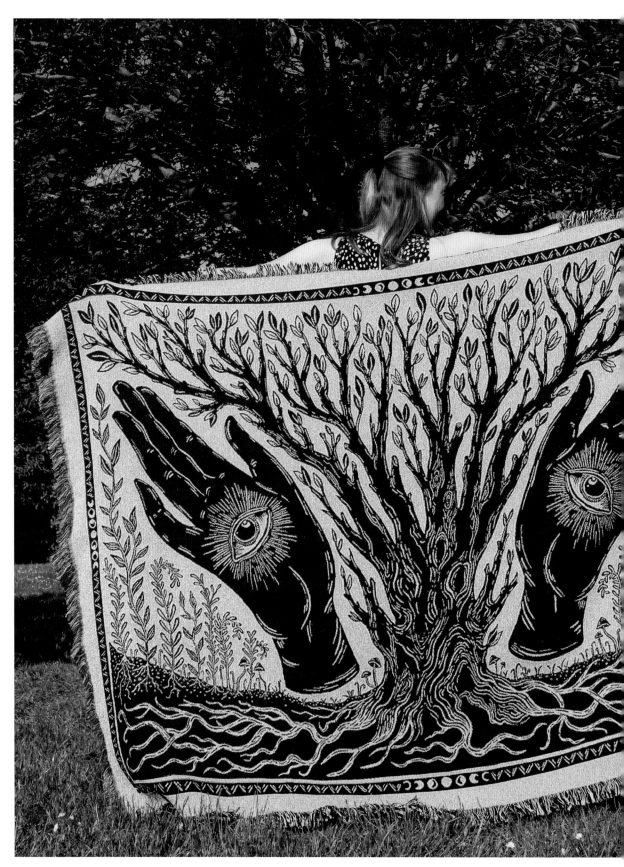

RACHAEL LOUISE HIBBS

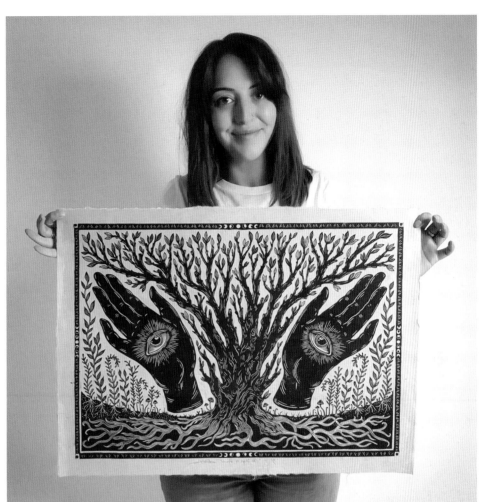

↑ The Shape of Power
 (2021)

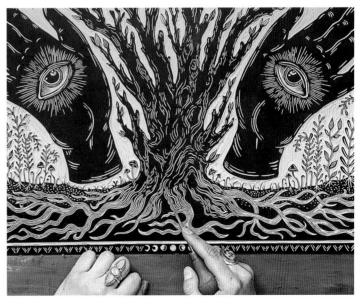

LINOCUT

Q: When and how did you get into printmaking?

A: I got into printmaking when I was working as an art technician in a school outside of London. They had a lovely old etching press that they encouraged me to use whenever I wanted. I started off small and then just grew to love the technique. I soon started carving in any spare time that I had and quickly developed a love for all things to do with printmaking.

Q: How did you hone your printing skills? Any tips for those who just jumped into the world of printmaking?

A: There is a lot of trial and error involved with printmaking and being consistent comes with time and patience. I love that there is always something new to learn and experiment with. I think I honed my skills after practicing many different print techniques. You become more natural with using the tools and you settle into a rhythm of working that becomes second nature.

Q: You have started a printing studio, developing a hobby into a business. Is everything working out as you expected? What is the trickiest for you?

A: I'm not sure what my expectations were for my printmaking practice but I never thought it would develop this far and that I would be a printmaking practitioner and educator for a living. I love what I do and I wake up every day excited to see what the day brings. The hardest part for me is the balance between working on your own practice and teaching others. Both are equally important to me so I try my hardest at both so this can be tricky to manage.

Q: You grew up in Oxfordshire. Did living there inspire you to create?

A: Where I grew up is very rural and the river is right on your doorstep, so, yes, I would say the natural world has inspired me immensely. As a child, I would go on walks and marvel at the different structures of leaf veins and colors of a feather. I am

Dynastid (2020)

RACHAEL LOUISE HIBBS

fascinated with how the ecosystem works, so that definitely feeds directly into my work.

Q: Plants and animals are common themes of your prints, sometimes integrated with some mysterious elements like in "The Shape of Power." Where did you get the inspiration for it? What do you try to express?

A: "The Shape of Power" was directly inspired by the novel *The Power* by Naomi Alderidge. The first line of the book says "The shape of power is always the same; it is the shape of a tree." I loved the concept that energy could be transferred through the roots and branches just like energy

running through our bodies. I tried to capture that power that one holds in their hands within this design.

Q: You even made it into a blanket. How did you come up with the idea? What was the process like?

A: I had always loved the idea of creating something more with my designs and I was very fortunate to work with Fibre Arts Weavers on this project. I supplied the digitally rendered design to them and they used their machines to create this beautiful woven throw. It's something I would love to do with more designs in the future.

LINOCUT

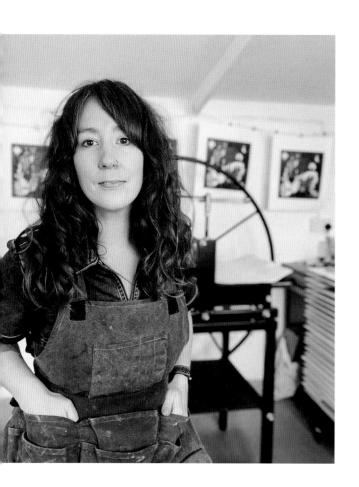

Nicole Revy

Prints by the Bay is the printmaking practice of Nicole Revy, an illustrator and printmaker from Bridport, Dorset. Working primarily in the medium of linocut, Revy creates unique and engaging prints that examine the connections between people and place. She often deals with the female experience and weaves together themes of nature, climate, and the human connection people have to the environment. Her style is a fresh and modern twist on traditional printmaking techniques. She creates small batch limited edition prints in both monochromatic and reduction linocut, and products printed with her unique designs.

Revy creates all her work in her home studio in Dorset and prints on a Gunning etching press. She has worked on many commercial illustration projects for big name brands and exhibits around the world.

"Natural earthy tones really speak to me as an artist and I think best suit my subject matter."

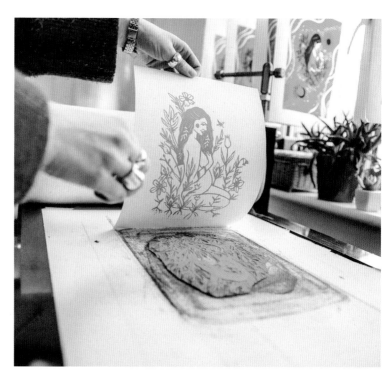

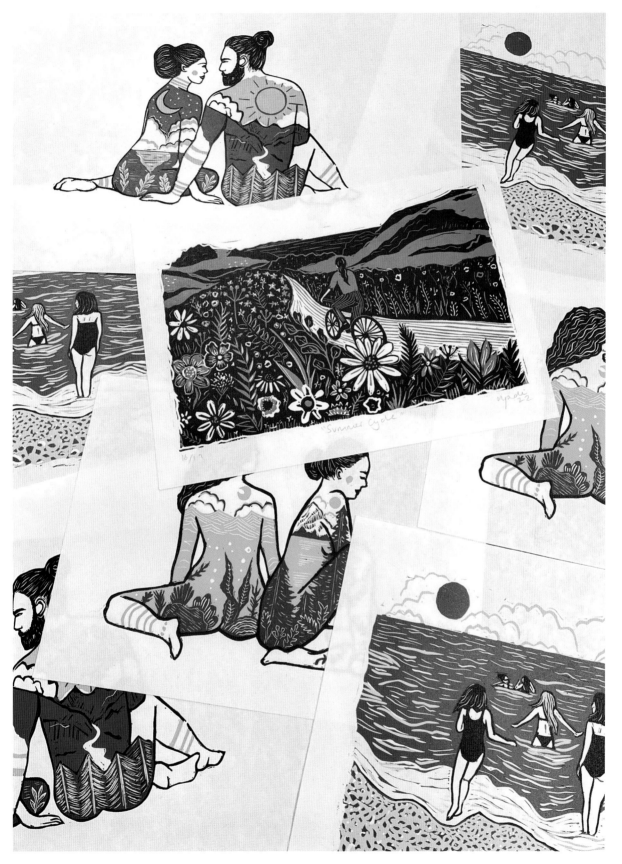

LINOCUT

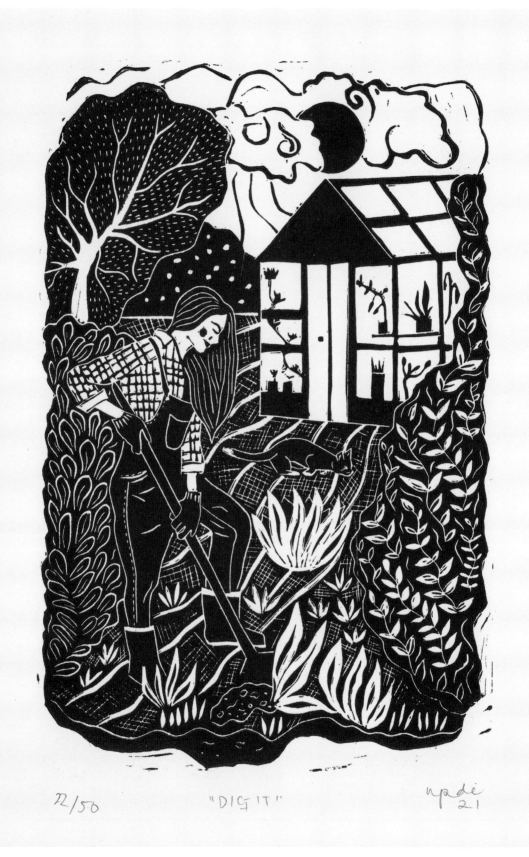

22/50 "DIG IT" nadé
 21

NICOLE REVY 038

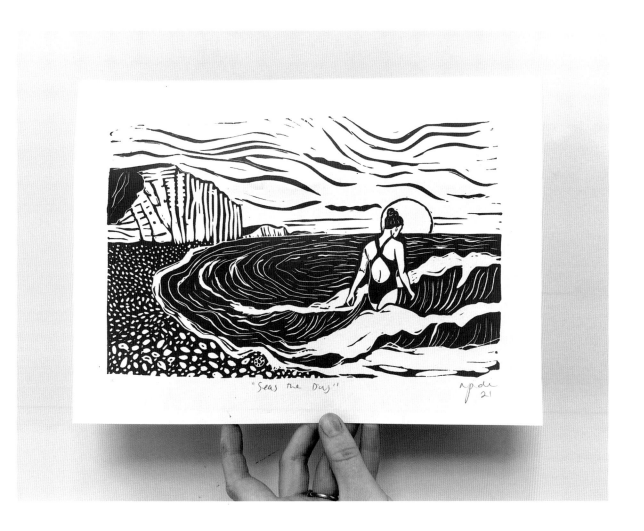

← Dig It (2021)
↑ Seas the Day (2021)

LINOCUT

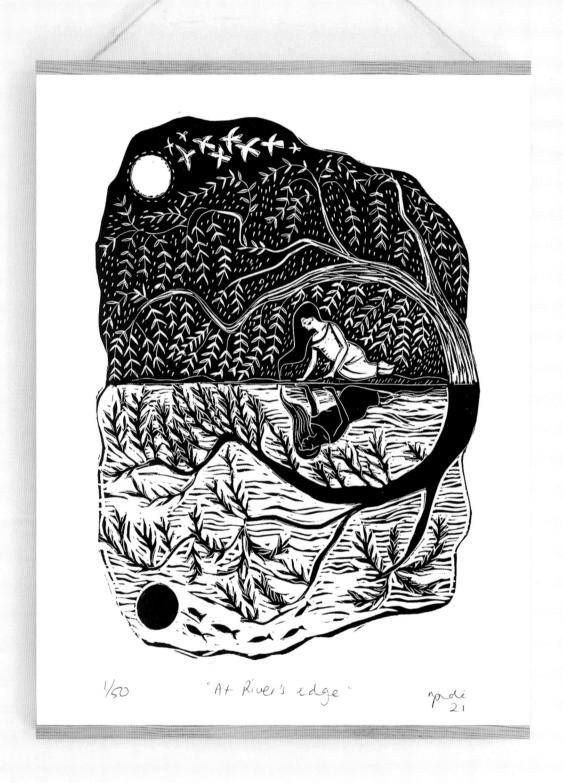

1/50 "At River's edge" nrodi
21

At River's Edge (2021)

NICOLE REVY 040

← notebooks (2021)
↓ Drunken Sailor Print (2020)

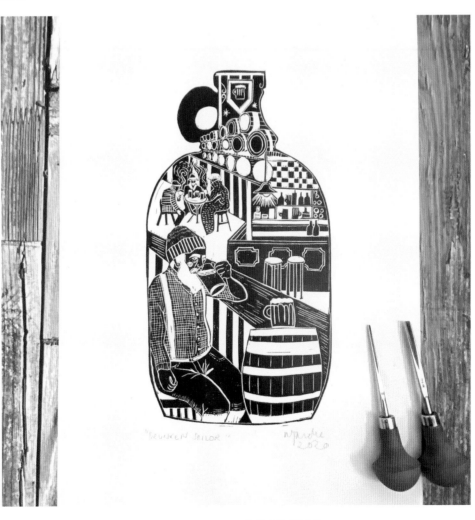

LINOCUT

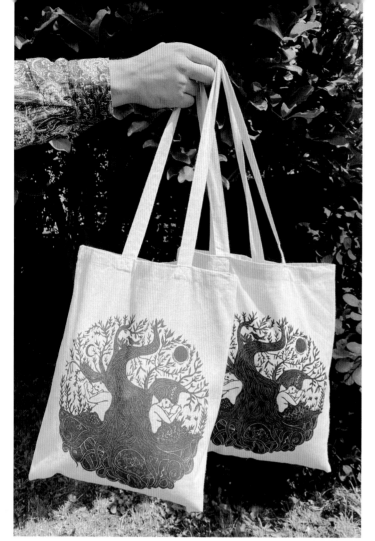

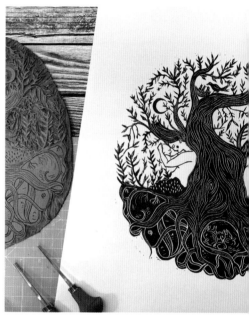

↑ tote bags (2021)
→ tin mugs (2021)

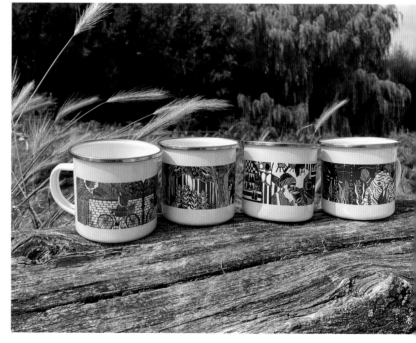

NICOLE REVY

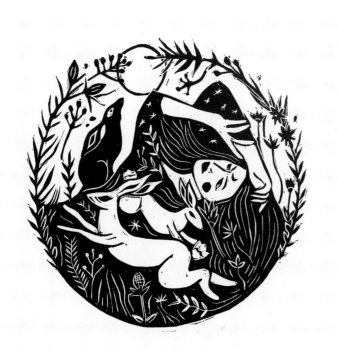

"My goal is to
be able to keep
making art works
that people
resonate with."

← Midnight Meadow (2021)

LINOCUT

Q: You studied illustration in 2007, creating murals and art. You got engaged in linocut again in 2019. Is there anything that pushed you to go back to experiment with linocut during these 12 years?

A: I had my daughters straight after graduating from university, so much of my 20s were spent raising children—this didn't leave me much room for creative experimentation! Once they were in school full-time I started to focus more energy into my art work again. I had been working in graphic design and marketing, which is very screen-based, so I think for me, I was yearning for the analogue, the hand-made touch. Printmaking and, in particular, linocut, really satisfies that need.

Q: Most of your works deal with female experience. And you always have a female character. Why do you care so much about females?

A: I can't really answer that fully as it is a subconscious drive! As long as I can remember, I have always drawn women figures in my artwork. Part autobiographical, part imaginary—they always seem to feature. I think it is because my work is derived from personal experience.

Q: You usually use colors like teal, blue, and green in your works. Why do you use these colors? Is it a hint of the connection between nature and human? Or the environment?

A: I just am naturally drawn to the colors of the land and the sea. Natural earthy tones really speak to me as an artist and I think best suit my subject matter.

Q: The materials, such as paper, linoleum, and ink are much important. Could you please tell us how you choose the paper?

A: Paper choice is made based on the type of linocut and printing method. Thin, absorbent papers work best for multi-colored prints. Crisp, smooth white papers are great for my ocean-themed prints and I love the handmade papers for mini prints.

← greeting cards (2021)
→ Cherry Blossom (2021)

NICOLE REVY

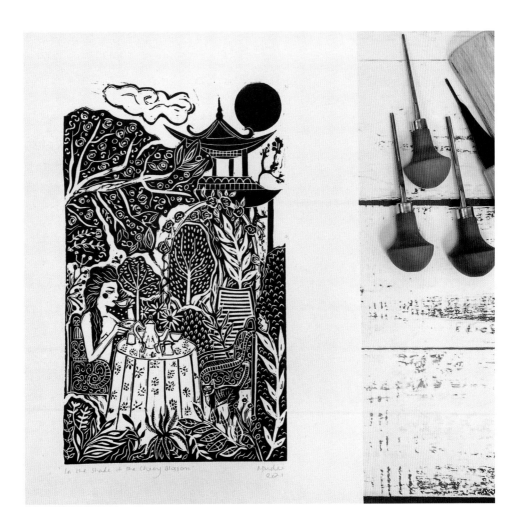

In the shade of the Cherry Blossom

Q: You mentioned that you also run workshops. What challenges do you face when you are teaching?

A: Workshop teaching is very rewarding, especially when your students see their prints for the very first time! It can be difficult getting each pupil enough help in large-sized groups, so recently I have reduced the size to offer more structure-based, smaller sessions. Future plans for teaching include fabric printing and stamp making.

Q: The artists you follow work in digital and analogue. How do they inspire you?

A: I really love to follow painters. It's something that I've never been able to do well myself, so I really admire the skill needed to create amazing painting. I love all mediums—watercolor, oils, mixed media. I love to see how other artists respond to the world around them—it's endlessly fascinating!

Q: Do you have an exhibition or any event in the future? What's your goal that you want to achieve?

A: I have a few exhibitions, markets, and fairs lined up in the south west of England from now until Christmas—it's a very busy time for us makers. My goal is to be able to keep making art works that people resonate with and perhaps to be able to illustrate my own book in the near future!

Harriet Popham

Harriet Popham is a printmaker based in Somerset. Her work is inspired by places and moments in time that bring her joy. Often within the silhouettes of vessels, Popham carves scenes and pieces together locations with lino blocks.

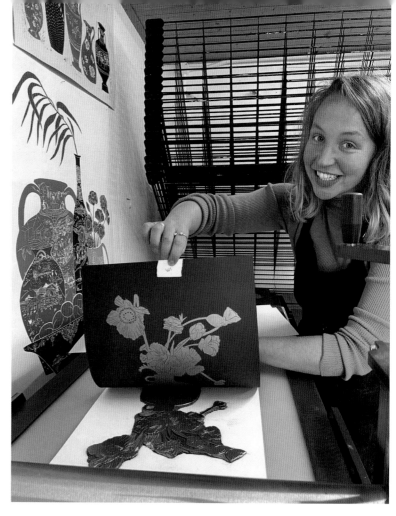

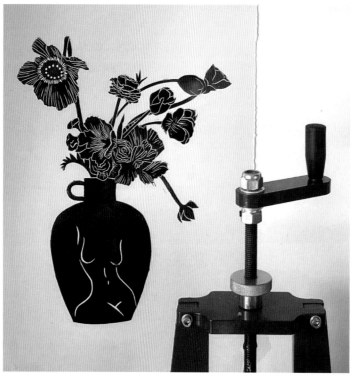

"Seeing people enjoying working with lino printing for the first time makes me very happy."

LINOCUT

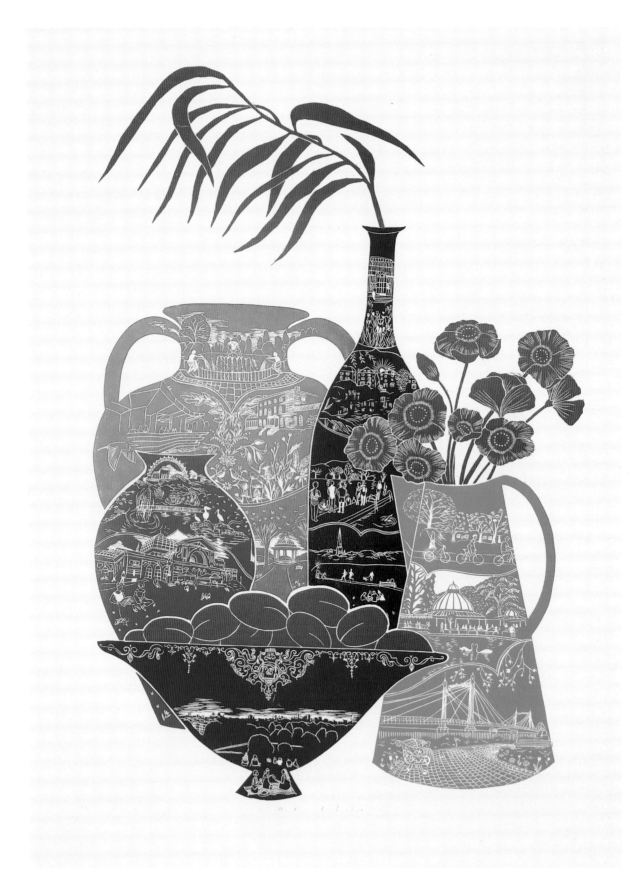

HARRIET POPHAM

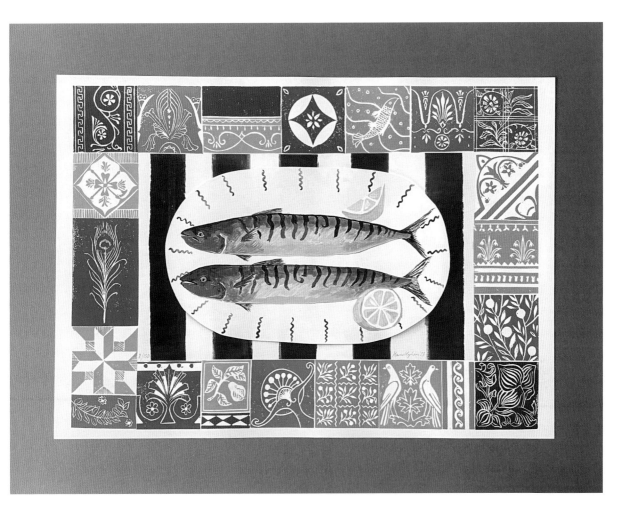

← Parks of London (2021)
↑ mackerel mixed media print (2023)
→ Sundae (2022)

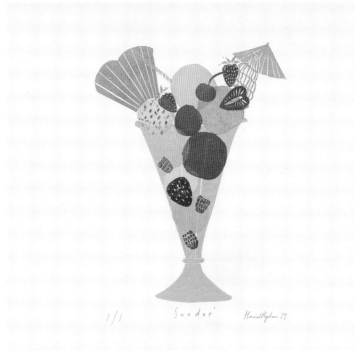

LINOCUT

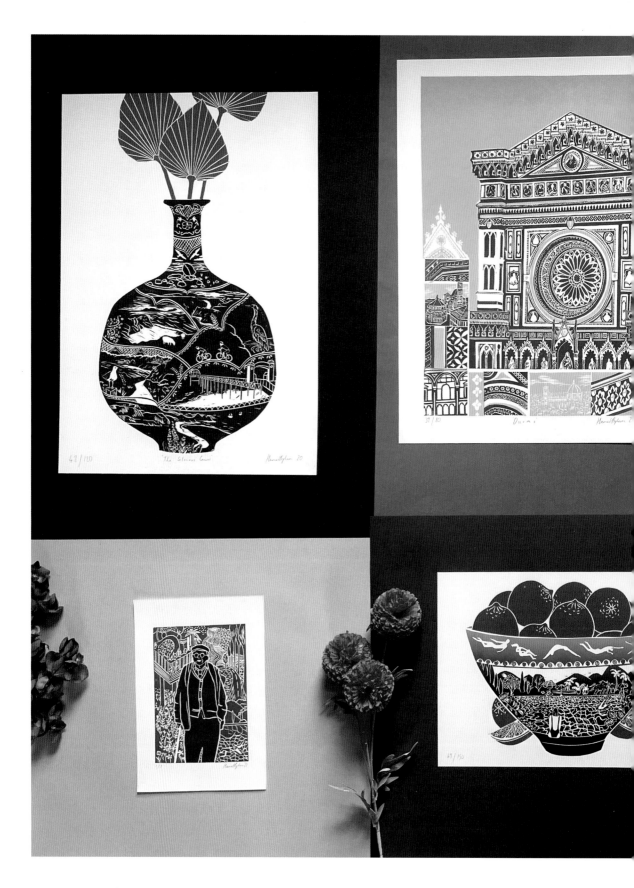

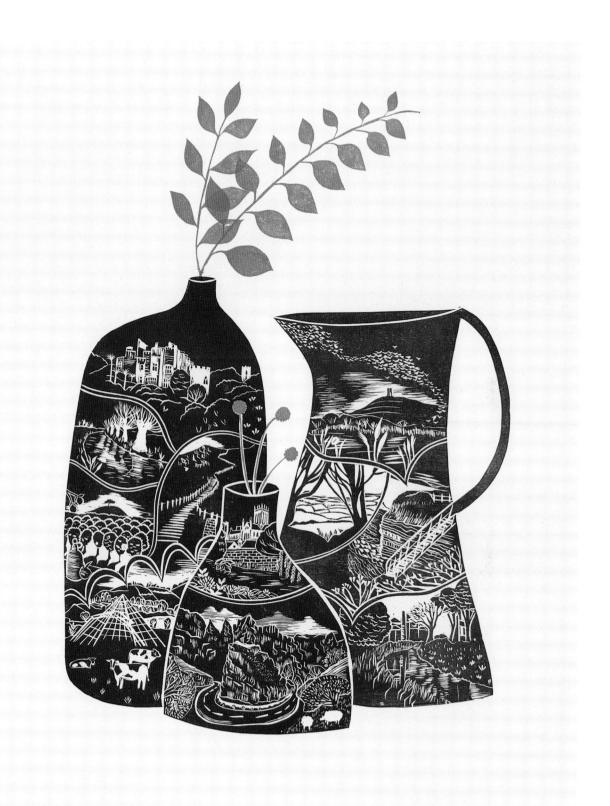

← multi prints on colors (2020–2022)
↑ Somerset Vessels (2020)

051 LINOCUT

"The carving is so wonderfully slow and calming. You can't really rush it."

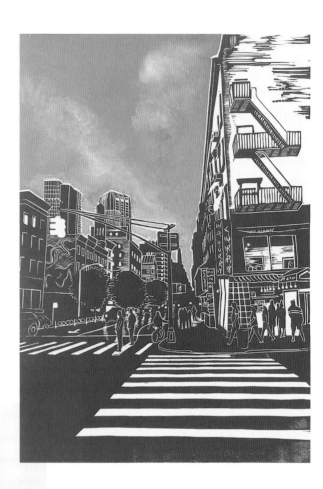

→ NYC print (2021)
↓ Penelope (2022)

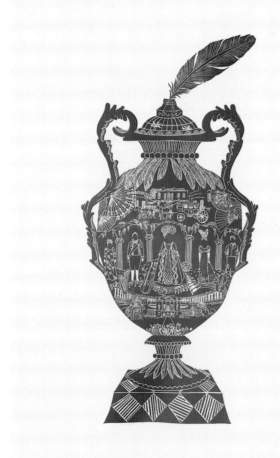

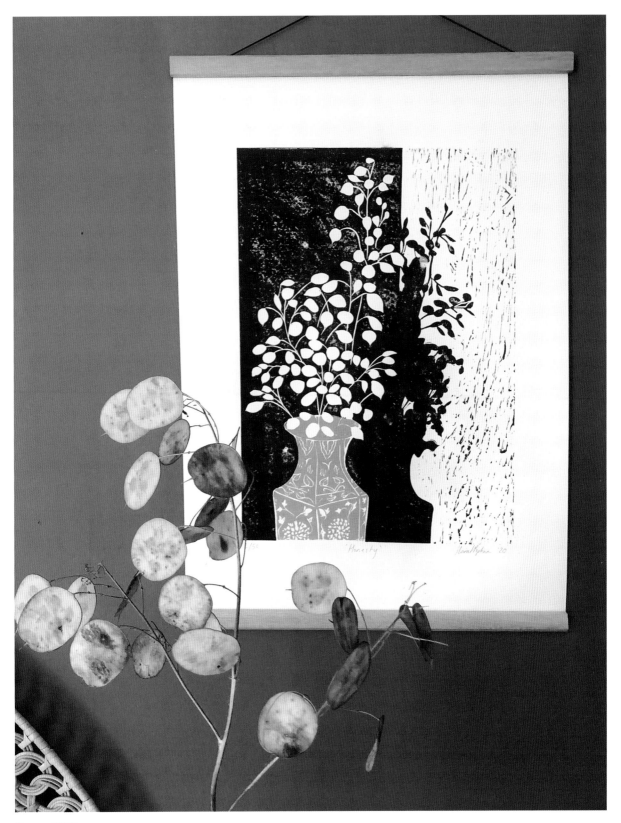

Honesty (2020)

LINOCUT

Q: You got interested in linocut in 2018 and ran several workshops. But you started to work with linocut in 2020. What happened in those two years?

A: I had my first go with some lino in 2018. At the time, I was doing illustrations for books and didn't have much time to take it any further. I was drawn to running workshops because I wanted some variety in my work life. When I realized my favorite creative workshop to teach was lino printing, I got increasingly invested in the craft.

During Covid, all workshops had to be canceled and, while at home during lock down, I started properly dedicating time to making lino prints just for me and challenging myself to work bigger.

I stopped taking on commissions and illustration projects and gradually focused solely on lino printing, which made a huge difference to my development as a maker and my business.

Q: You love to run creative workshops. How do these workshops feed in to your own creations?

A: Seeing people enjoying working with lino printing for the first time makes me very happy. It's such a satisfying process and watching others get immersed in it further fuels my love for it. On top of this, seeing what people can achieve in just a few hours inspires me to try and work more intuitively and playfully and not always on really labor intensive blocks that are very time consuming to plan.

Q: Your works depict various objects, such as plants, landscapes, and people. Do you have these objects in front of you before you create or do they unfold as you work?

A: My prints usually begin with a visit to a place or a museum where I will sketch and photograph objects and architecture. This research feeds in to the design process

Sunday Besties (2022)

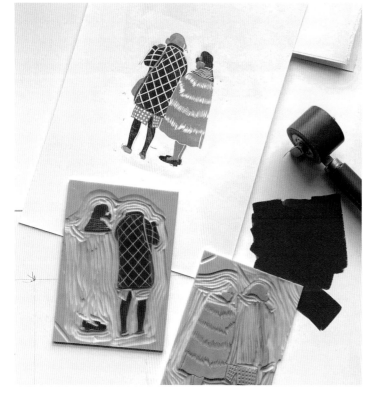

HARRIET POPHAM

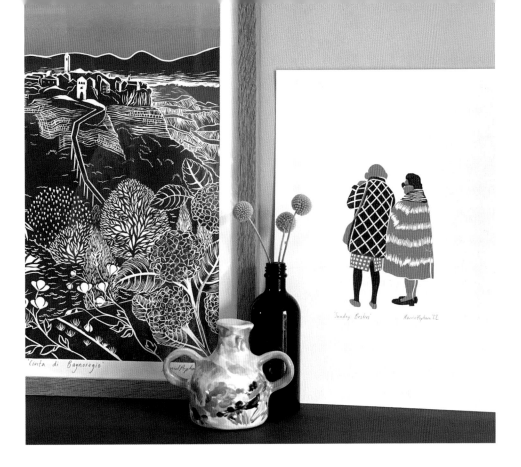

later. The way I create a print involves pulling multiple elements together, sometimes positioned within decorative tiles and vases, so there is usually a mixture of improvised pattern and structure as well as working from real life objects, plants, and places.

Q: You studied embroidery and textile design for interiors. Do these have any influence on your linocut printing?

A: For my degree, I designed wallpapers and fabrics, which were densely packed with drawings. I think this playful way of incorporating multiple elements inside one design has carried through to my lino prints. My degree course, surface pattern design at Swansea College of Art, hugely encouraged creative drawing practises and showed us so many ways we could utilize drawing and mark making within the creative industry. From silk screen printing on to fabrics, drawing with stitch, book covers, digital textile design and prints for

interiors. It was a wonderful course and although I came to lino printing afterwards, I'm so pleased to have studied such a varied and exciting degree course which still informs the way I work.

Q: Which step do you like most in the process of printmaking? Why?

A: I'd struggle to choose between the carving and that first ink up. The carving is so wonderfully slow and calming. You can't really rush it and it's so satisfying. I love the commitment of making lines by gauging out the lino after what can be a long time in the planning stage. The first time you roll some ink on to a fleshly carved block is very rewarding. You finally get a really good sense of what it's going to look like printed in your chosen color and, after the complex and slow nature of carving, it feels wonderful to cover large areas with one big swoop of the roller. The sounds are lovely, too.

"What attracted me most about this technique is the amount of detail you can achieve."

The Netherlands

Sofie van Schadewijk

Sofie van Schadewijk is a printmaker, illustrator, and mom of two little girls. Though she did study at the art academy, she is completely self-taught when it comes to relief printmaking. Subjects that often make an appearance in her work are female figures with long hair, cups of steaming tea or coffee, a little magic, cats, a lot of nature, and tiny cottages.

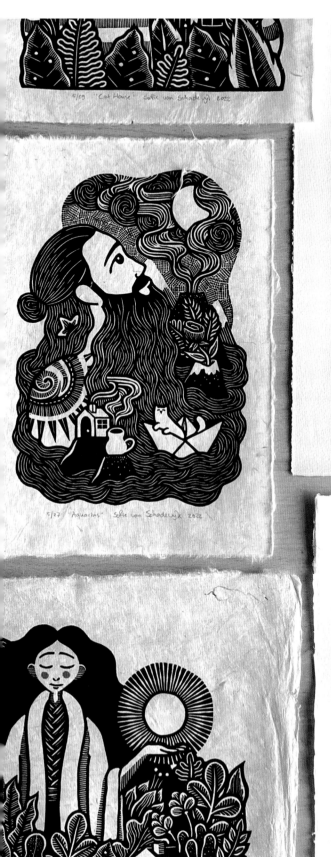

5/29 "Cat House" Sofie van Schadewijk 2022

5/27 "Aquarius" Sofie van Schadewijk 2022

80/118 "Three of Us" SvS 2022

LINOCUT

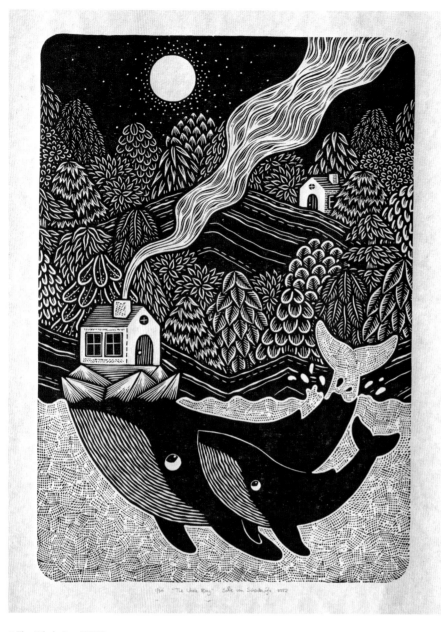

↑ The Whale Bay (2022)
↗ Pachamama (2021)
↗ Aquarius (2022)

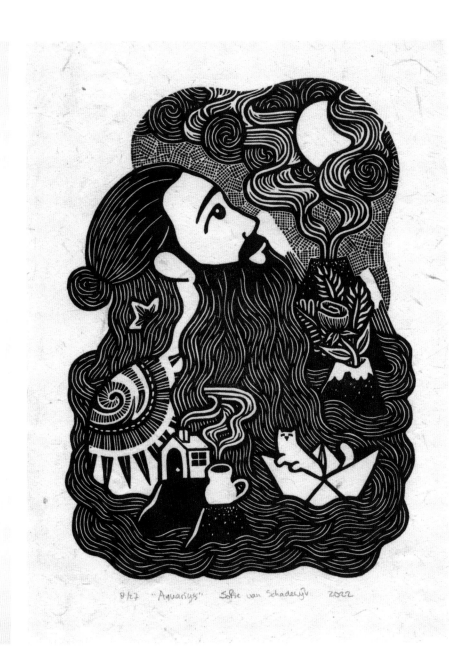

8/27 "Aquariys" Sofie van Schadewijk 2022

LINOCUT

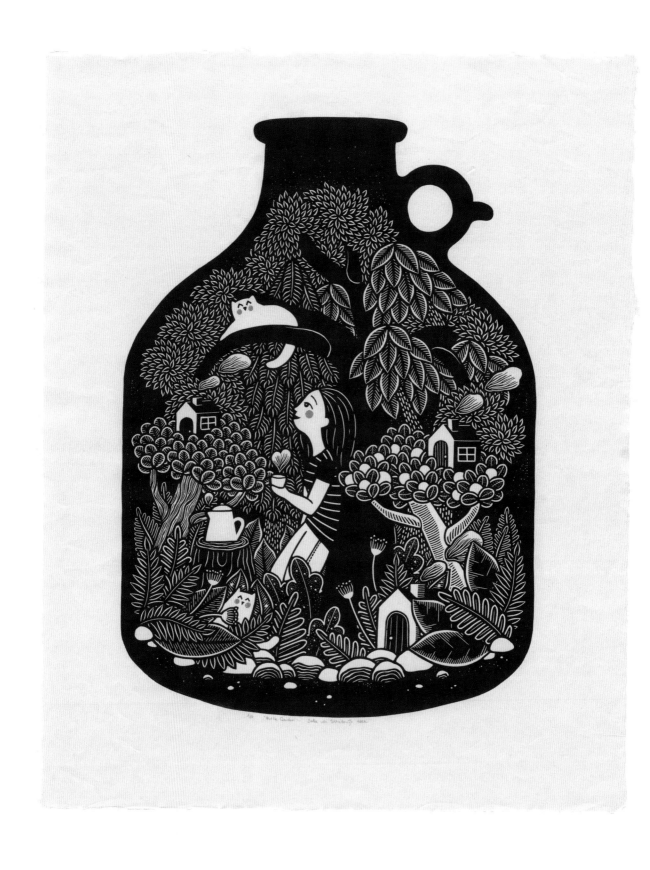

SOFIE VAN SCHADEWIJK

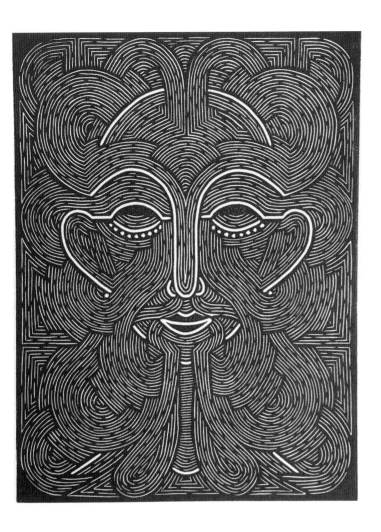

"I find nature
quite inspiring,
but also stories,
like fairytales
or folklore."

← Bottle Garden (2021)
↑ The Face (2021)
→ woodcut ornaments (2022)

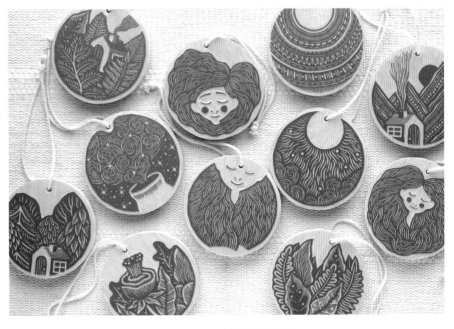

LINOCUT

Q: You studied graphic design when you were at university. Could you please tell us why you chose to study graphic design at that time?

A: I loved typography (still do), so that aspect was really appealing. And I thought it would be more likely to find a job in graphic design after I graduated ... not the best reason to pick a certain education, I know.

Q: How did you get interested in block printing? Was there any turning point?

A: Before I started block printing, I mainly created black and white pen drawings, which I screen printed onto paper and textiles. I came to a point at which I felt my work lacked something, I couldn't put my finger on it. It was time to try something new and, around that time, I discovered a few relief printmakers on social media. They were able to achieve so much detail in their work. I never realized that was a possibility with this technique and I was immediately intrigued. So, I decided to invest in proper tools and ink and got

busy. Block printing really lifted my work to another level, I think. And there's so much character in a handmade print. It makes the image even more livelier.

Q: You work in many kinds of block printing, such as linocut, woodcut, and engraving. What is interesting about each technique?

A: Woodcut and linocut are almost the same in technique, though with woodcut you have to take the woodgrain into consideration while carving. Linoleum is more forgiving, but I tend to love woodcut more because there's more character in the final print and you can achieve sharper details because of the density of the wood.

Wood engraving is much different from wood or linocut. You'll need a different set of tools and the block is made of very dense end grain wood. The character of a wood engraving print is a lot less bold in comparison to woodcut or linocut prints. What attracted me most about this technique is the amount of detail you can achieve.

← woodcuts (2021)
→ Pant House woodcut
 triptych (2022)

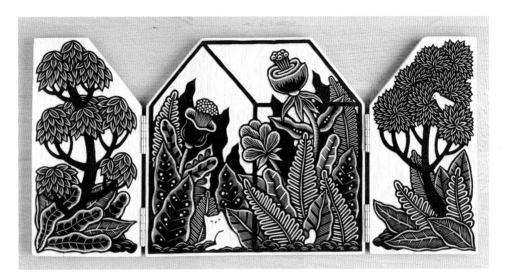

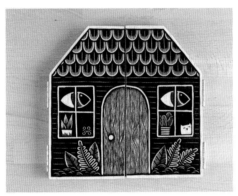

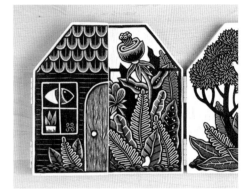

Q: Your works include many subjects, from nature and human figures to landscape. Where do you look for inspiration?

A: The ideas for my work usually just pop up in my head, while I'm in the shower or cooking dinner. I find nature quite inspiring, but also stories, like fairytales or folklore. I don't necessarily look at art or pictures for inspiration, though they can be helpful when trying to work out certain details in trees, plants, flowers, etc.

Q: Your figures have lots of hair. Why do you love to draw thick hair?

A: Hair is just a very nice texture to carve and it's fun to play around with. What would an ocean of hair be like or what would happen if we were connected to each other through hair?

I used to be a bit jealous of anyone that has a nice, full head of hair (because mine is anything but), so maybe that has something to do with it, too.

Q: Do you have any favorite printmaker? Why do you love them?

A: My favorite printmaker must be Valerie Lueth from Tugboat Printshop (Pittsburgh, Penn. in the United States). She is an amazingly skilled woodcut printmaker. To me, anything she makes is literally breathtaking. Her work is very rich in both color and detail. I could look at it for hours and never get bored.

United States

Jason Limberg

Jason Limberg is a printmaker and illustrator who calls Michigan's Upper Peninsula home. Predominately working in linocut, his inspiration is found hiking in the forest and canoeing in the lakes. These beautiful places are where he daydreams and imagines the magical lives of animals. A deep reverence for wildlife and nature, along with exploring wild places with his wife and husky, is what fuels Limberg's work as an artist. He works to create an appreciation for animals and nature through his linocuts.

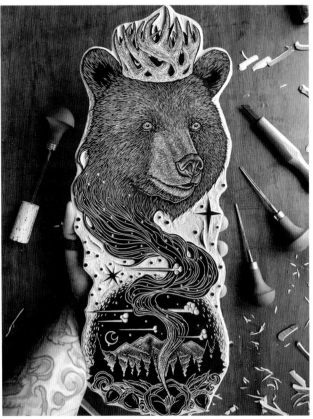

"It comes naturally to me to daydream about the magical lives of animals, imagining them in a fantastical world."

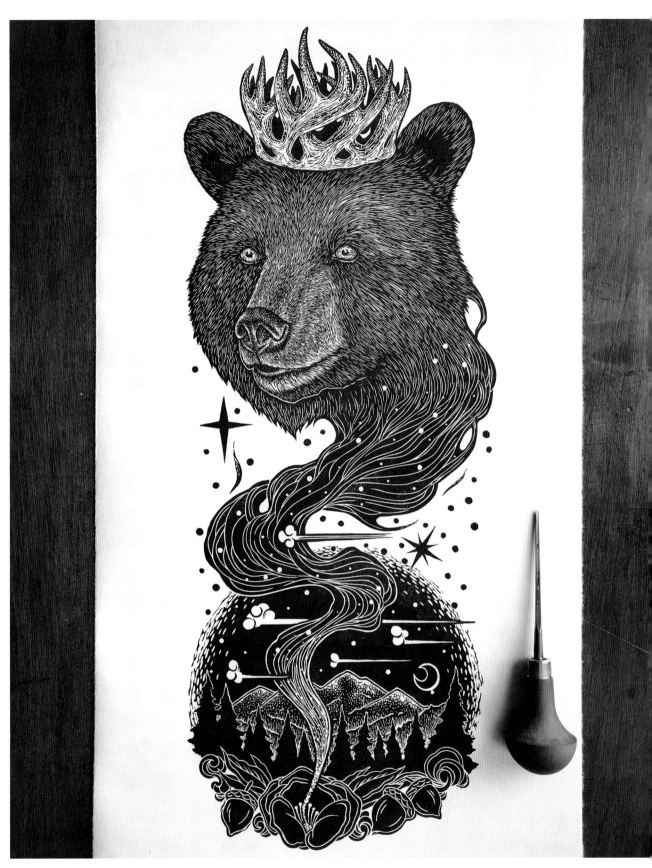

LINOCUT

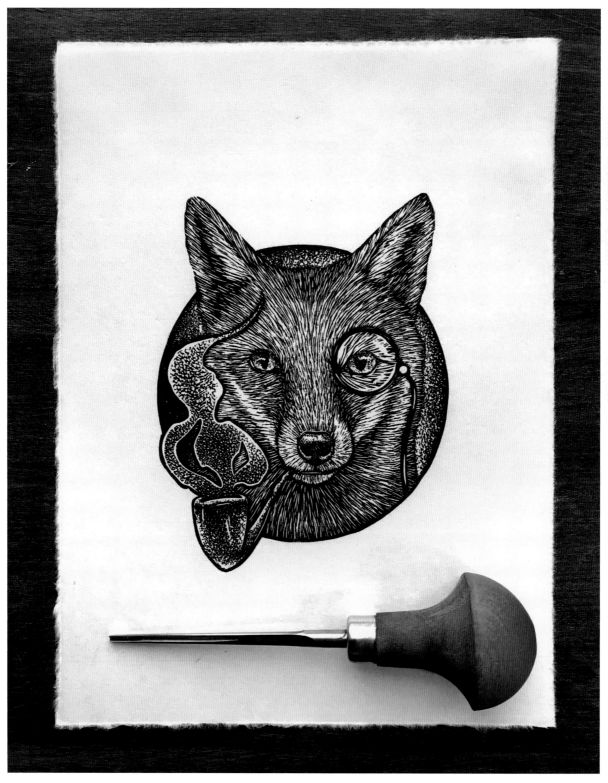

Mr. Fox (2020)

JASON LIMBERG

066

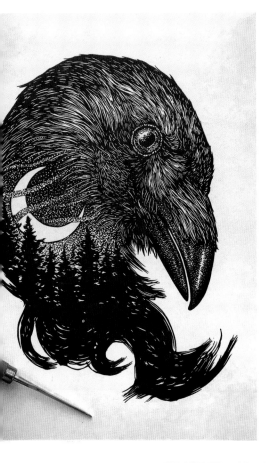

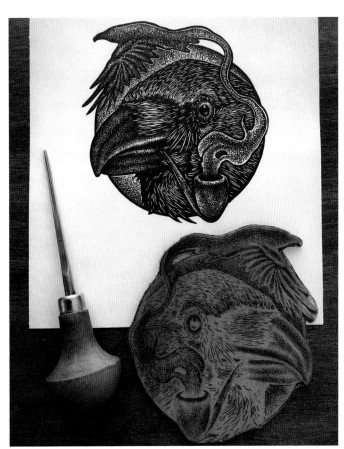

↑ Raven Moon (2020)
↗ Creator (2021)
→ Star Bringer (2020)

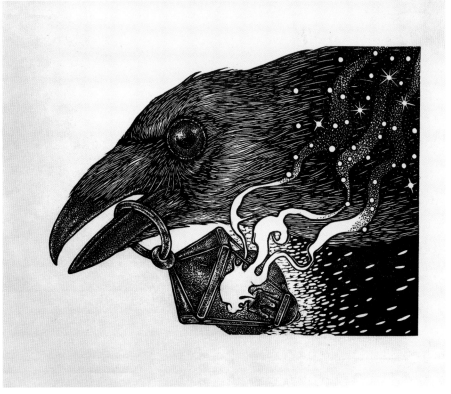

LINOCUT

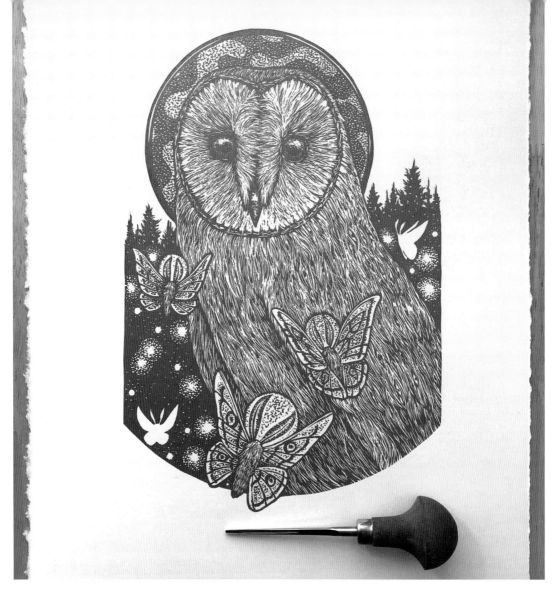

"I want my passion for the natural world to shine through and, hopefully, resonate with others."

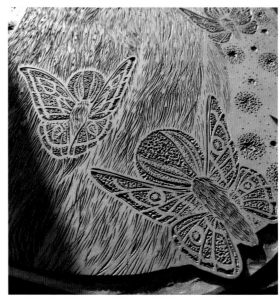

JASON LIMBERG

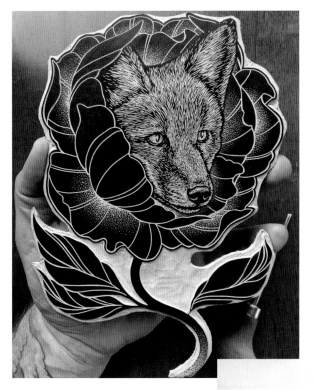

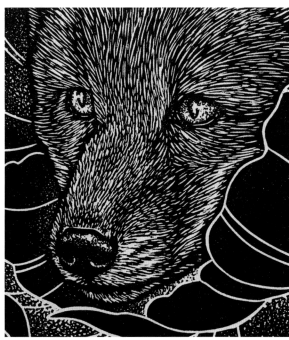

← Midnight Dance (2020)
→ Lupus Blossom (2021)

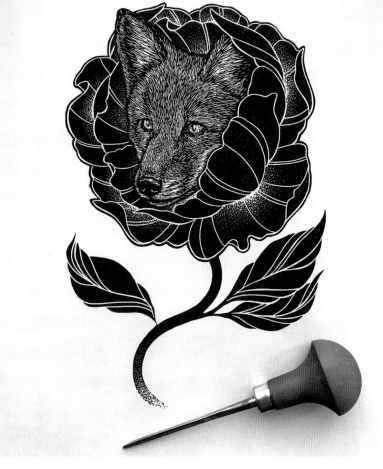

LINOCUT

Q: Most of your works are related to animals, the forest, and its inhabitants. Why are you interested in them?

A: Great question! I am very passionate about nature and wildlife. When I am hiking in the forest, I feel the most alive. It comes naturally to me to daydream about magical lives of the wildlife, even if it is a little more fantastical. Telling their story is a way of sharing my reverence for the wilderness.

Q: How long have you been a printmaker? Why do you combine linocut printing and animals?

A: I have been a printmaker for a little over two years. Before that, I mainly worked in pen and ink. My art and ideas have always been centered around animals, so including them in linocut was a seamless transition.

Q: Your works are full of delicate details. How long does it take to finish a piece of work? And what are your challenges during printmaking?

A: Depending on size, a piece will typically take me two to three weeks from sketching to printing. I really love getting lost in carving the details and like to take my time as it brings me a lot of joy to see the image emerge in the block. The biggest challenge for me is in the printing as I have an expectation of how I want the details of the print to look. The best part of printmaking is that there is always so much to learn and I enjoy the challenge.

Q: You love hiking and observing nature. Could you share an impressive journey with us? Is there any creation related to this journey?

A: Love this question. A few years ago my wife, dog, and I were hiking and we happened to come across a wolf in our path. The interaction lasted no more than 20 seconds, but it was one that has stuck with me. Nature can be fleeting like that. Making eye contact with such an amazing creature in the wild is something I will always cherish. Eventually, I will create a print that will share a story of the experience.

Q: How do you want people to feel when they look at your prints?

A: I want my passion for the natural world to shine through and, hopefully, resonate

← Night Spirit (2021)
↗ Night Spirit & Gleam (2022)

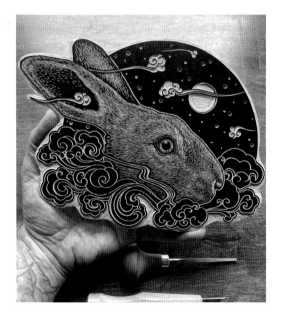

JASON LIMBERG

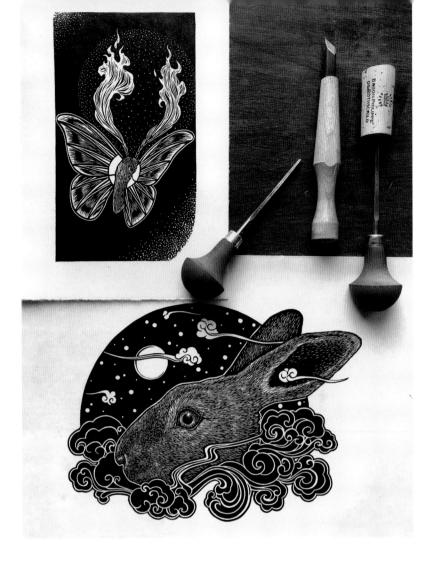

with others. I truly believe that we protect the things we love and maybe people's love of nature and wildlife will either deepen or be awakened when spending time with my prints. It is an ambitious goal, but why not shoot for the moon?

Q: What is your favorite print of your own?

A: My favorite print of my own is "Bear King (P49)." Bears are one of my favorite animals and I enjoy the idea that the black bear is the king of the northern forest. Also, the print was fun in creating, experimenting with different flow, textures and concepts. I can see that it will be a print that inspires future growth and themes in my work.

Q: What is your next printmaking challenge? Do you have anything that you want to do most?

A: It seems like the challenges in printmaking never end. I always want to design, carve, and print better. But, some challenges I have set for my art is working on a larger scale with more dynamic compositions that dive deeper into the fantastical and mystic. Animals will always be a constant. Also, I would love to print a series of smaller prints and bind them by hand to make a limited collection of books. Honestly, I have more goals than time. Excited to see what the future holds!

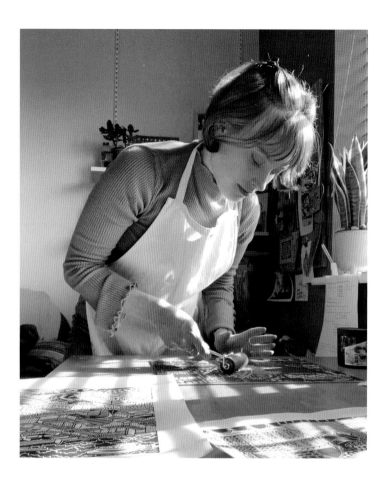

United Kingdom

Ella Flavell

Ella Flavell is a printmaker from Dudley who has been making linocut prints under the name Burin & Plate since 2016. Her work focuses on landscapes, cityscapes, and film scenes with an emphasis on pattern and graphic contrast. She is self-taught, but has a background in art history and a long-held interest in art making has provided the foundations for her practice.

"I love the block printing process because it combines so many things— drawing, sculpting, even a bit of math!"

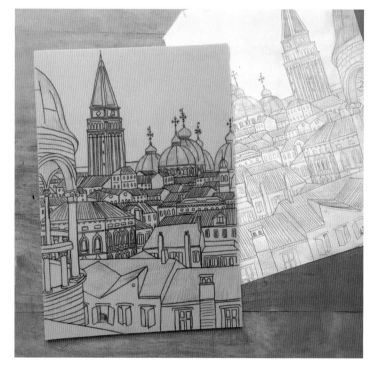

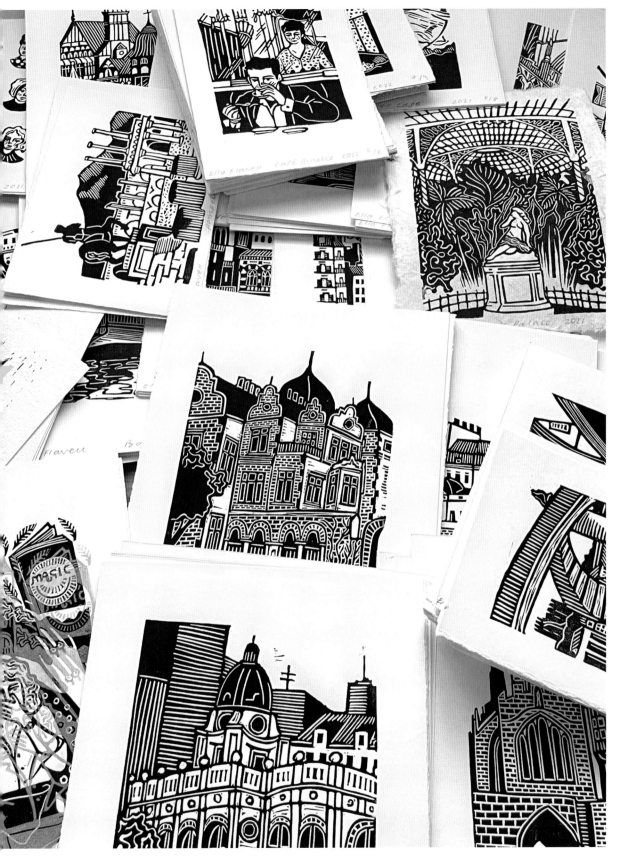

LINOCUT

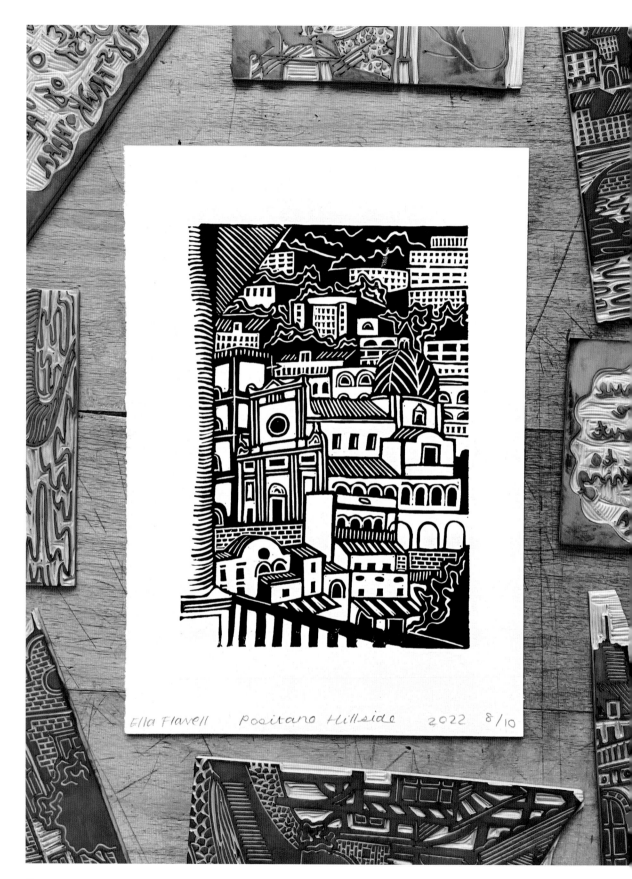

Ella Flavell Positano Hillside 2022 8/10

ELLA FLAVELL

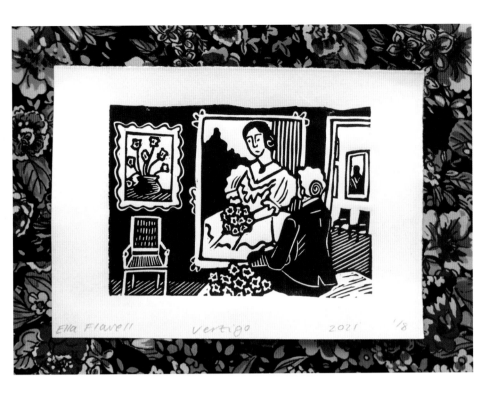

← Positano Hillside (2022)
↑ Vertigo (2021)
→ Bringing Up Baby (2021)

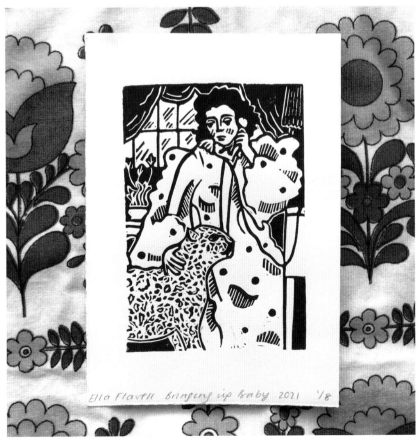

LINOCUT

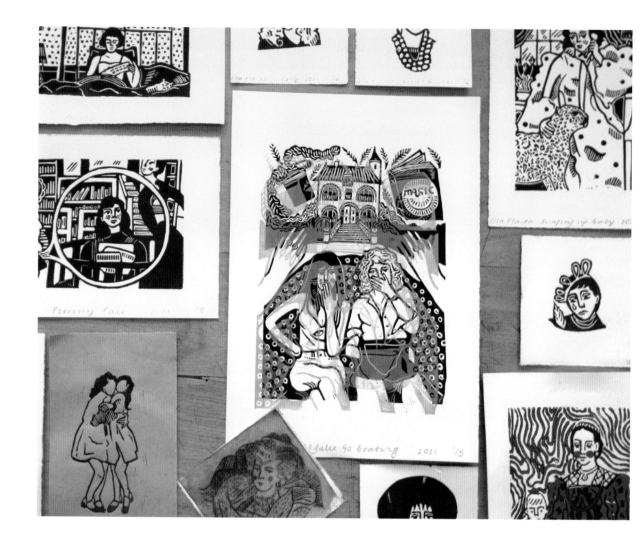

↑ Celine and Julie Go Boating (2021)
← Eleonora di Toledo (2021)
→ Votivkirche, Vienna (2022)

ELLA FLAVELL

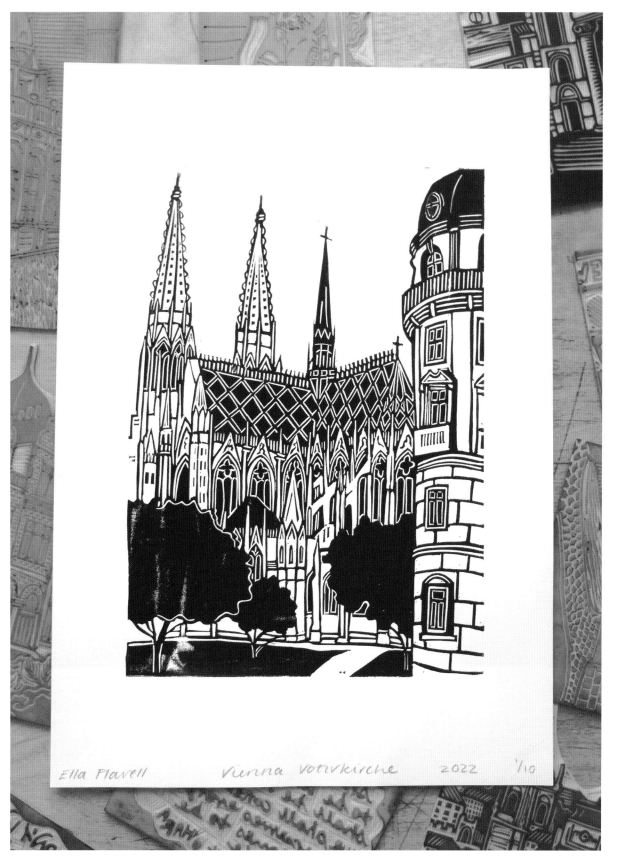

Ella Flavell Vienna Votivkirche 2022 ¹/10

077 LINOCUT

Q: You got interested in the linocut process when you studied 18th century printmaking. How did this history influence you?

A: We studied 18th century printmaking during the second year of my undergraduate degree in art history. I'd only ever tried printmaking once a few years before this at school, and it was a process that, at the time, had really resonated with me, more so than painting or drawing ever did. The university module reignited this interest because it explored a really interesting turning point in the history of Western printmaking, where it was being used for both high and low art purposes—everything from cheap satirical comics to high-end reproductions of famous artworks. The techniques were fascinating and there's many of them—such as lithography and mezzotint, which I'd love to have a go with. The main influence for me from this period however was that printmaking made art affordable for lots of people to have in their homes and that's something I'm interested in doing in my own practice. Additionally, especially in the printed reproductions of famous paintings, there are some really interesting uses of pattern and form, which are almost abstract and yet pre-date abstraction for centuries. I think printmaking has always been a very radical and experimental art form.

Q: Some of your works are buildings or landscapes of the city. Do you take photos by yourself and transfer it onto the block? What are your challenges during this process?

A: Most of my prints are taken from my own photos or, if I haven't got the right angle, I usually walk around the location on Google Street View, because you can usually find the right spot. I then do a rough sketch of the composition, which I then transfer onto tracing paper where I flesh out the details. I find tracing paper transfers the pencil lines onto the block much easier than normal sketching paper. The main challenge, as I mentioned above, is finding the right angle, so that there's enough visual interest in the print while still making it recognizable. In a lot of my prints I've played with scale and perspective, so that buildings appear closer together than they are in real life, just so that I can fit them all in. This can be a long process and, for prints where I've moved a lot of buildings, it takes quite a few sketches to get it right.

Q: What do you love most about the block printing process?

A: I love the block printing process because it combines so many things—drawing, sculpting, even a bit of math! I really love

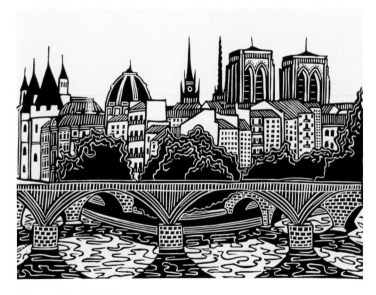

← Île de la Cité (2021)
→ The Victoria and Albert
 Museum (2022)

ELLA FLAVELL

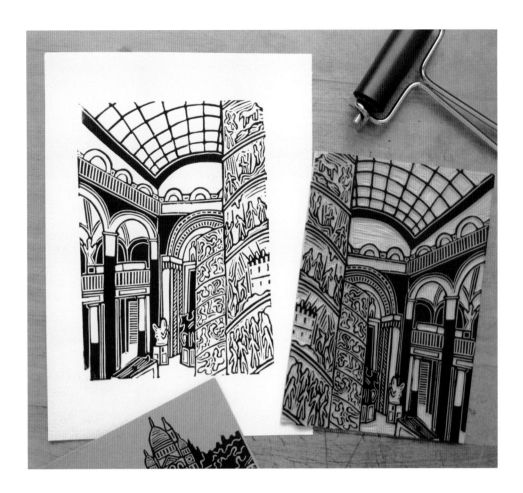

being able to fully immerse myself in a block, especially when carving all the intricate details. You get to really know the subject and you start thinking about how the space has been constructed, what the best way to convey texture or form is, and it really does transport me into the place I'm carving. It's also a very physical process, especially when printing by hand. It's both very technical, such as getting the right amount of ink and pressure, for example, but then also very therapeutic. You start being able to do things by eye and by instinct and you feel so connected to what you're making.

Q: What's your favorite place to go to find inspiration?

A: Holiday photos are my main starting point. I'll go through albums or scroll back through my phone and see if anything sparks my interest. Daydreaming is also where I find a lot of ideas for subjects, especially during lockdown when we were stuck indoors. I'd let my mind wander and usually turn my dreams of escaping to Italy or Spain into prints. Whenever I get blocked though, I usually end up looking a lot more at other people's works in museums or online. My day job is as a researcher in art history, so looking at and thinking about other people's art is almost second nature and spending time with other works of art can be really rewarding. Even if you don't draw directly from what you see, it's a good exercise to keep you thinking visually and you never know what you might come across that will spark an idea.

United States

Lili Arnold

Lili Arnold is a Santa Cruz, Calif.-based printmaker and illustrator specializing in botanical block prints. After studying printmaking in her last two years at the University of California, Santa Cruz (UCSC), she fell in love with the process of creating multiples and tapping into the tactile satisfaction of working with her hands. As her creative priorities continued to shift, she transitioned into making prints full-time and has since been on a journey of inspiration and appreciation of the natural world.

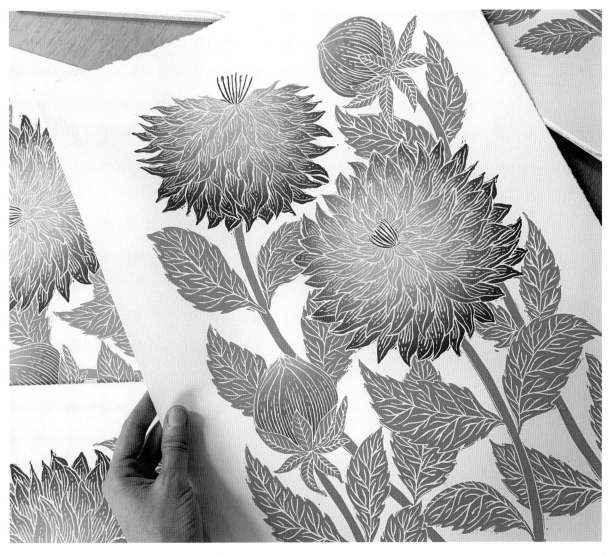

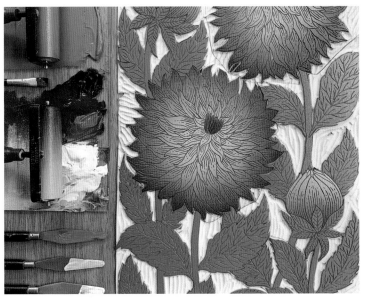

"There is so much
inspiration out
there, it's truly
never-ending!"

LINOCUT

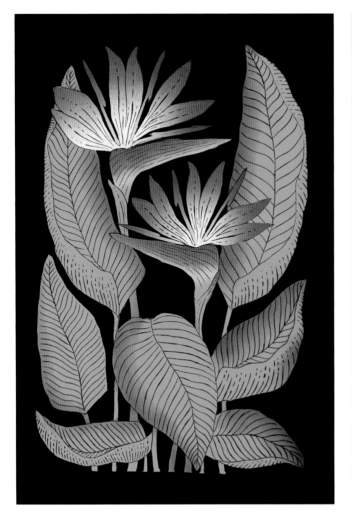

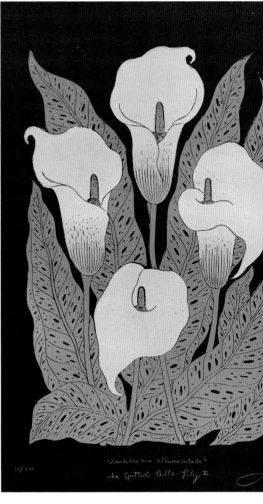

↖ Zantedeschia Albomaculata, aka Calla Lily (2021)
↑ Strelitzia Reginae, aka Bird of Paradise (2021)
→ Romneya Coulteri, aka Matilija Poppy (2021)

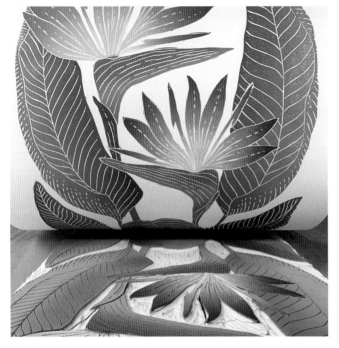

LILI ARNOLD

082

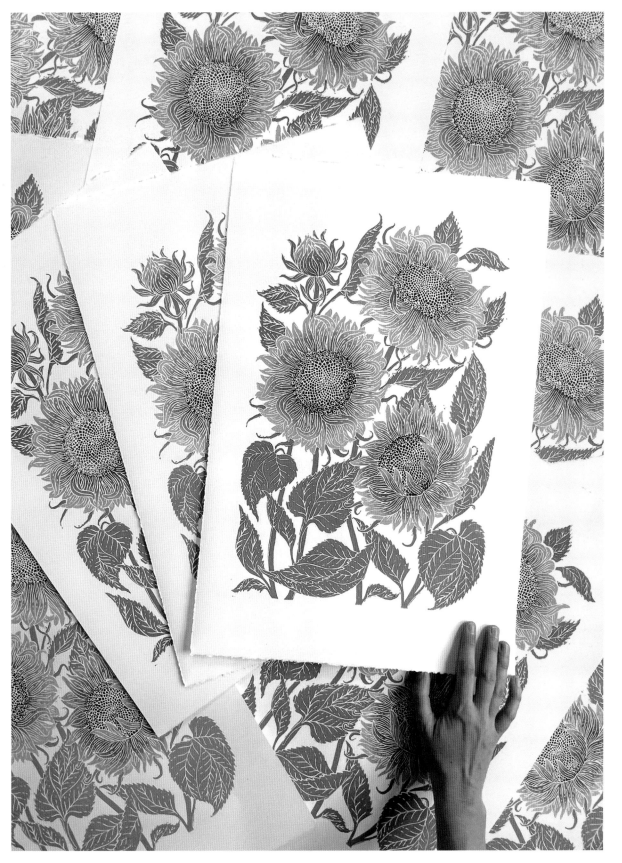

LINOCUT

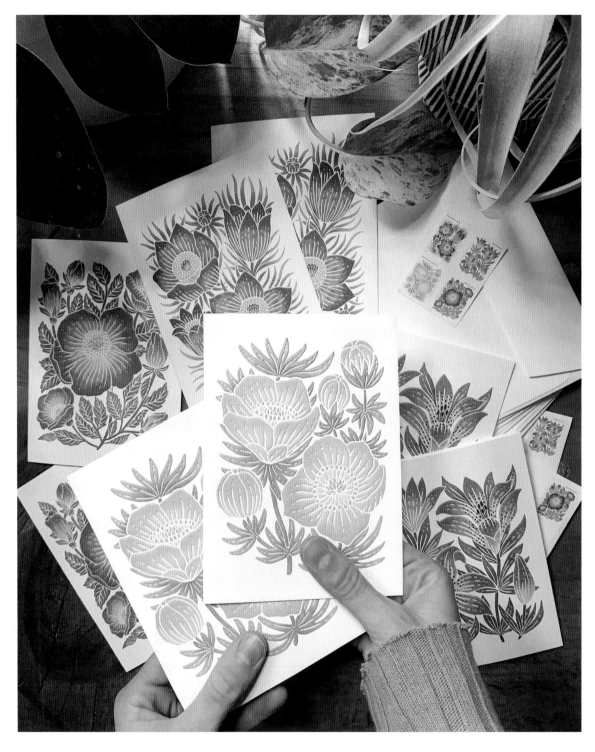

"I think the mishaps are a necessary
part of the process."

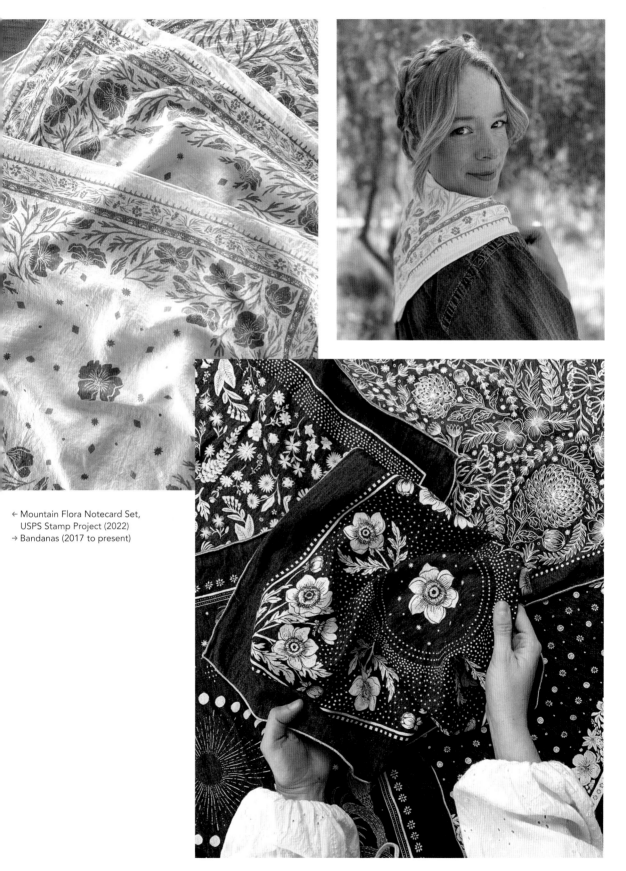

← Mountain Flora Notecard Set,
 USPS Stamp Project (2022)
→ Bandanas (2017 to present)

LINOCUT

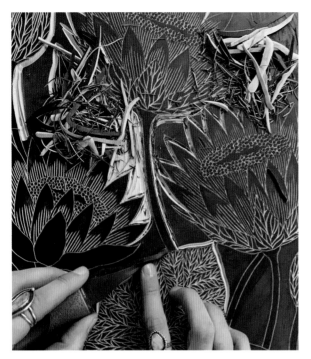

Step 1: The first steps involve drawing the image onto the block, then carving out the background and carving the fine line details.

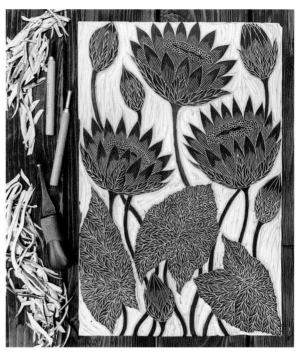

Step 2: This is the finished carving of Nymphaea Caerulea, aka Egyptian Lotus.

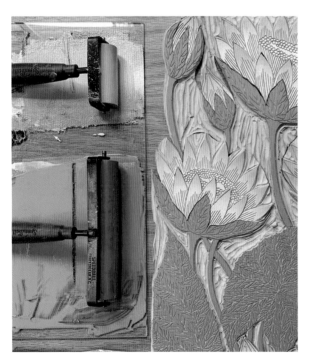

Step 3: This is an example of how the block looks once it's fully inked. On the left are Speedball ink rollers.

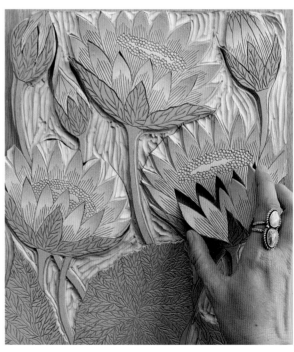

Step 4: This is an example of how the different pieces will fit together. Each color is cut into a different piece, then put back together like a puzzle before printing.

LILI ARNOLD

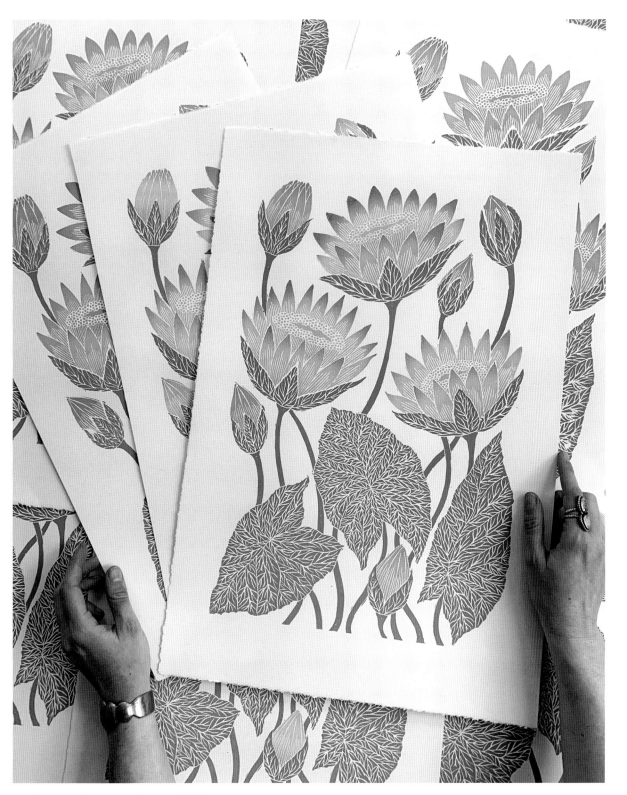

Nymphaea Caerulea, aka Egyptian Lotus (2019)

LINOCUT

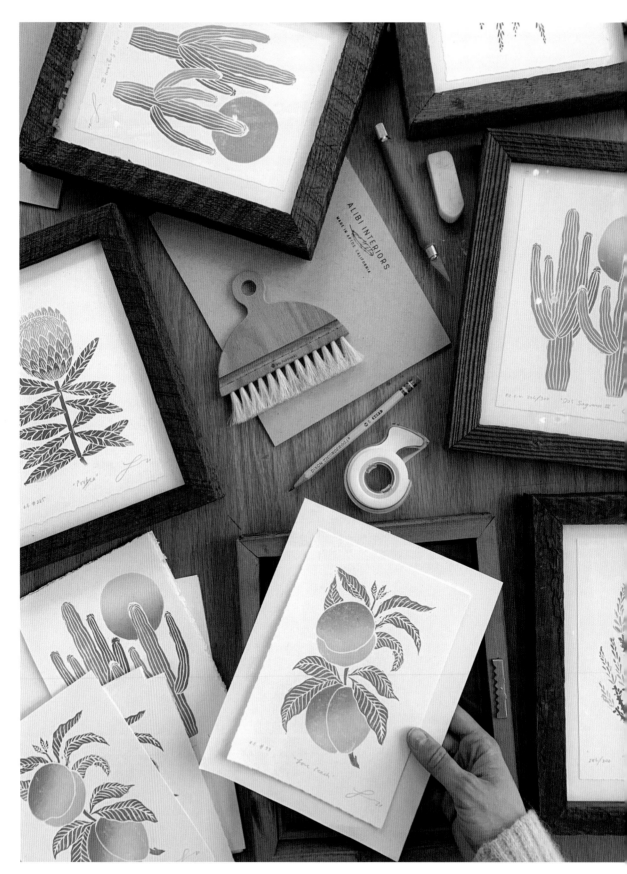

LILI ARNOLD

Q: You started your creative career as a graphic designer and now you work as a printmaker. When and how did you get into printmaking? What appeals to you most about it?

A: I was introduced to printmaking as a child by my mother. She has always been a huge creative influence and very encouraging when it comes to pursuing art in any way. When I was about 10 years old, my family all made block printed holiday cards and my parents taught my sister and I how to use the tools and create the prints from the block. It was an absolute blast! We continued to play around with printmaking over the years, but it wasn't until I entered the printmaking department at UCSC in my third year of college that my love and appreciation for the printmaking process truly took off. I was introduced to lithography, intaglio, and digital printing, which expanded my awareness of the printmaking world and furthered my interest in the concept of making multiples and sharing them with a wider audience. After college as I entered the working world, I put my printmaking passion on hold for a few years while I figured out how to work as a creative and make a living. At that time graphic design was the only route I could find.

About five years into that career, I was craving the feeling of working with my hands again, so I inevitably fell back into a little bit of printmaking on my free weekends. The reason why I got back into block printing of all things was because the materials were accessible and all I needed terms of a work space was my desk! I started small in size, in quantity, and in time spent, and my drive continued to grow in pursuing the joy I felt while creating handmade block prints. What I love most about printmaking is the ability to create a piece and make many prints from the same block, each one just a tad different from the individual inking process. The ability to share these prints with many people is very rewarding. Another aspect I love about printmaking is that it's an accessible art form for a range of budgets, both as a maker and as an art collector. Prints can be priced lower than a painting or sculpture because the ability to make multiples makes it easy to reproduce yet they still remain an original handmade works of art.

Q: Did you have any blocks in your career or what was your biggest challenge?

A: I faced the biggest challenge in my career during my time as a graphic designer when I realized I wasn't fulfilled and I needed a change. At that time, I didn't know what that change looked like, so the search within myself began. I couldn't afford to just quit my job and experiment or try something new, so the period of discovery had to happen slowly as I found the time outside of work to explore my creativity and passions. When I started to get a little bit of traction with my printmaking I realized there was a LOT to do in order to make it into a business and, potentially, a career. I had to figure out a website, a way to pack and ship prints efficiently, a way to brand myself that was cohesive and authentic, a way to grow my audience and establish potential wholesale client … the list goes on. It's a lot to start an art business from scratch having never done it before! There were many mistakes and learning experiences along the way. I think the mishaps are a necessary part of the process and it all makes me appreciate the journey that much more.

LINOCUT

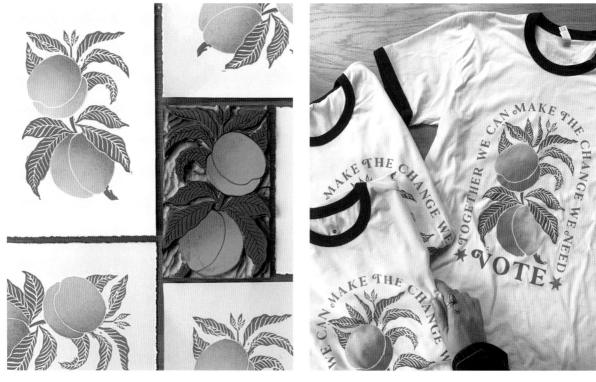

↑ Love Peach (2020)
↗ Love Peach VOTE Tee (2020)

Q: Where do you get your inspiration from?

A: My inspiration comes primarily from real-life experiences in nature. I really fell in love with plants as a theme for my prints after spending time at my local nursery. First, it was cacti, then my inspiration expanded into all types of flora that usually have large, colorful blooms. I also started collecting books on botanical illustration and wildflower field guides, while also visiting botanical gardens and arboretums anywhere I could find one. There is so much inspiration out there, it's truly never-ending! Another channel of inspiration comes from my mother who is a passionate gardener who taught my sister and me about the beauty of plants and the rest of the natural world. It was immensely impactful having been a child and witnessing my mother transform her quarter-acre yard of dirt and tall, dead grass into a vibrant, colorful, thriving oasis of green with an array of beautiful blooms.

Q: The colors of your prints are bright, vibrant, and not noisy at the same time. How do you achieve that? Any skills of choosing color and inking to share?

A: I absolutely love color, but I'm also pretty picky when it comes to how to translate color in my art. I want to pay homage to the beauty of plants as you see them in nature, but I also think about how a plant might need to be translated with a small amount of "artistic liberty" as it becomes 2D composition. My go-to ink color mixing trick is to add little bits of copper, gold, or silver into the palette which gives the image a subtle luminance, while toning down the saturation a bit. I find that these colors end up being a bit gentler on the eyes and also end up being more cohesive as a collection of work.

LILI ARNOLD

WOOTCUT

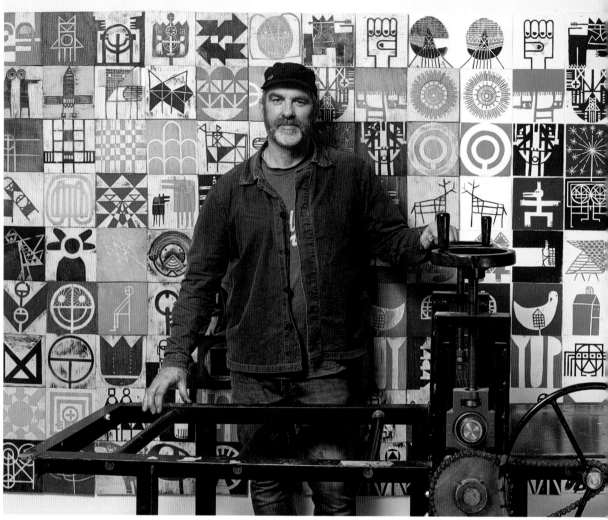

P: Chris Saunders

United Kingdom

John Pedder

Woodcut printing slows down John Pedder, allowing him to invest more of himself in apparently simple details. His main motive is the basic need to create. The subject matter tends to deal with the nobility of life: finding the honor and goodness in a person, a deed, a situation, coupled with a large helping of humor. Then, hopefully, you have what you see before you, an aesthetic journey using craft skills and design to try to make sense of an increasingly bewildering world. Sophistication is all well and good, but in the primitive, people will find the real truth.

JOHN PEDDER

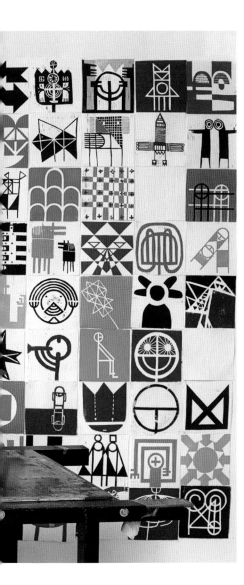

"The simplicity comes from honing the image down to its absolute essentials without losing its power and beauty."

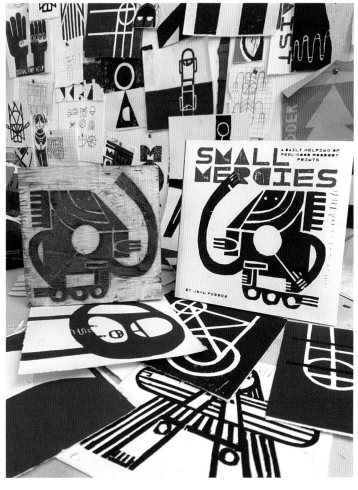

WOODCUT

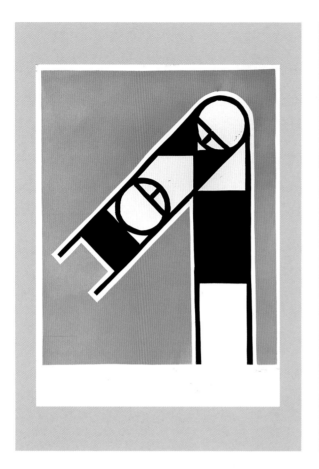

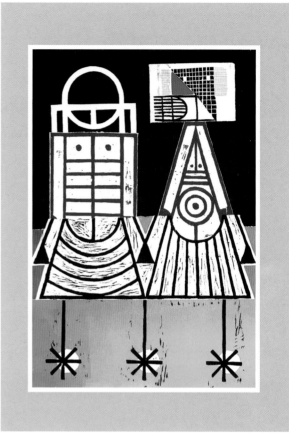

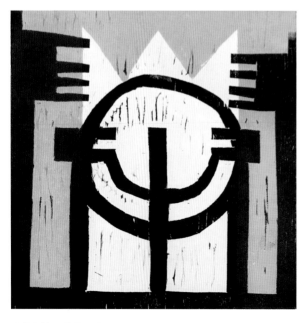

JOHN PEDDER

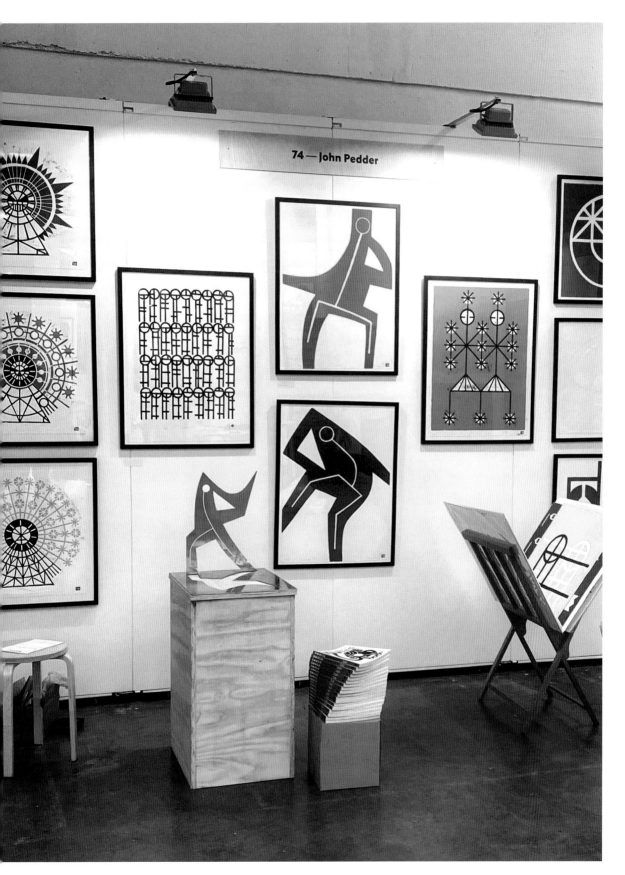

74 — John Pedder

WOODCUT

"My inspiration comes from an attempt to lift the everyday happenings that all of us experience."

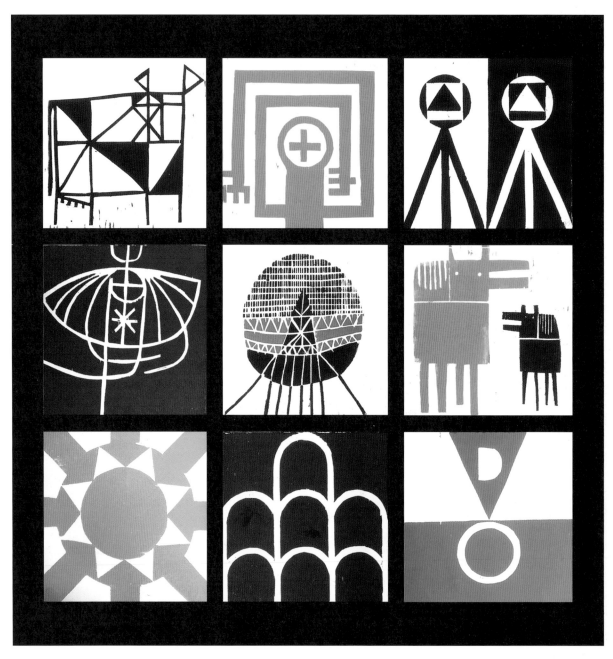

↑ Small Mercies (2020)
→ Profiles (2018)

WOODCUT

↖ On Reflection (2021)
↑ Individuals (2023)
← Knuckles (2021)

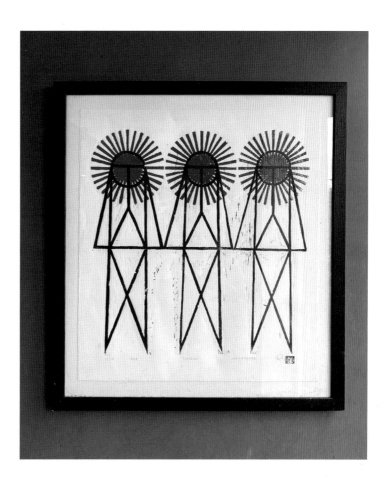

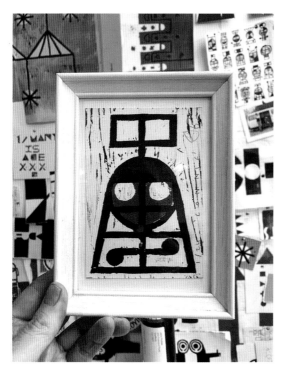

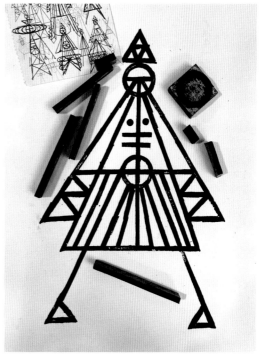

099 WOODCUT

Q: You have been a builder and maker for decades. Is there anything that stimulates you to make woodblock printing?

A: I've always been an artist before a builder, but when I discovered that I could use my making and building skills to help create two dimensional works, everything magically fell into place.

Q: What were your challenges during this transition from 3D to 2D creation?

A: There was no challenge. It was very quick, like opening a door to a better way of working.

Q: Most of your works are simple geometries and bright colors. What do you want to express through these figures?

A: The simplicity comes from honing the image down to its absolute essentials without losing its power and beauty. I wish to express positivity and nobility in these figures. Also, a sense of joy and humor is essential.

Q: You mentioned that inspiration is very important. Can you share how you find inspiration?

A: My inspiration comes from an attempt to lift the everyday happenings that all of us experience. To highlight the small joys of life can give people a sense of real purpose.

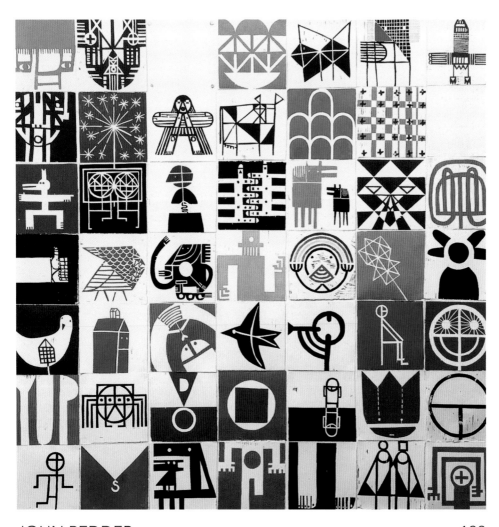

JOHN PEDDER

Q: What is your process in creating a work?

A: I begin by drawing. Drawing is the root of all my art. It's been with me since I was a small child. The idea becomes a reason to continue with that drawing process. It's then all about the qualities of simple mark making and printmaking that offer me the incredible gift of honesty and spontaneity. Woodcut printmaking, in particular, gives something back to me in the form of happenstance because you can never be quite sure how the carving is going to react to your design.

Q: Which do you like most among your works? Why?

A: It's impossible to claim a favorite. I could use the excuse that they are all my children, but it's simply a case of my mind changing from one minute to the next. I could give you one now, but by the time the book is released it will undoubtedly be another.

"I love the tactile nature of wood and the careful process of making a block and printing it."

United Kingdom

India Rose Bird

India Rose Bird is an artist and printmaker based in Staffordshire. She works primarily within the relief techniques of woodcut, wood engraving, and linocut. India's prints are a method of storytelling, drawing inspiration from nature, mythology, cultural folklore, and masquerade rituals. Her work is often characterized by playful narratives and enchanting creatures.

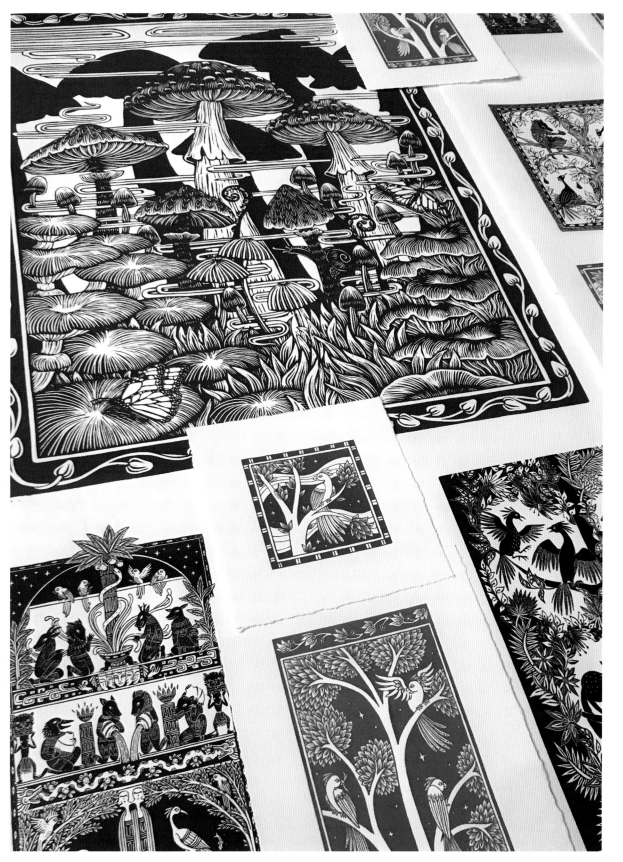

WOODCUT

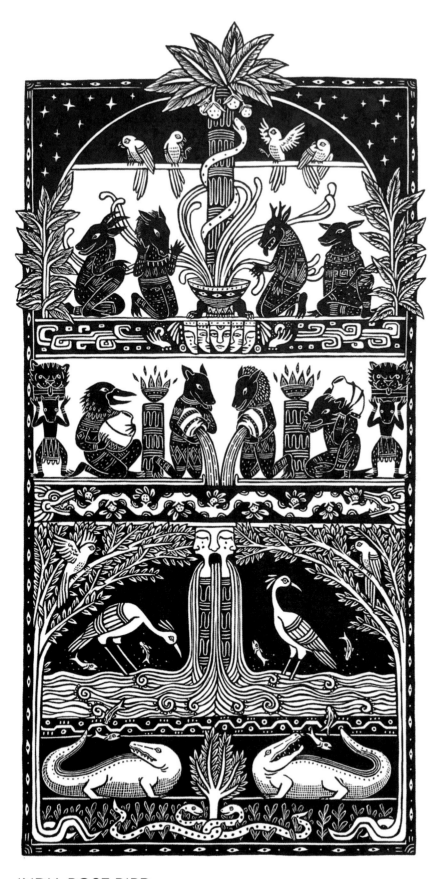

INDIA ROSE BIRD

← Toltec Spring (2020)
↑ The River Garden (2021)

WOODCUT

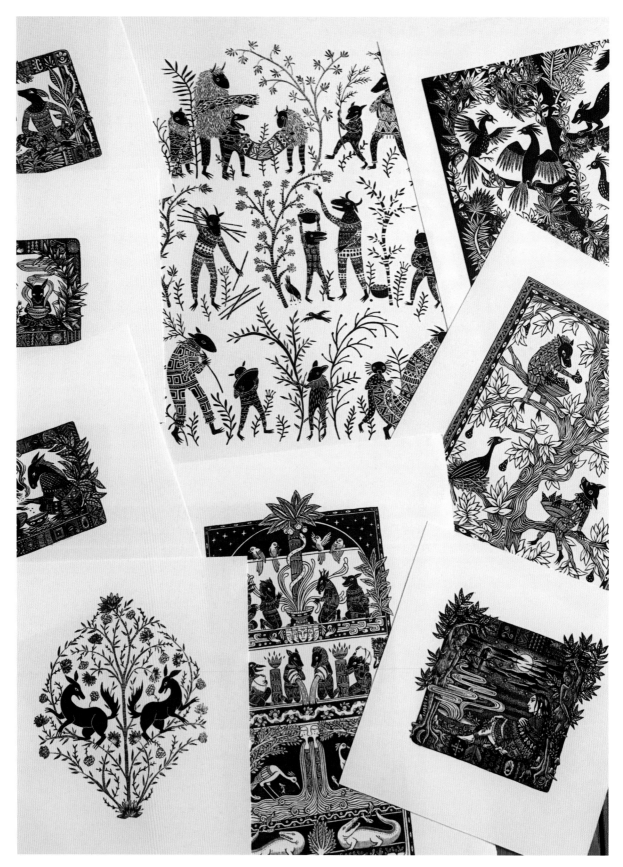

INDIA ROSE BIRD

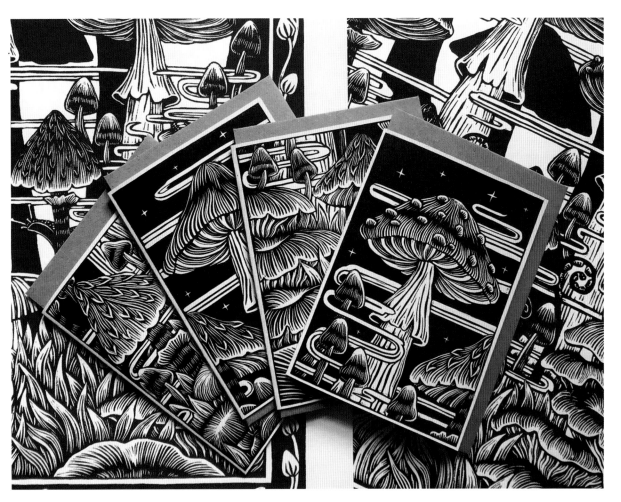

← prints
↑ Mystic Mycelium screen prints
and cards (2022)
→ linocut prints (2019)

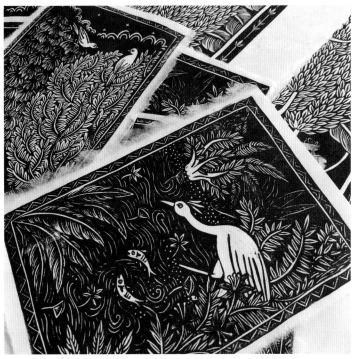

WOODCUT

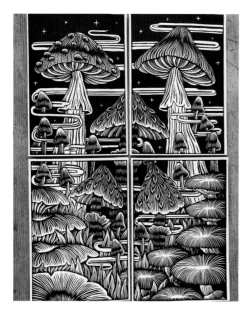

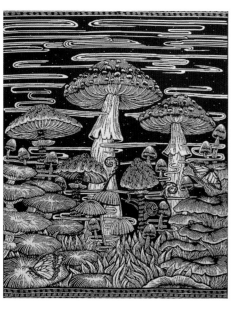

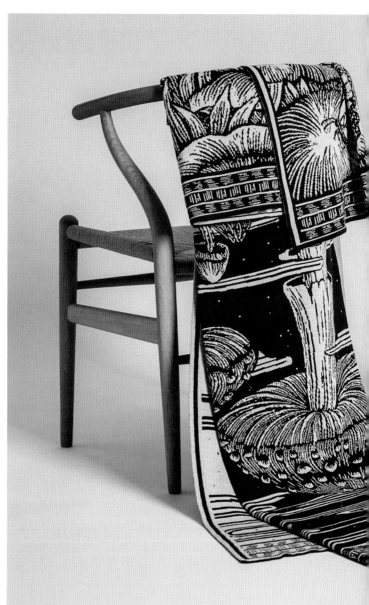

"Folklore, mythology, and fairy
fairytales have always deeply inspired
my work growing up."

← Mushroom Card set (2022)
↓ Mystic Mycelium blanket (2021)

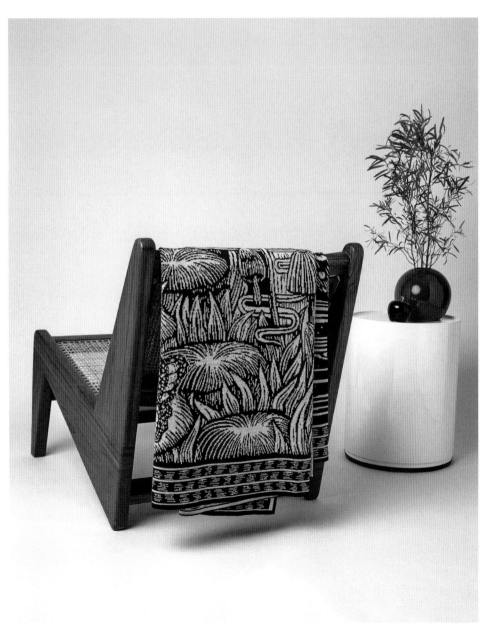

WOODCUT

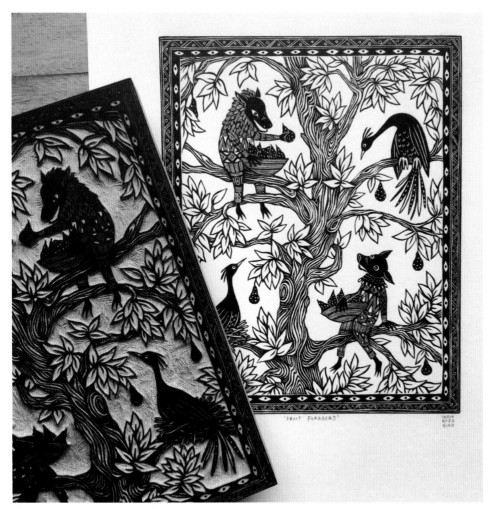

↑ Fruit Foragers (2019)

Q: Can you share with us your artistic experience? How long have you engaged in printmaking?

A: I first started practicing printmaking, particularly woodcut, in 2012, my final year at university, where I studied surface pattern and printed textile design. I was very inspired by traditional wallpaper manufacturing methods of woodblock printing, such as the work of William Morris. I created my own series of blockprinted pattern designs for my final major project.

I love the tactile nature of wood and the careful process of making a block and printing it. It is a very slow, meditative, and grounding process. The finished block is also such a beautiful art piece in its own right.

Q: Most of your works are about folklore, mythology, and ancient ceremony. Why are you interested in them?

A: What I love about folkloric practices, and the art of ceremony and ritual, is how it connects us to the things that make us truly human—community, celebration, and the world around us. I see these practices as a way of getting back in touch with nature and the land that birthed us. Folklore, mythology, and fairytales have always deeply inspired my work growing up. It makes me look at the world in a different,

more magical way and allows me to create my own stories.

I also find a lot of my inspiration in the detail and beauty of traditional craftsmanship, including highly intricate Indian miniature paintings, breathtaking Japanese woodcuts, laboriously detailed Medieval art, and ancient relief sculptures and frescoes. I'm inspired by this attention to detail and how traditional, meticulous artistic practices throughout history have been used as a method of storytelling.

Q: Which work is your favorite? Why do you love it?

A: My favorite projects to date are always my collaboration pieces, and the opportunity to elevate designs by combining forces with a fellow creative. I recently collaborated with Ambar, a London homewares company, where we translated one of my woodcut prints into a woven blanket design. We took the woodblock print of my design "Mystic Mycelium" and translated it into a huge, merino wool throw. I have one of these blankets myself and it is like wrapping myself up in my own woven, psychedelic, mushroom forest!

Q: How long do you need to finish a piece of work?

A: The timeframe it takes to complete a piece of work completely depends on the material, the scale, and the complexity of the design. Wood engraving blocks can take anywhere from a couple of weeks to a month to complete, depending on the size. I also have to ensure I schedule time off when carving, so that I don't strain my hands too much.

The most time I have spent on a piece is six months, when I worked on a meter long, extremely detailed woodcut commission.

The client was very pleased with the final result, so it was definitely worth the labor!

Q: What is the biggest difficulty during the process of printmaking?

A: I guess the biggest difficulty in printmaking is the ambiguity of it, and not fully knowing how a design is going to look until you've printed it. But that's also what I love about it—it keeps me on my toes and it keeps it exciting.

Another difficulty with any kind of relief printmaking is the terror of slipping on the block and ruining the design. I have done this twice before, where I slipped my tool accidentally across a block I was carving and had to start all over again. Fortunately, mistakes are made to be learned from and I haven't slipped on many blocks since.

Q: You have about 40,000 followers on Instagram. You love to share your life and work on it. Do you have any tips to manage this kind of internet platform?

A: One of the best things on Instagram is the printmaking community you can find on there. I've connected with so many different printmakers around the globe, and it's great to have peers and likeminded folk on the platform to bounce ideas off. It's a very open and encouraging community. So, it's good to use hashtags related to your niche and explore and follow other artists working within the same techniques.

One thing I've been trying to do less of is share every single project I'm working on on Instagram. I think it's important to find time within your day to just create for your own sake—play, explore, have fun, and not fixate too much on the outcome and whether something is "Instagrammable."

WOODCUT

Originally from Orange County, New York, Brian Robert Knoerzer studied visual art and printmaking at Purchase College and received a bachelor of fine arts degree in May 2000. While studying at Purchase, he was inspired by an introduction to Antonio Frasconi's printmaking work and powerful woodcut imagery. In 2003, he opened an independent artist studio and started making paper and publishing printed images. His artwork is internally sculptural and painterly although it is rooted in a pursuit of modern graphic imagery often inspired by a balance of botanical imagery and urban environments.

United States

Brian Knoerzer

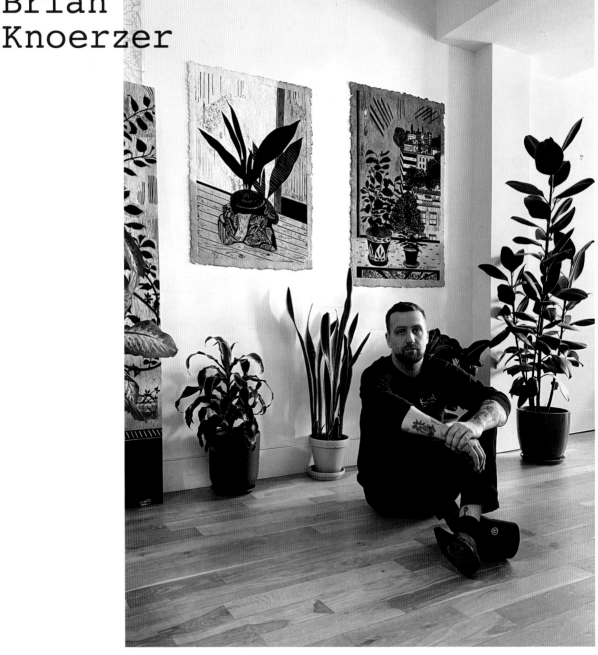

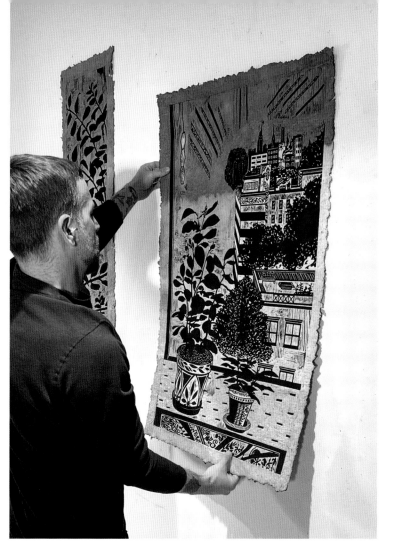

"It is a tranquil moment, a form of meditation for me to empty my mind and follow the flow of the line."

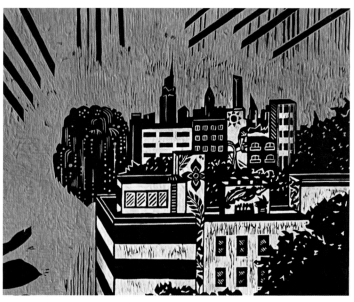

WOODCUT

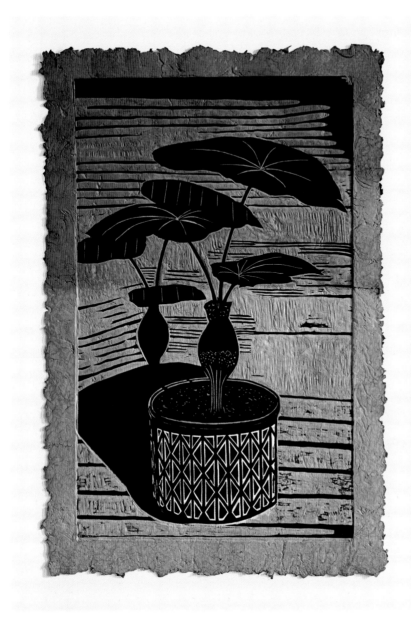
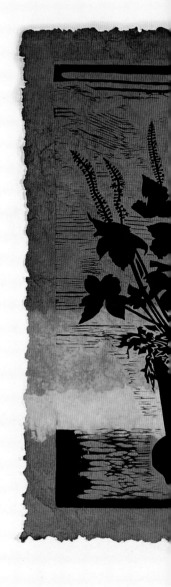

↑ Buddha Belly (2022)
↗ Coral Bells (2021)
↗ Cast Iron Plant (2022)

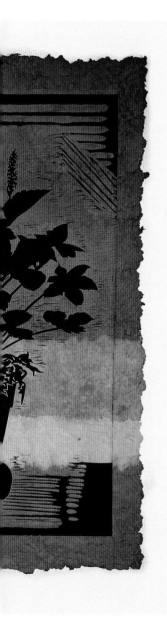

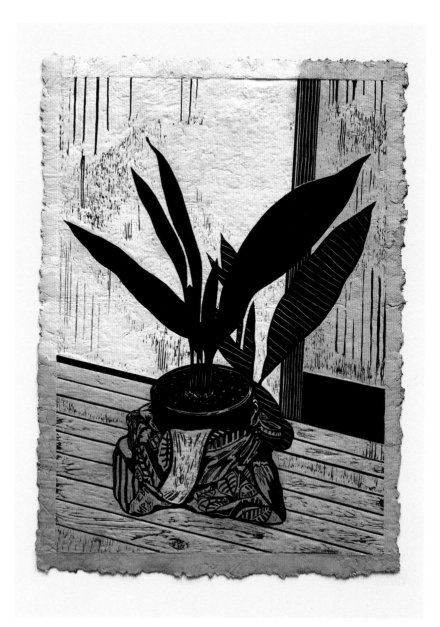

WOODCUT

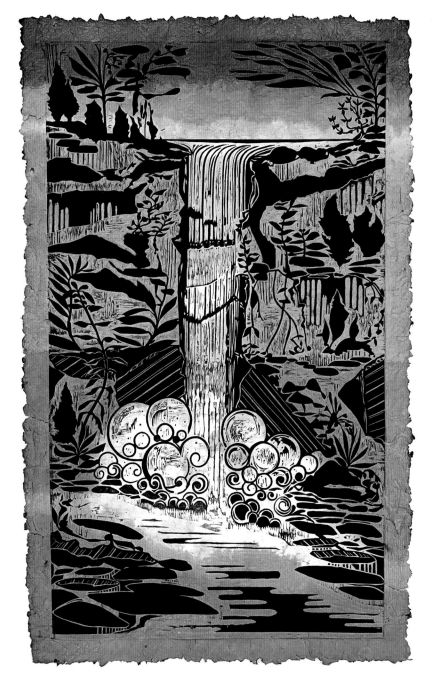

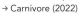

← Montezuma (2023)
→ Carnivore (2022)

"The color combinations create atmosphere and depth, which transform into an illusion of space in the finished print."

BRIAN KNOERZER 116

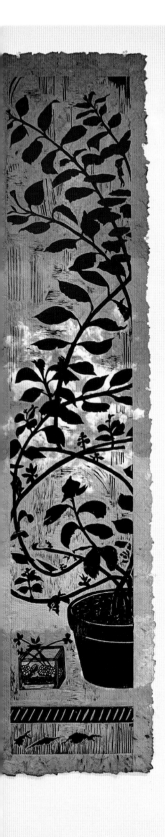

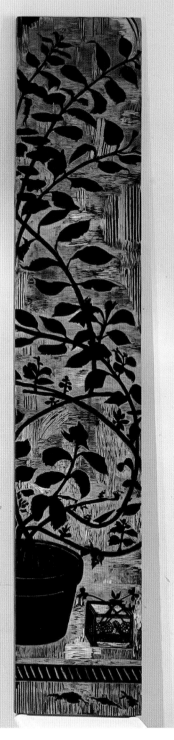

WOODCUT

Q: Most of your works are about plants. Why do you choose them? What do you want to express?

A: The plants represent our emotional expressive side and the natural continuous growth we experience as people living our lives. The woodcut designs are made as suggestions of character, personal interactions, or in the case of multiple plants, the exploration of relationship dynamics. The most recent images are based on memories of places. They explore narrative dynamics through a language of botanical symbolism and interlocking plant silhouettes over semi-abstract landscapes.

Q: There are also many plants in your studio. It seems that you love plants with big leaves the most. Is this right?

A: The shape of each plant is a suggestion of character and the leaves influence the feeling of a work. The larger leaves do have a particular presence that I tend to gravitate to, although the delicacy of smaller leaves can create a visual conversation. Diversity in scale is always worth exploring when designing a new piece. The image is a story of shapes, so I tend to mix and match things until they feel right for the work.

Q: You often use pink, blue, and green in your works. How do you choose color in your printing works?

A: The paper is cast in colors that work as an abstract painting, initially. The color combinations create atmosphere and depth, which transform into an illusion of space in the finished print. Color is mostly made by dyeing the paper fibers directly through a process of repeated exposures and saturation.

Q: How long do you spend on one work?

A: A woodcut on handmade paper typically takes between three and six months to complete, and the series will include five to 10 versions of the image printed on handmade paper. The process includes drawing, stenciling, carving, paper casting, printing, refining the block, and printing again on handmade paper. It is somewhat labor intensive, although I enjoy the range of artmaking techniques involved. There are elements of sculpture, painting, and design considered throughout the different stages of a project.

Q: Which of your works do you like most?

A: Soho is one of my favorite images. It's based on an experience I had in 2020 when downtown New York City was somewhat abandoned during the pandemic. Many businesses had boarded up the windows because of protesting and civil unrest in the city. It felt like the city was wild again, growing through this extraordinary challenging time. I was riding around on a bicycle, photographing the empty streets and was overwhelmed by the state of the city. It was somewhat terrifying, although it also felt like somehow this would change things permanently and for the better.

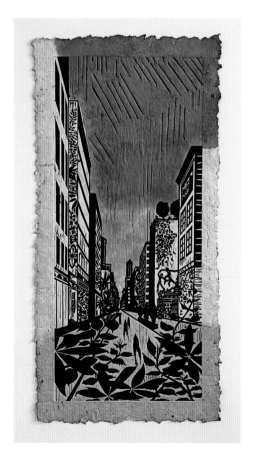

← Soho (2021)
→ Midtown (2021)

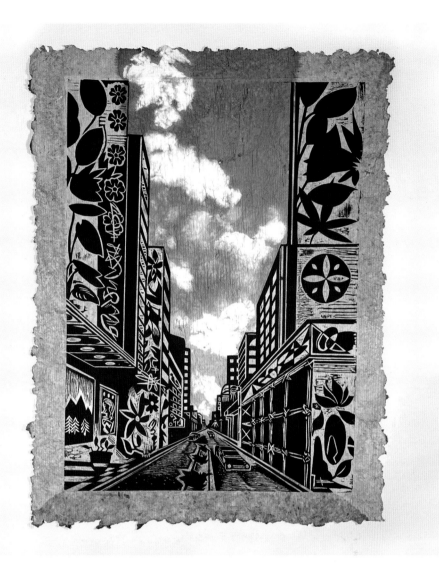

Some businesses will suffer as we evolve our beliefs. However, culture, art, and this expression of natural growth would surge.

Q: What should one pay most attention to when working on woodblock printing?

A: Woodblock printing can incorporate subtle variations and natural textures. You're working with a natural material, so you have to consider its strengths when you're choosing and printing images to carve. The grain, direction, and natural imperfection add character you can utilize.

Q: What is your plan for these next few years?

A: Innovation in printmaking inspires me. I plan on developing this handmade paper technique and creating a series of large-scale images printed on handmade paper. The subject will involve more architecture and botanical combinations designed to suggest a balance of structure and ephemeral nature. I'll continue looking for opportunities to share my work with a wider audience and engage with artists and people who support developing a respect for nature through art.

WOODCUT

United States

JustAJar

JustAJar Design Press is a family-owned letterpress and design studio run by Bobby and Sara Rosenstock. It specializes in custom woodcut posters. The studio and storefront is located downtown in the historic, river town of Marietta, Ohio.

"The rich textures of the woodcut mark and the woodgrain textures printed on paper are what drew me in, and the challenge of learning to be a better craftsman has kept me making woodcuts for the past 20 years."

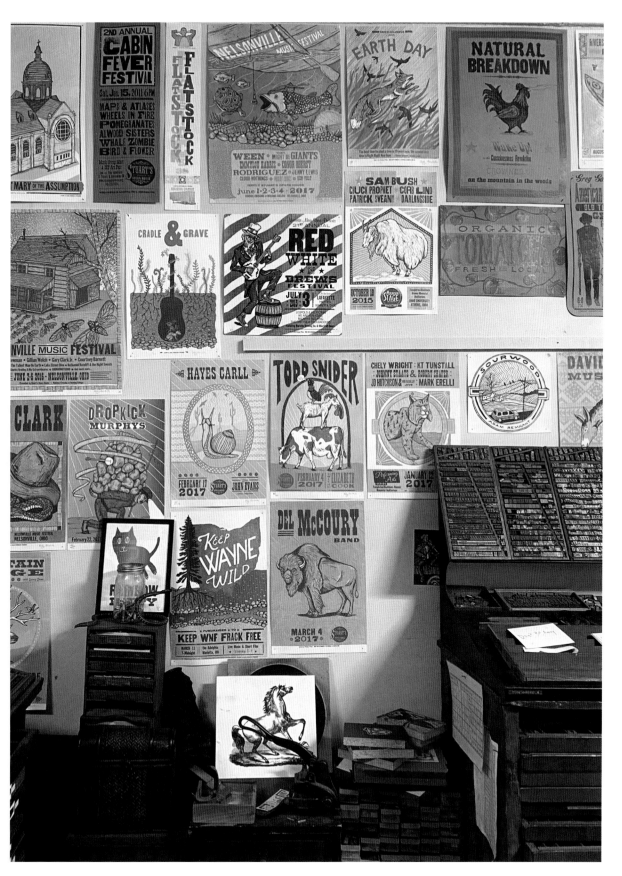

WOODCUT

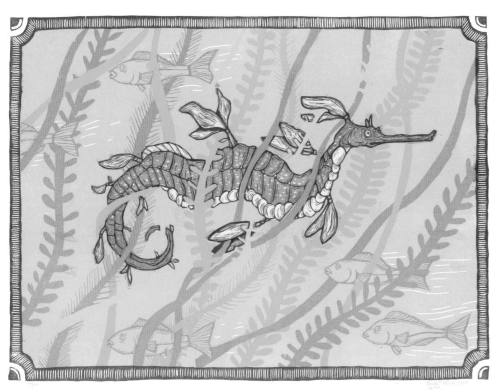

← Weedy Sea Dragon
(2018)
↙ Bully Strings (2022)
↓ Hare (2019)
→ Wondrous Wonder
(2011)

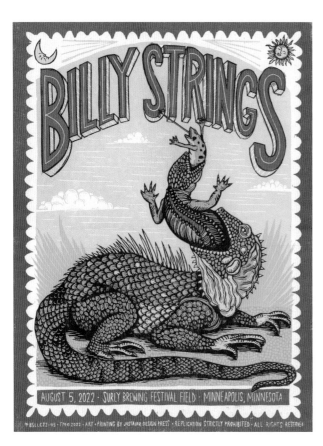

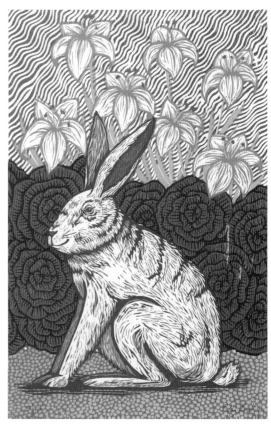

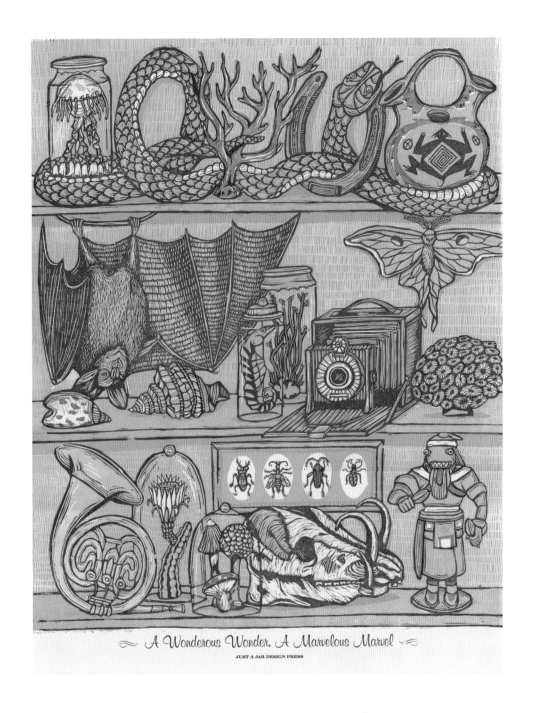

~ A Wonderous Wonder, A Marvelous Marvel ~

JUST A JAR DESIGN PRESS

"I play the banjo and the old-time
music of Appalachia has a big inspiration
on my work."

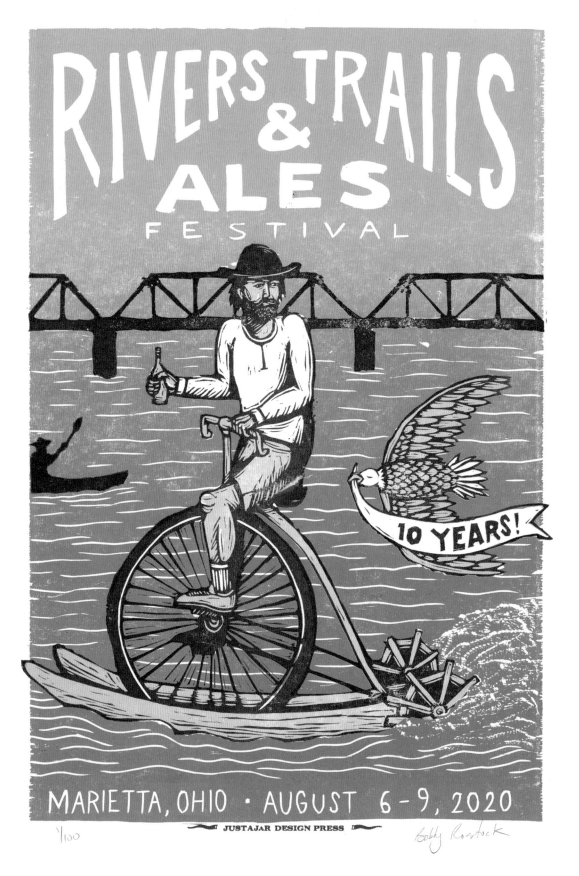

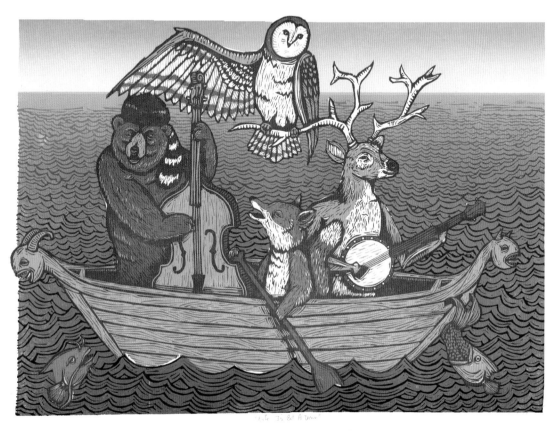

WOODCUT

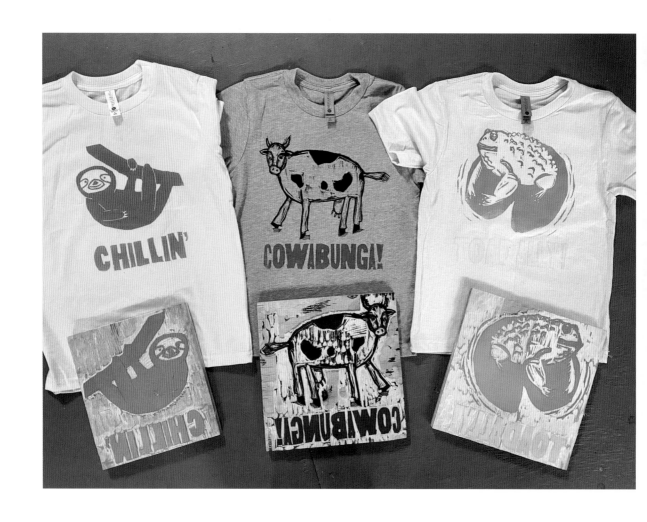

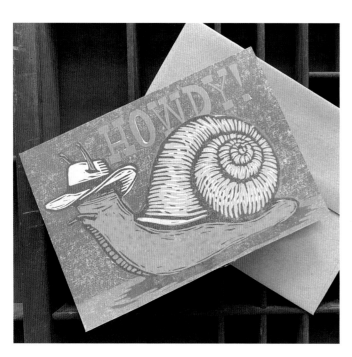

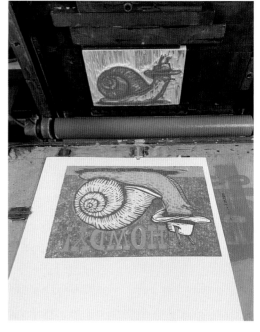

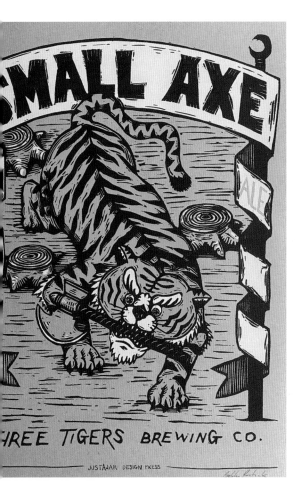

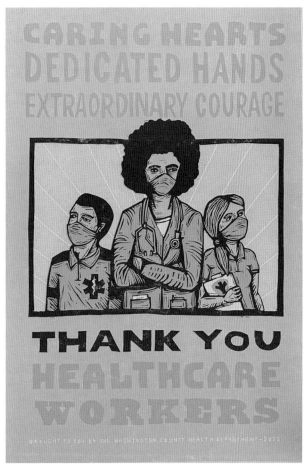

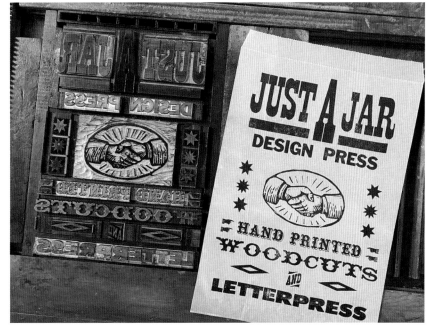

WOODCUT

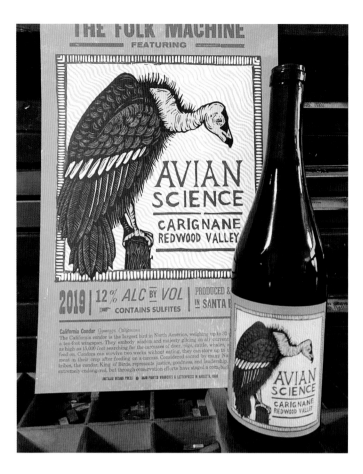

Q: You are a family operated press, focusing on letterpress and design. What's your division of responsibilities?

A: JustAJar is a shop run by Bobby and Sara Rosenstock. Bobby creates all of the illustrations, woodcuts, and does the printing. Sara is a full-time professor of graphic design at our local college and also runs the design side of the business, creating logos, branding, websites, and merchandise for the shop.

Q: You have posters, woodcut prints, and design works in your studio. How do these three parts influence and assimilate into each other?

A: Our shop is known for our custom woodcut posters that we create for musicians. We also create woodcut fine art prints, t-shirts, greeting cards, and offer a range of graphic design services. Whether creating art for a client, making things to sell in our shop, or making our own art prints, all of our work stays true to our style and is created with care and precision.

Q: Why did you choose woodcut? It is an ancient craft, which lasts for many years. What do you think of it?

A: I (Bobby) made my first woodcut print in 2003 and immediately fell in love with the process. Learning the craft of carving and printing was very fulfilling and the idea of being able to make multiples, allows the work to be more accessible to the public. The rich textures of the woodcut mark and the woodgrain textures printed on paper are what drew me in, and the challenge of learning to be a better craftsman has kept me making woodcuts for the past 20 years.

Q: Your works look retro and vintage, not only the colors, but also the topics. Could you please share with us your inspiration? What do you want to express through your works?

A: My work is inspired by traditional folk art and the community that surrounds me. I live in a small town along the river in southern Ohio and I'm inspired by the Appalachian traditions from our region and the natural beauty of our area. I play the banjo and the old-time music of Appalachia has a big inspiration on my work. I love working with muted colors, experimenting with patterns and mark making, and letting the woodcut process shine through my work.

Q: You have a big studio and many prints. What do you do there?

A: Our storefront is open to the public two days a week. We host many school groups and like to teach them about letterpress and woodcut printing. We host regular events where we will feature other artists from our area and have live music. We want our shop to be a hub for folks who love art and music to be able to gather and enjoy.

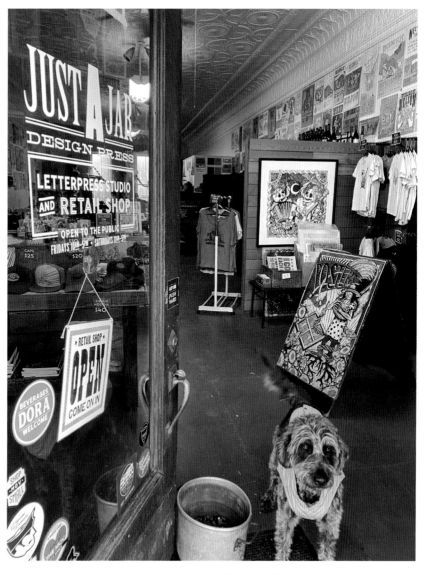

Bradley Blair

Bradley Blair is a self-taught artist specializing in woodcut printmaking. After a lifetime of doodling and drawing, he has worked his way to full-time artist through the world of printmaking. Starting to carve in 2018, he has produced many different designs with the original purpose of printing on clothing, in-person at music festivals. That has successfully transitioned into larger projects, serious commissions, and a new gateway into art culture. Featuring dark, whimsical, and fantasy-type designs, his art has found a home among hundreds of thousands of like-minded individuals attracted to the weirder side of life.

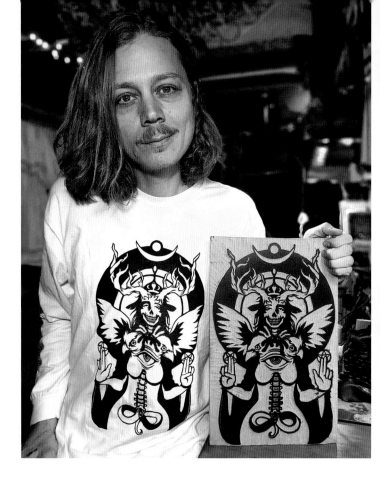

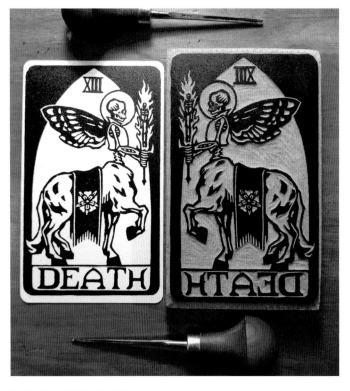

"I've always been very attracted to the art of existing tarot decks throughout my life."

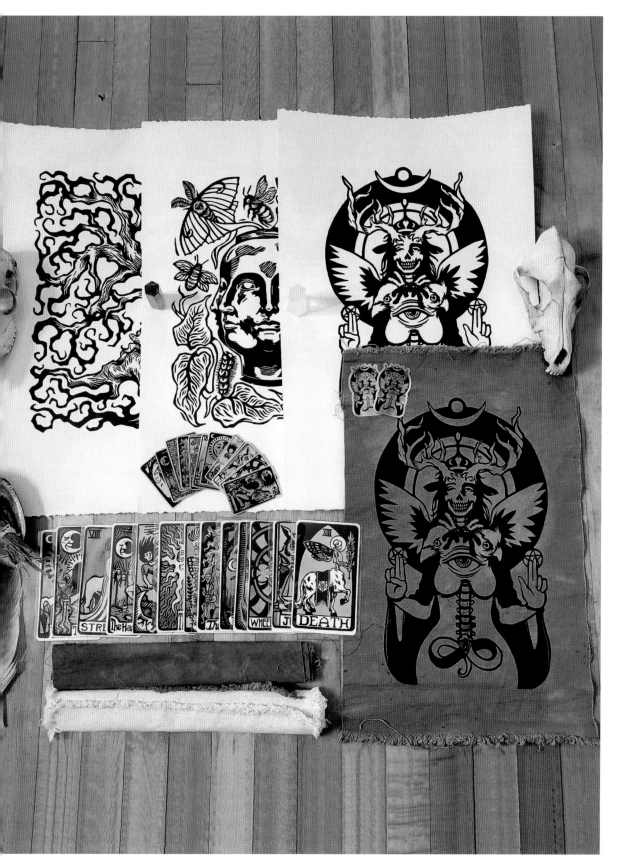

WOODCUT

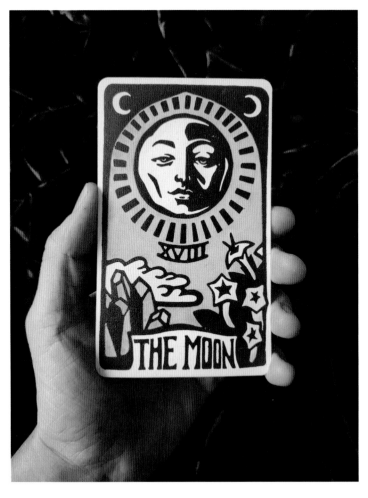

↑ The Moon
→ Tarot cards (2020 to present)

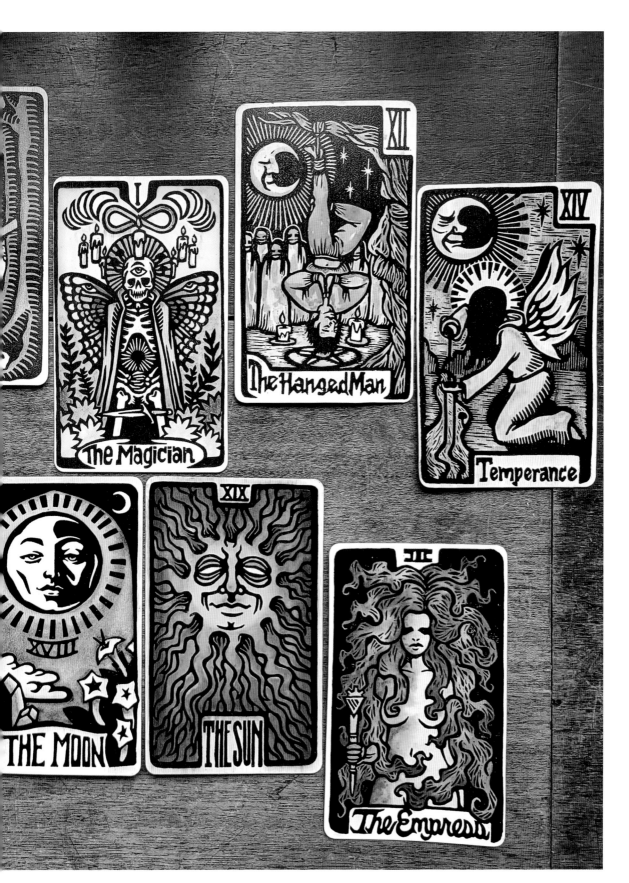

"The satisfaction of accomplishment far outweighs the difficulty of the challenge."

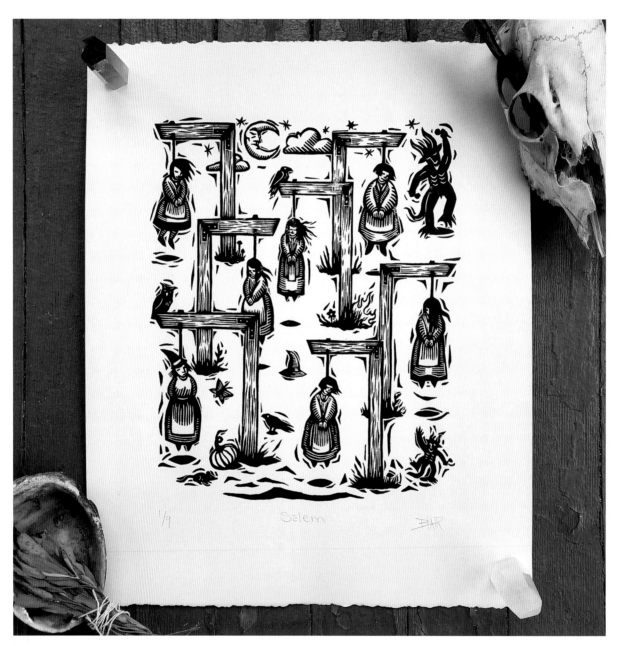

Salem (2021)

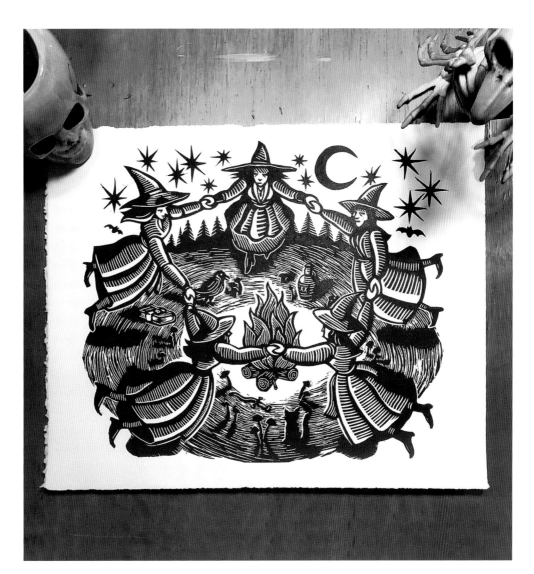

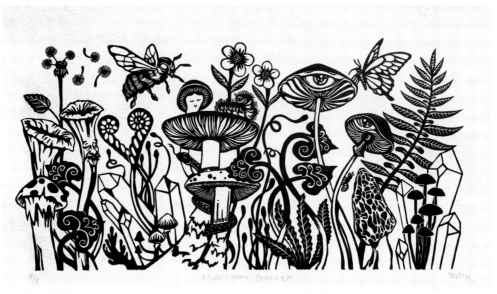

WOODCUT

Q: Your work is filled with mystical. What do you want to express through them?

A: I look at my work as a conduit for the universe to evoke emotion from the viewer. I believe creativity is channeled, not obtained. The "flow-state" we chase is always ready and available to anyone willing to align themselves with it. The main goal and feeling I wish to express and share through my art is love.

Q: Most of your works are tarot cards. Why did you choose this medium?

A: I've always been very attracted to the art of existing tarot decks throughout my life. Tarot cards hold a very personal relationship with their user. I love the idea of being able to let my art become a part of that relationship. Ever since I began carving, I knew that creating a tarot deck would ultimately become a reality. It's the most traditional and genuine form of printable tarot. It's a block of wood and a piece of paper, mated through ink. I have been learning each card individually as I create them. Through this project, I have found my own relationship with tarot. I read the cards for myself and interpret them through the lens of my own reality. I appreciate the insights and perspective they can produce.

Q: What do you take notice of when you look at a woodcut printing? Color? Technique? Or anything else?

A: My favorite woodcut pieces are full of different patterns and textures. Although I don't produce much of these myself, my designs are a bit more medieval in appearance. I really enjoy observing the flow and contrast of patterns in a design. These are things I'd like to incorporate into my own art soon.

Q: There are many delicate details in your prints, How long does it take you to finish a print?

A: Aside from the hours it takes to draw a final design that's ready to transfer to

block, a small woodcut that is a 1:1 ratio, such as my tarot, takes me roughly four to six hours of carving time for a 3.5 inch × 5.5 inch block. It's important to not have a single slip-up while carving as any mistake could mean starting over from scratch. Larger woodcuts I've produced have taken up to five days of carving to complete. Taking care of your wrists, hands, and joints is incredibly important. Carving for too long can have tremendous effects on your wellbeing. Stretch, stretch, stretch!

Q: What was your biggest woodcutting challenge so far?

A: My most recent project that I have completed was a series of 55 woodcuts. This was a huge project, and it became my full-time job. I was commissioned to create an entire deck of cards for a tabletop role playing game called "Werewolf in the Dark." I designed, carved, and printed all 55 designs from scratch within a six-month period. Completing that project is one of the most gratifying things I've ever done. The satisfaction of accomplishment far outweighs the difficulty of the challenge.

Faces (2022)

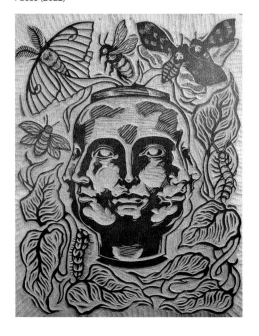

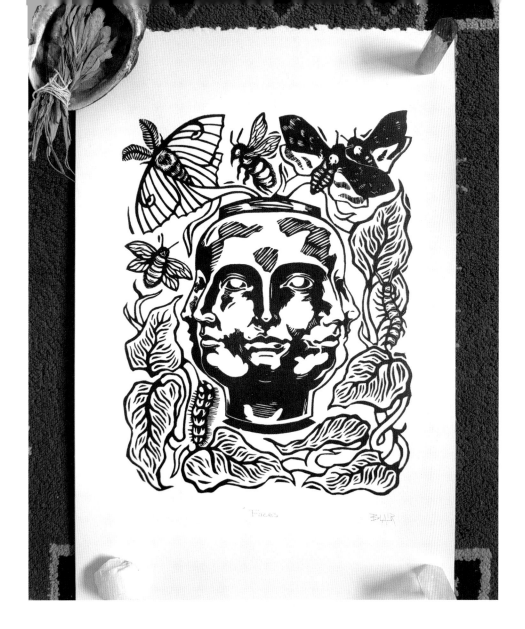

"Faces"

Q: You have about 100,000 followers on Instagram. Do you have any tips to managing a platform account?

A: Don't forget the 360,000+ on tiktok (haha). I don't know many artists that have gained a following the way I have. Incredibly organic, I gain followers in phases. Sometimes I go a month or more without posting. But when I do, I make sure it's top-quality work and relevant to where I am artistically and spiritually. I don't believe in saturating your platform with bits of subpar work. I share all the gritty bits of my story for those who really want an in-depth look. Making videos of my entire process seems to have the most success for me. I love to show how taking a seemingly useless piece of wood and turning it into art can impact a human to their depths. At the same time, it's incredibly important for your mental and physical health to remain intact. You have no obligation to your followers. Share your truth and let go of expectations you put on yourself. It's about the art.

United States

Kristina Hoover

Kristina Hoover is a Florida native working primarily in the reduction woodcut printmaking process. Inspired by Florida's landscape and her surroundings, she aims to transform ordinary life into something new by highlighting the bright, bold, and colorful beauty found outdoors. Hoover has been creating all her life and instantly fell in love with printmaking.

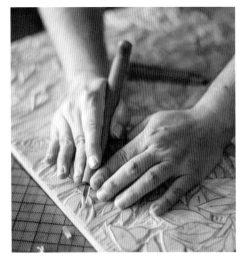

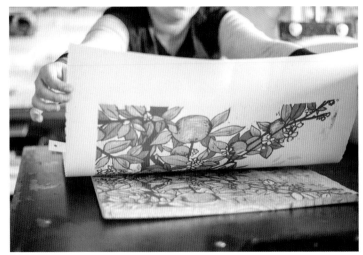

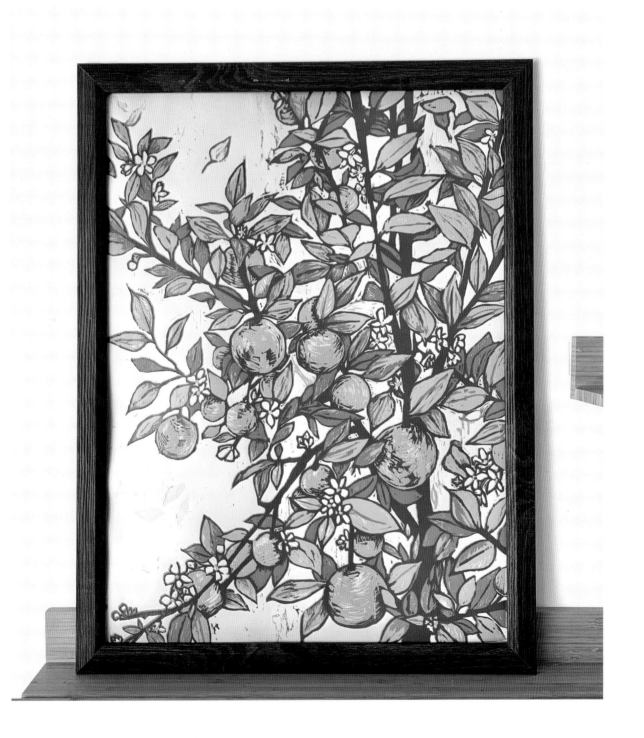

"I re-create my view as a way of
sharing and expressing the endless beauty
that surrounds us."

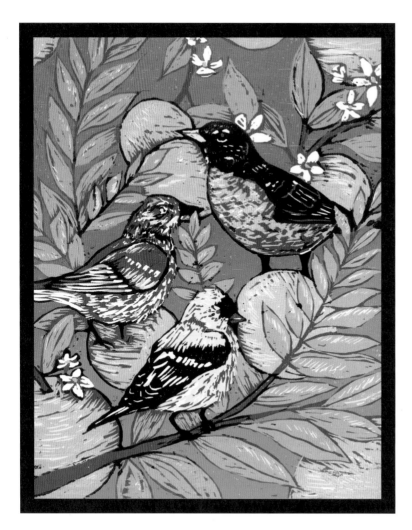

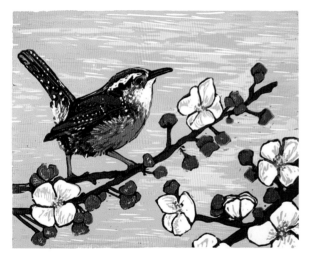

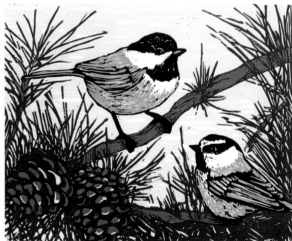

KRISTINA HOOVER

140

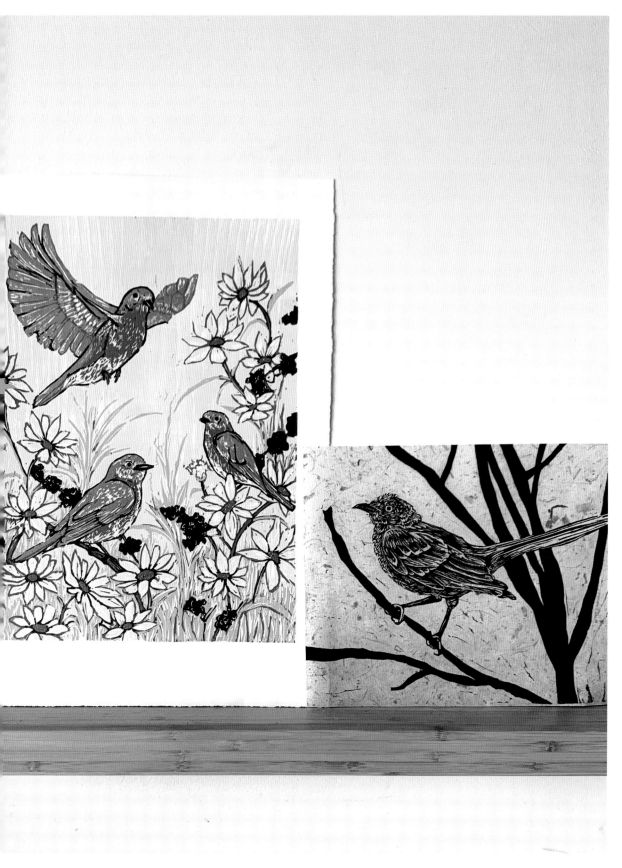

WOODCUT

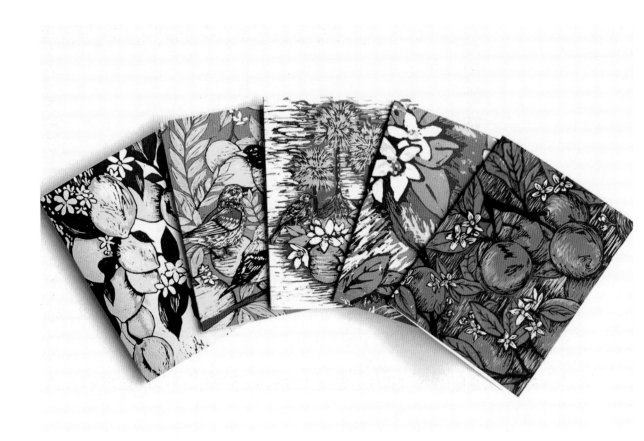

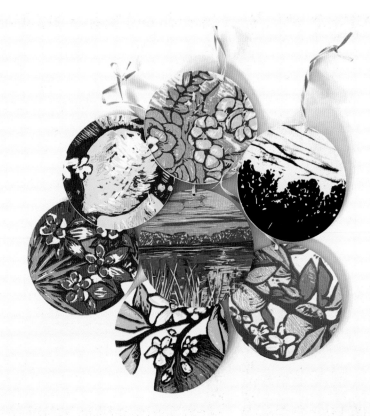

KRISTINA HOOVER

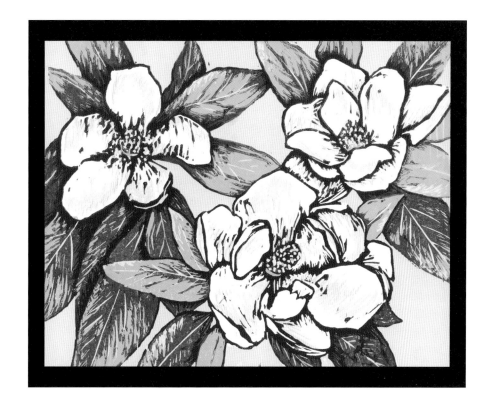

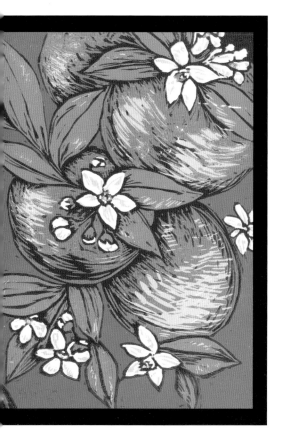

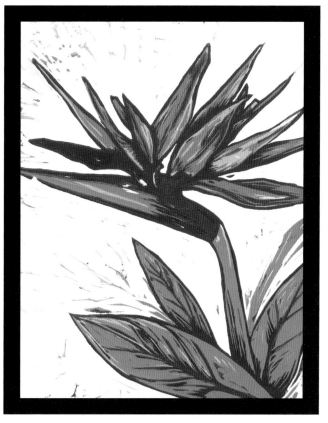

WOODCUT

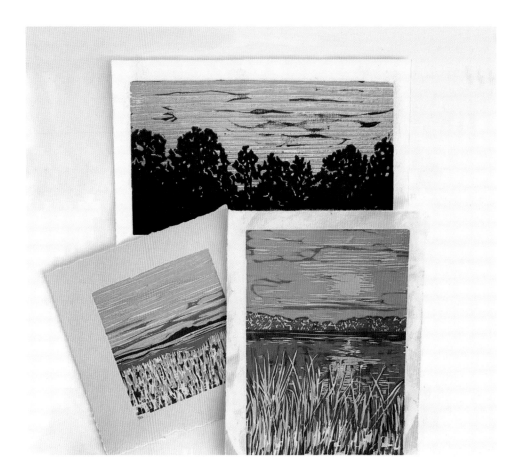

Q: Can you tell us something about your childhood?

A: As a child, I always liked drawing and creating whenever I could. I was the child who would get caught drawing on the walls sometimes. Luckily, the drawings were never too big. This passion stuck with me as I got older and I continued to pursue different art mediums over the years. After learning about printmaking, I instantly fell in love with the process.

Q: You use bold and bright colors, such as red, orange, and green in your art, which is natural and colorful like an oil painting. Do you have any tips to using this kind of palette?

A: I like a vibrant palette, colorful, and attention-grabbing. I stick with a relatively warm and earthy palette and include one or two pops of cool colors to even out the composition. I try to visually balance all the colors so one color doesn't overpower the others.

Q: How does the lush nature of Florida influence your creations?

A: Nature is something that surrounds me every day. I enjoy viewing and being in its calming presence. Florida's landscape is full of a variety of different plants, flowers, and animals. The bright Florida sun seems to only enhance the saturated colors of the landscape. I work very intuitively, highlighting the bright colors, organic shapes, and repetitive patterns and lines found in nature. I re-create my view as a way of sharing and expressing the endless beauty that surrounds us.

Q: Which process is the most challenging when you are printing?

A: I always say figuring out what to draw is the hardest part and printing is the easiest, if you can believe that. I do a lot of prep work before I begin printing to ensure everything runs smoothly. This includes having my ink premixed, my press set, and all my paper registered. Since I use multiple colors, registration plays a big role in my work because it's how all the colors line up correctly. If the block or paper shifts, or doesn't get placed in the same spot each time the colors won't line up. Working large has also presented some challenges for me. Like having enough space, maneuvering a larger woodblock, and, again, making sure everything gets lined up correctly.

Q: In your opinion, what makes woodcut printmaking a unique and valuable art form and what do you hope viewers take away from your work?

A: The repetitive creation process in printmaking is so unique. It lends itself to such a different final look than you would see in a painting or drawing. Personally, I let the multi-step process play a role in shaping my work. I let the repetition of carving and printing a woodblock transform my marks, lines, and colors. The process and layers it takes to create the art become just as important as the final image. A lot of time and effort goes into carving and printing. It's like creating 2D and 3D art at the same time.

For me, it's not about realistic precision, but rather the essence that gets created and transformed through the physical and tactile printmaking technique of woodblock printing.

Q: What advice would you give to aspiring woodcut printmakers and what resources or references would you recommend for those interested in learning more about this art form?

A: When beginning, I recommend starting small, learning the basics, and growing from there. When carving, it's important to take your time, practice, and then begin to experiment. Printmaking is so vast and filled with so many different techniques, the possibilities on how to use and layer them become endless.

There are many online resources, including social media, that provide endless information from artists all over the world who are sharing their creative processes. Everyone creates a little different from one another and each artist becomes a great resource for learning new skills. I am a big advocate for taking a hands-on class. Oftentimes, many places have local art classes you can take to learn the basics and get a feel for if you like the carving and printing process.

← woodcut prints (2019)
→ Mist (2019)

Singapore

Lim Jia Qi

Unimaginative spaces in the urban environment, most commonly associated with the Singapore "lifestyle," are a key interest in Lim Jia Qi's work. Through passive observation of everyday life, she endeavors to capture the poetics of spaces and structures, reconstructing them in terms of narrative and/or the absence of such.

Coming from a printmaking background, Lim is interested in the advancement and explorative nature of this traditional medium. She adopts techniques, such as painting on carved woodblock and printing with soft pastel instead of ink.

"I have always been fascinated by the relationship between nature and the urban environment in Singapore."

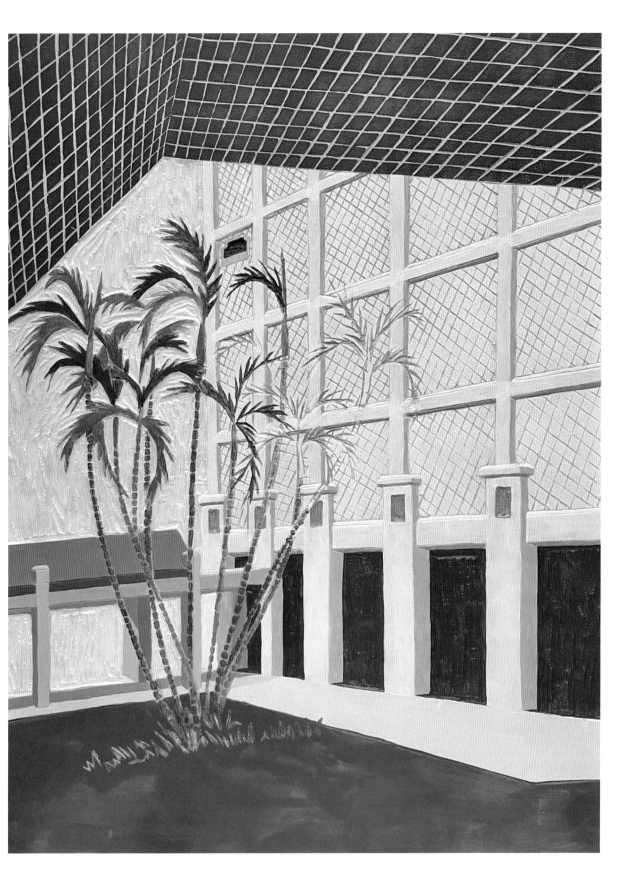

147 WOODCUT

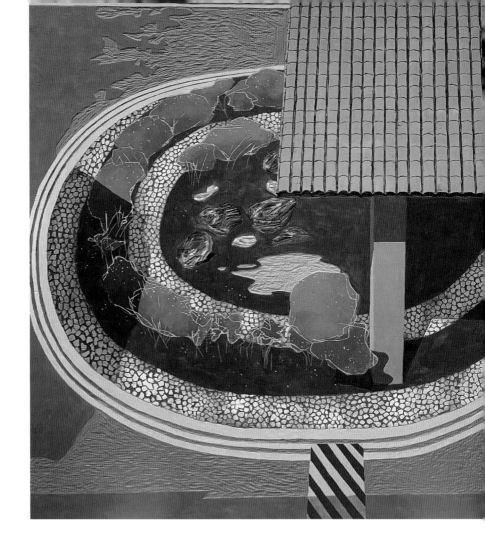

↑ Roundabout (2022)
← Snippets Green 6 (2022)

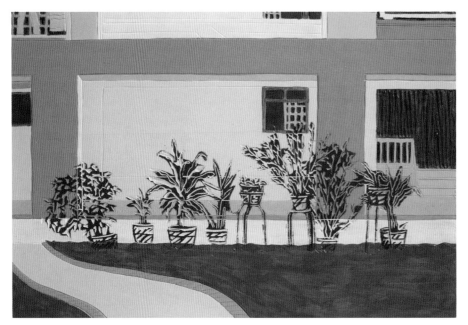

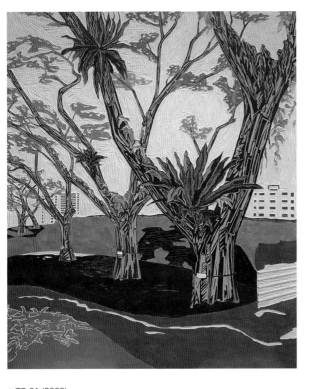

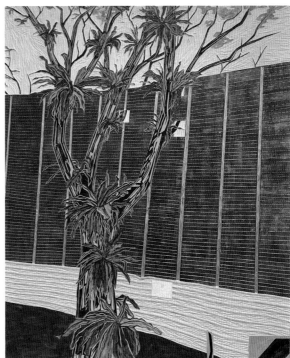

↑ TR-01 (2022)
↗ TR-03 (2022)
↓ TR-02 (2022)

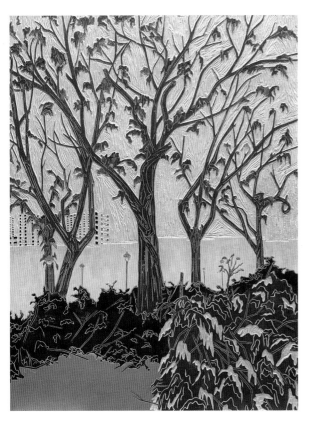

"In essence, I use printmaking techniques to create art in a manner similar to how painters paint."

WOODCUT

↑ In and Out (2021)
→ Garden View Sketch (2021)

← Pots (2021)
↓ Snippets Green 5 (2022)
↙ Snippets Green 7 (2022)

Q: Your works are often about the city, trees, and the environment. Why are you interested in these topics?

A: I have always been fascinated by the relationship between nature and the urban environment in Singapore. When one thinks of "nature," we often visualize spaces untouched by humans. However, in densely populated cities like Singapore, our experience of nature is more closely intertwined with our urban surroundings. Occasionally, we may catch a glimpse of a plant pushing its way through a crack in the concrete pavement or observe vines using the walls of buildings as a scaffold for growth. Nevertheless, nature is not alone in trying to survive our urban environment. From time to time, we see infrastructure being developed with consideration for the preservation of existing trees and designated areas of growth for flora and fauna. This balance between our built environment and natural world has been my inspiration for my recent series of works.

Q: The method you use to create is not common. You carve the block and paint on the woodblock directly. Why do you choose this medium to embody the topic?

A: During my time in art school, I specialized in printmaking. One of the techniques taught was woodcut, which involves carving woodblock and printing them onto paper. As I developed my skills and visual language, I began to question the need for creating editions of my prints. I realized that the carved woodblock itself could serve as a unique work of art. To achieve this, I started painting on my woodblocks, using printmaking techniques like rolling paint with a brayer to create specific effects in certain areas. This approach not only allows me to develop my own unique artistic style, but also allows me to explore and repurpose certain techniques used in printmaking.

Q: You are depicting the landscape of city, but the colors you use are soft pink and green, and other pastels. Why do you use this style of colors?

A: Even though Singapore has an abundance of trees, flora, and fauna,

← WAY HOME (2022)
→ WAY HOME bottles
 and work (2022)

much of its nature is the result of human intervention with trees being planted by humans and nature spaces being designed and allocated by humans. As a result, rather than using natural colors to represent nature, I tend to incorporate artificial pastel colors such as pink and purple, which are also commonly used in Singapore Housing and Development Board (HDB) housing flats.

Q: You held an exhibition "Urban: Backyard" in 2022, which shows the beauty of city and nature. What does Singapore look like, in your opinion?

A: In my opinion, Singapore is a city where nature and the urban environment coexist in a unique and harmonious way. Despite the impression of being a cold and concrete metropolis with our many high-rise buildings, there are hidden pockets of nature throughout the city that are thriving if one takes a closer look. With a little imagination, one can even see these spaces as miniature gardens and ponds,

adding a touch of poetic beauty to the city. It was this beauty that I aimed to capture and showcase in my exhibition, "Urban: Backyard."

Q: How has your woodcut printmaking style and technique evolved over time, and what have been some of the key influences on your artistic development?

A: Through the years, my woodcut printmaking style has progressed from traditional to more modern approaches. As I have developed my craft, I have become more comfortable with letting go of certain printmaking conventions, such as creating editions, which has led me to present the woodblock itself as the finished work. I draw inspiration from contemporary figurative painters like David Hockney, Peter Doig, and Mamma Andersson, who have played significant roles in shaping my visual language. In essence, I use printmaking techniques to create art in a manner similar to how painters paint.

Roman Klonek, born in Poland, is a German-based artist specializing in illustration. Taking influence from Eastern European cartoon styles and having studied graphic arts in Duesseldorf, Germany in the 1990's, he discovered a passion for woodcut printing. For the past 20 years, many prints he created are populated by a wide range of whimsical characters in bold colors, mostly half-animal or half-human, and often presented in awkward situations. His work can be described as a bizarre balancing act between propaganda, folklore, and pop culture.

Germany

Roman Klonek

P: Eva Sieben

"Printmaking requires high concentration, precise cutting out, and color application."

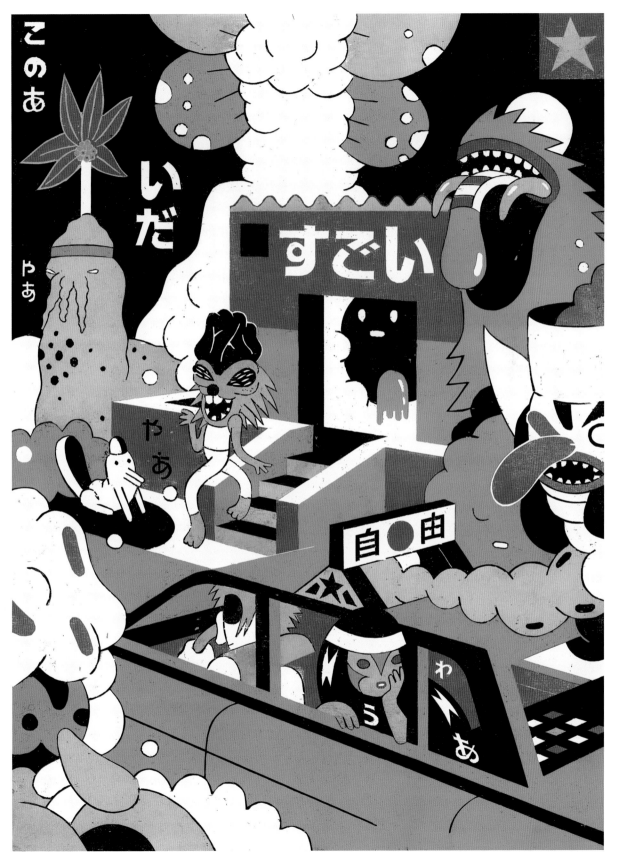

WOODCUT

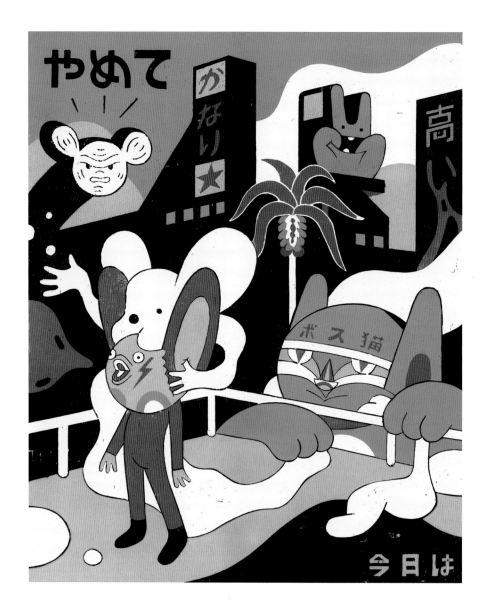

↑ Up on the Roof (2021)
→ Citysounds (2021)

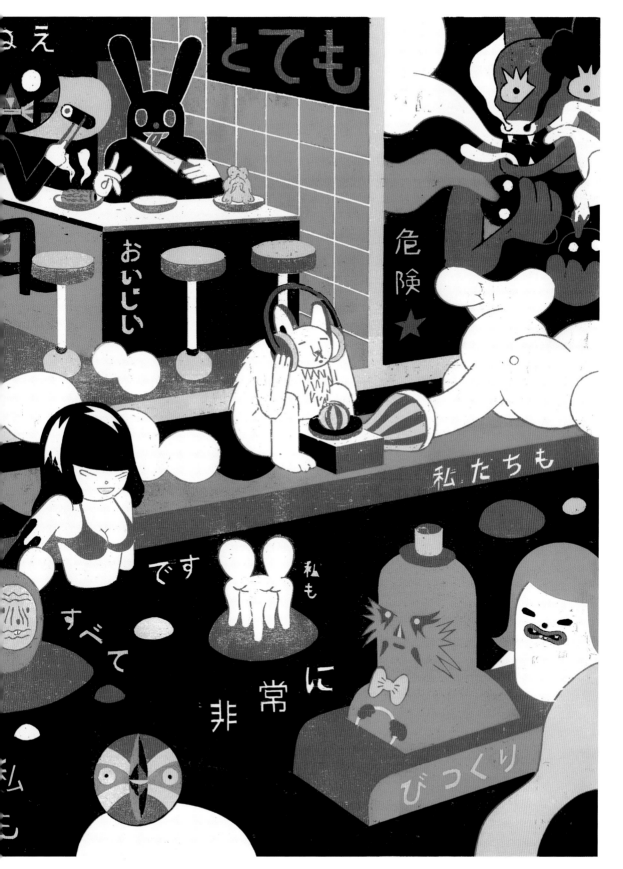

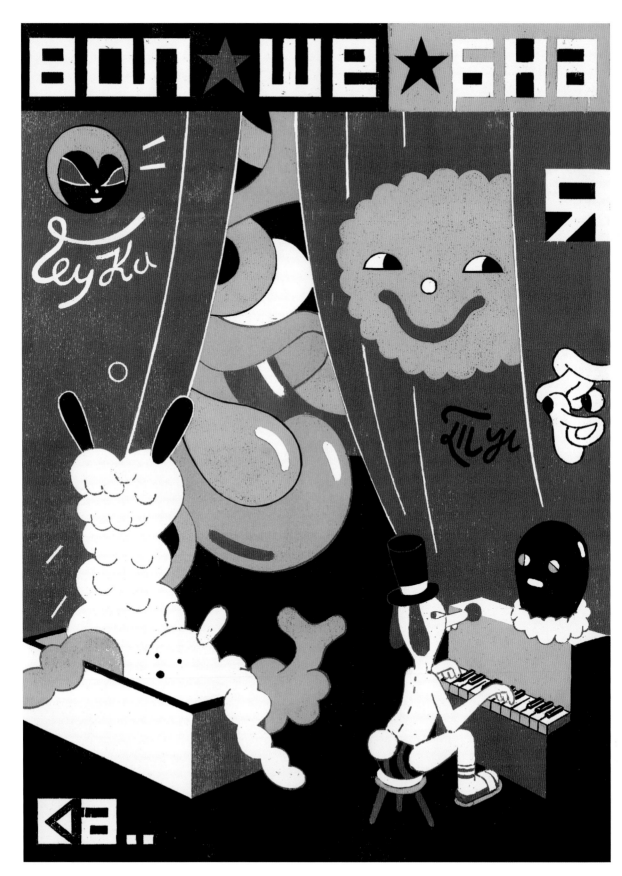

ROMAN KLONEK

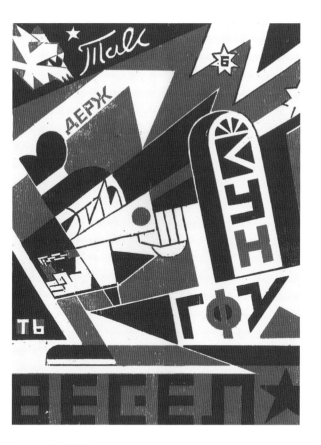

"My goal is a very
special balance:
it must not be too clear,
but not too confusing
either."

← Magic Box (2022)
↑ Al Do Lee (2021)
→ High Energy (2021)

WOODCUT

Road to Kyoto (2022)

Step 1: Draw a mirror-inverted image on a flat block of wood and cut out all areas that you want to be white.

Step 2: Mix red oil ink, the first color, with a roller on a smooth surface, apply the ink to the woodblock and transfer onto paper with a printing press.

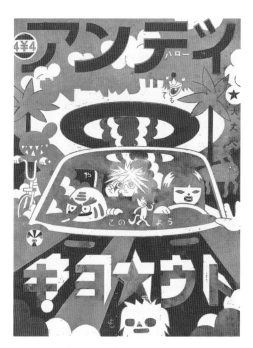

Step 3: Cut out all areas that remain in light pink and print the next color—black.

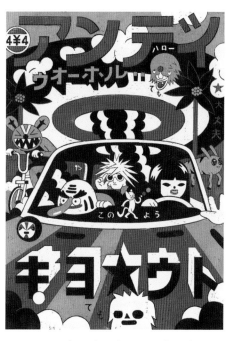

Step 4: When the plate is reduced to the areas of the last color and a retake is not possible anymore, print blue mixed with white.

WOODCUT

Q: In the 90s, you studied graphic arts in Duesseldorf, Germany but then you jumped into the world of printmaking, making your own creative practice for over 20 years. How did you start your journey as a printmaker? What appeals to you most about it?

A: In the middle of my studies at the University of Applied Sciences for Design, a woodcut course was offered there. I signed up and quickly realized that the technique was absolutely my cup of tea. The work steps that are necessary to produce a woodcut printing contain everything I expect from demanding and creative work: wild, unbridled, experimental when finding a subject matter. Printmaking requires high concentration, precise cutting out, and color application. And, in general, working with wood, including carving, cracking, and splitting the board, I need to walk around the workplace 100 times. This is the kind of work I love to dive deeply into.

Q: What kind of difficulties or challenges have you had over the years? What has kept you doing in printmaking?

A: I don't particularly like it when the colors smear too much or are applied too lightly and also if the color layers were not exactly enough on top of each other. Of course, over the years, skills would be naturally improved. My contour lines, for example, are getting thinner and thinner. It is like a little addiction. I can say all that is very satisfying and also necessary because my view of this business is getting sharper and sharper. My curiosity about what a woodcut of a certain idea would look like in the end is still as keen as it was in the early days. And that is probably the best sign and the best motivation to keep going.

Q: Most of the characters you portrayed in your prints are half-animal or half-human. Where do you get inspiration?

A: The key is to draw a lot. I especially like drawing wildly and closing my critical rating at the same time ...The doodles are often layered on top of each other. So, by the end of a week, there will be a lot of random material. I love to browse through the pages of my scribble books, pick up and combine different elements, such as haircuts, noses, mouths, a couple of rabbit or elephant ears, which is just right.

Q: You state that you like to place your characters in awkward situations. What

ROMAN KLONEK

drew you to do that? What do you want to express through your work?

A: I try to achieve a certain mood when composing a picture. My goal is a very special balance: it must not be too clear, but not too confusing either, both would be dull. I'm trying to find the middle position between "too clear" and "to confusing". There always has to be a little puzzle that arouses curiosity in my work. It is like something in life that I don't understand, but it makes me feel curious and something about this matter makes me want to look into it somehow. And it is good if my thinking process has been stimulated, even though I still find it strange, I should

continue to try to recognize a connection and crack mysteries.

Q: The use of bold colors and playful composition are the striking parts. What was the trickiest part to achieve the outcome? Did studying graphic arts contribute to your creation?

A: I think so. I was very busy with poster design during my studies. And bold colors and playful composition are nice recipes for good posters. That is also the reason why I prefer bold colors and letters. In my artworks, letters are not information carriers, but design elements and viewers do not have to be able to read them.

WOODCUT

ΓΙΕΡΟΝ
ЕШЕ

Q: What's the biggest number of colors you have worked with on one piece of works? Do you still remember how you finished that work?

A: My record is five colors. I could not imagine how it would look if I used more. If I used more colors, the image would be very noisy to me.

Q: Printmaking is a traditional art form. As you see it, what are the current trends in the German art scene?

A: It is a wide field. As far as I can see, a lot of artworks are done in classic black and white. This kind of art form is very traditional, but on the other hand, contemporary themes are used. I cannot see a clear trend yet, but it's very popular these days. This certainly has something to do with the fact that people are a little tired of the digital world and they find it very refreshing and satisfying to engage with some ancient techniques, that are, of course, faulty.

ROMAN KLONEK

RUBBER
STAMP

T-zuan started printmaking as a hobby while working as a graphic designer after graduating from art college. T-zuan makes prints the same way he listens to music, watches movies, or reads books. He makes prints on days when he is happy, on days when he is sad, and on days when nothing is happening.

Japan

T-zuan

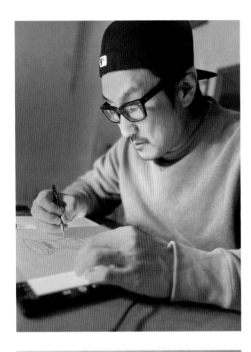

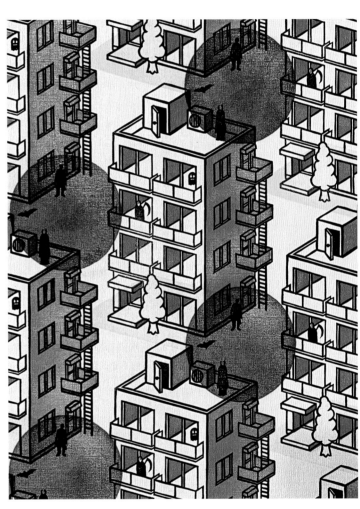

"Many of the geometric forms are shaped by emotions I have felt in the past."

RUBBER STAMP

169

RUBBER STAMP

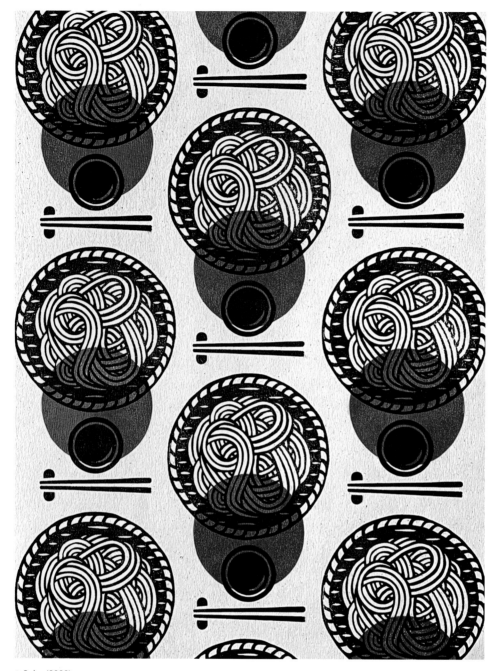

↑ Soba (2022)
→ Rabbit Brothers (2023)

"I think mainly themes like 'silliness,'
'ridiculousness,' and 'ordinary'
are common."

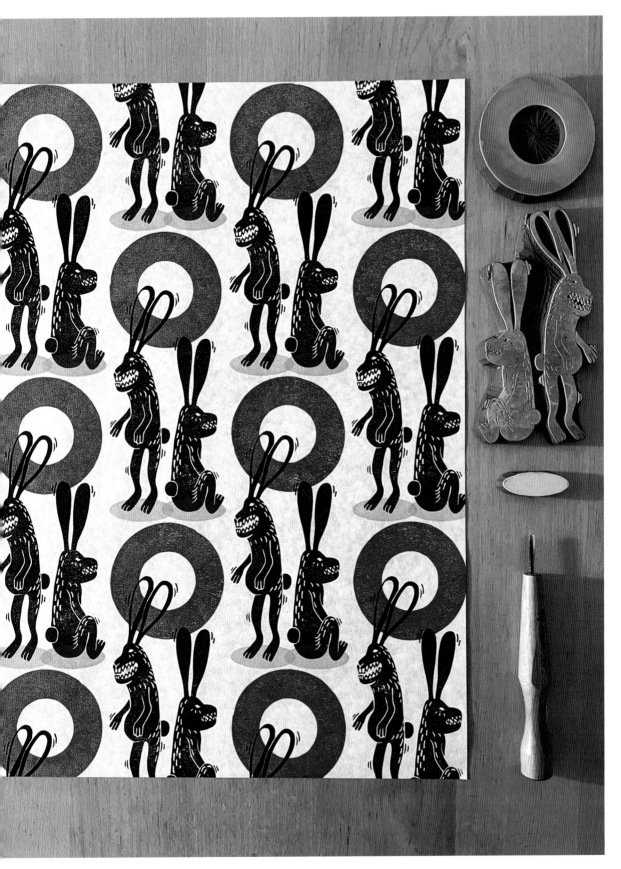

RUBBER STAMP

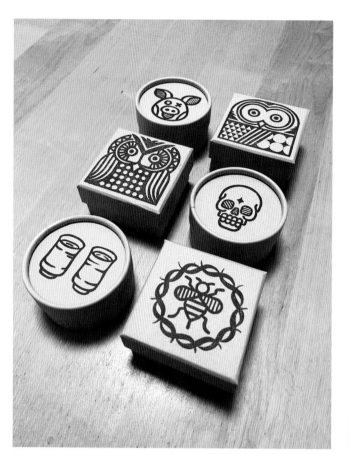

↑ little gift box (2021)
→ Fish pattern cloth (2021)

Moon and Rabbit (2022)

RUBBER STAMP

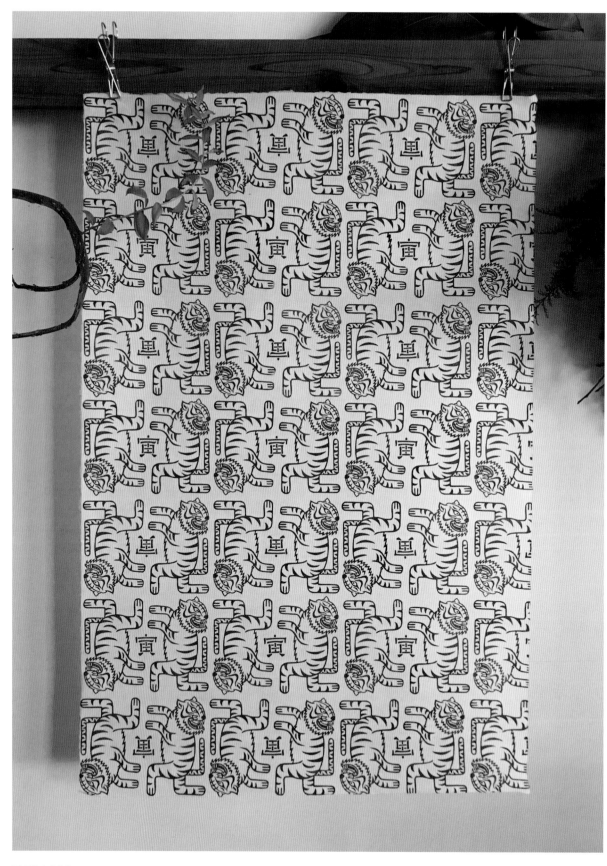

Q: Why did you choose stamp-making, rather than linocut or woodcut printing?

A: First, the rubber plate was the most accurate material for engraving the lines of the preliminary sketch.

Second, I used to make large-format works using silkscreen, but I wanted to make works that would be more intimate with the lives of the people who hold them in their hands, so I started making hand-sized stamps.

Q: Most of your works are neat and repeated patterns, why do you choose this kind of composing?

A: First of all, I create a work of art with the message I want to convey. Of course, on its own, I want the work to convey a strong message. But when I arrange the work as parts, the message disappears at first glance and it becomes just a pattern. However, as you look at it later, the message is slowly conveyed. I find this way of conveying the message interesting and that is why I create my works in this way.

Q: There are many elements in your works, such as geometry, animals, people, insects, and others. Where does your inspiration come from?

A: I choose them from the things that have been impressive in my life. Many of the geometric forms are shaped by emotions I have felt in the past.

Q: How long do you need to finish a print?

A: It depends on the motif, but it takes about one day for a rough sketch, one day for carving, and one day for printing. I work as an art director during the day, so I work after work in the night. It takes me one to two weeks to complete a work.

Q: What have been working on recently? Do you have anything you want to do?

A: Until now, I used to create my works thinking only about "form," but, recently, I have been adding "color" to my thinking as well.

Q: What do you want to express through your works?

A: The works are a reflection of my emotions at the time, and that's all. But I think mainly themes like "silliness," "ridiculousness," and "ordinary" are common.

Year of the Tiger (2022)

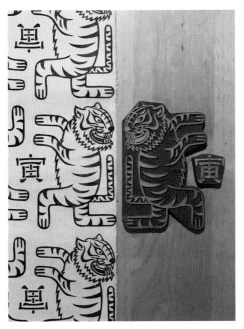

RUBBER STAMP

"I would say be yourself and create the art you want to do and not think about what others want to see."

Sweden

Viktoria Åström

Viktoria Åström is a freelance artist, illustrator, and animator. She has a bachelor's degree in computer science from Lund University and a master of arts degree in design for interactive media at Middlesex University. After Middlesex, she worked as a web developer and web designer for a few years in London before undertaking a post-graduate certificate in animation from the London Animation Studio where she graduated in 2003. She paints watercolors, makes large ink drawings, and creates prints by carving rubber. She runs a web shop on Etsy where she sells her work, but she also does illustrative and 2D animation work for clients. Besides working by hand, Åström also paints and designs a lot digitally.

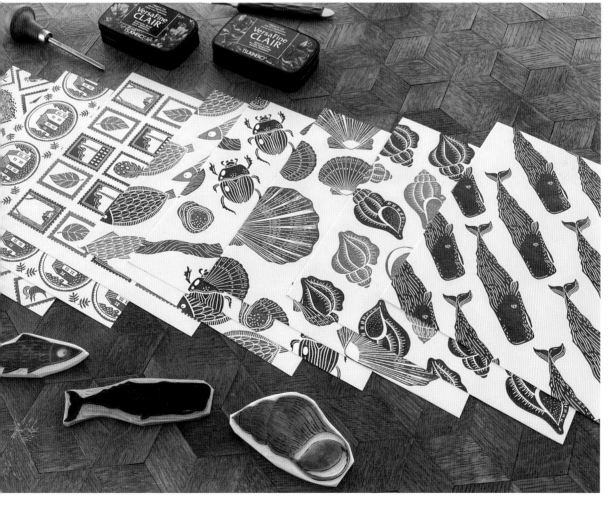

177 RUBBER STAMP

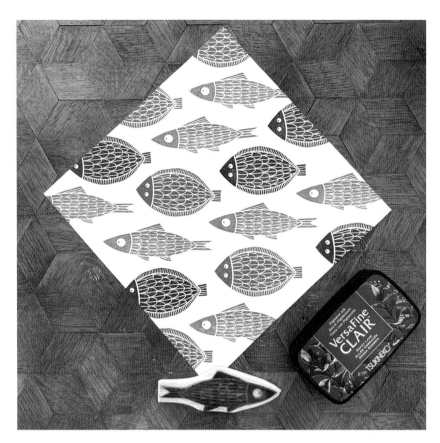

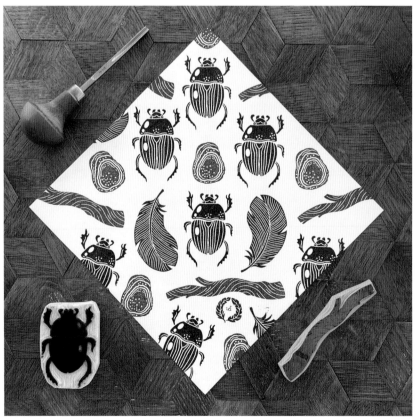

VIKTORIA ÅSTRÖM

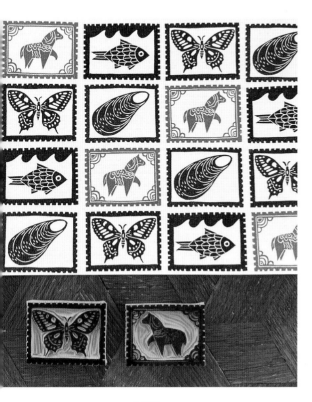

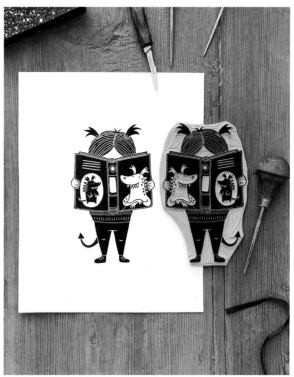

179

RUBBER STAMP

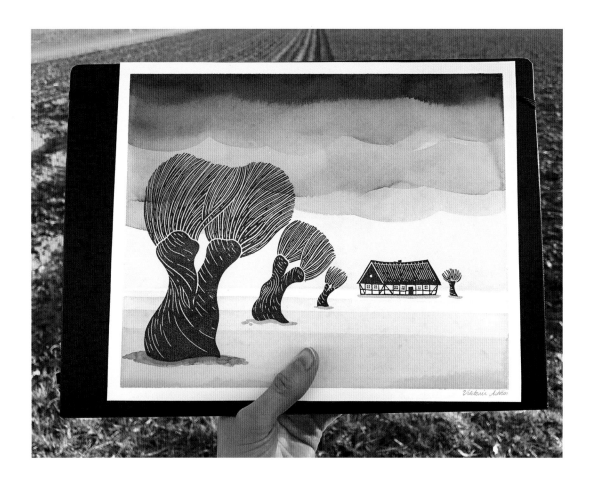

↑ Southern Sweden
← Roach Fish (2021)
→ Humpback Whale (2020)

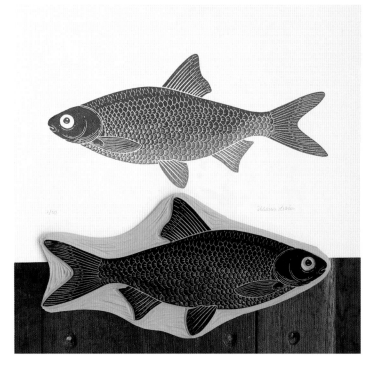

VIKTORIA ÅSTRÖM

180

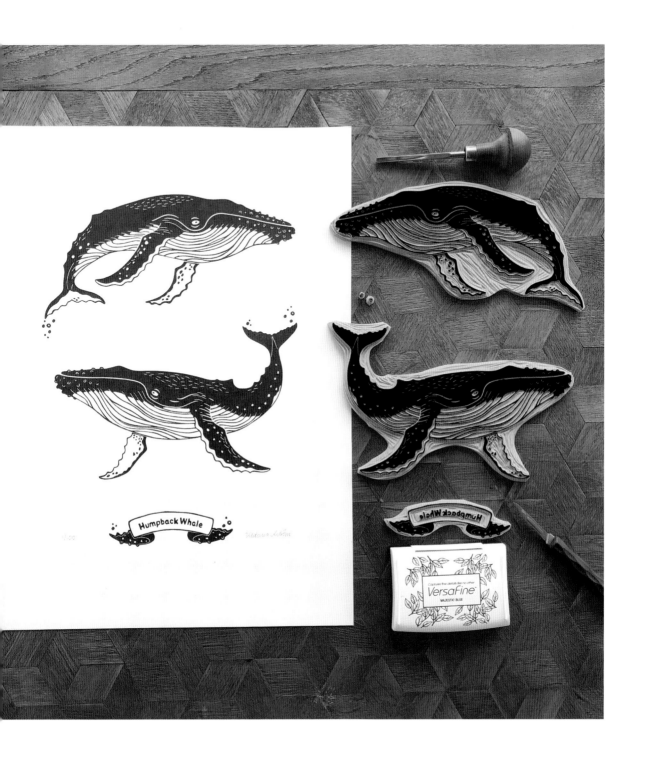

"Art is my hobby and I try a lot of new things all the time."

RUBBER STAMP

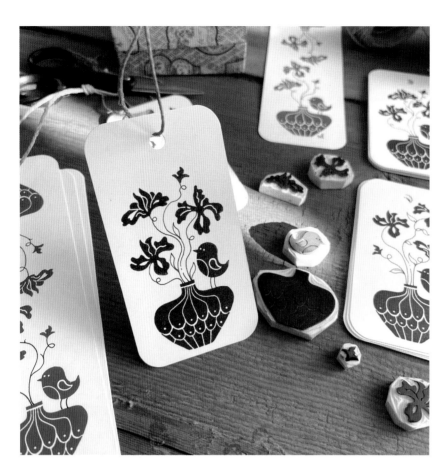

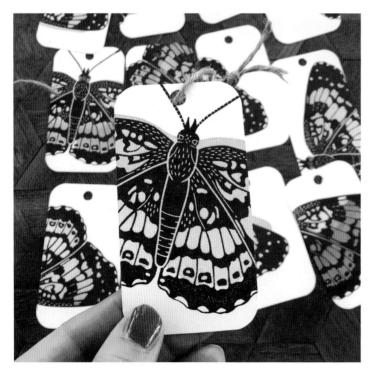

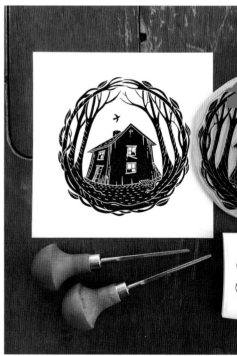

VIKTORIA ÅSTRÖM

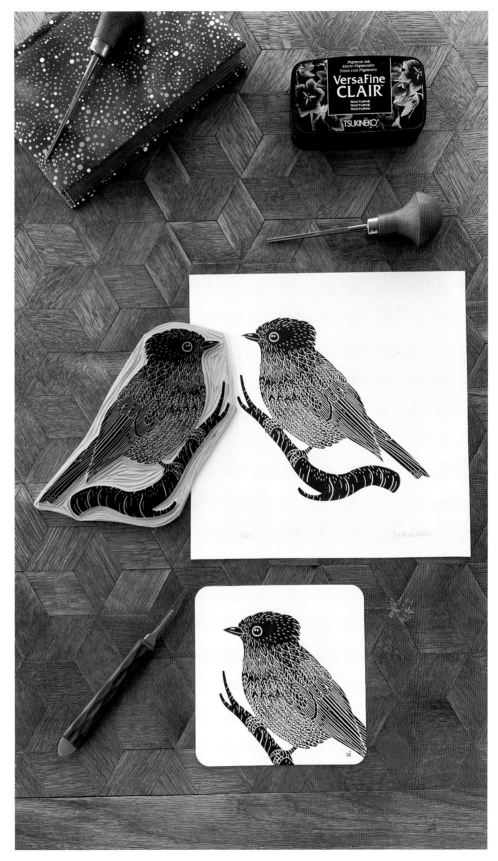

RUBBER STAMP

Q: You have rich experiences in different fields, such as computer science and interactive media. Do they have any influence on your work of printmaking?

A: This is such a fun and tricky question. I have never thought about this. I have a degree in animation too, and I can see how that has influenced me greatly. I like character design and bringing a narrative into my carvings, if I can.

I guess I just love problem solving and when I was working with programming and came across a difficult piece of code that wasn't working, I loved the detective work of trying to find an answer. The best part was going around through the day, thinking about how to solve something and, suddenly, the answer would dawn on me. There was always a solution and I would run to my computer to try it out. When it comes to art and printmaking, I do a lot of thinking before even sitting down to sketch. I see the picture in my mind before I make it and this process can take a few hours or several days. I guess I do approach finding a solution to a certain composition the same way I would think about how to program something. When I have the answer, I run to the studio and get to work.

Q: Your works are full of purity and innocence. Where does your inspiration come from?

A: Thank you, that is lovely to hear. When it comes to my carvings, I get a lot of inspiration from nature. There are so many lovely patterns in nature that lend themselves very well to carving, like the feathers of a bird or the scales on a fish. I love details and it's almost meditative to carve these kinds of patterns. But I also draw a lot of inspiration from cities and people around me. I love going around taking pictures of houses or out in the countryside photographing derelict houses. There are a lot of these in certain areas of Sweden. Many of them are very beautiful and you can see these in some of my work, too.

As a child, I loved reading (and still do). I get a lot of inspiration from my childhood and the stories I used to read. I have always been fond of sweet stories that have a twist or a darkness to them. That is something I search for when creating my own work. I loved Astrid Lindgren, Tove Jansson, Maurice Sendak, and Tim Burton, to name a few.

Q: You use many colors in your works. Do you have any preference of color?

A: Yes, I love blue. Duck Egg Blue is my favorite or Payne's grey, which has a hint of blue in it. I use mostly inkpads when printing with my stamps and there is a limited palette. I enjoy mixing colors, which was a challenge for me at first. But it's nice to be limited, too, if that makes sense. I use Versafine Clair Ink Pads and my favorite shades are Medieval Blue, Monarch (purple), and Pinecone (brown). They go lovely together.

Q: As a rubber stamp printmaker, have you ever met any challenge or difficulty during these years? What were they?

A: I started to carve in 2015, but I have been a freelancer, for the most part, since 2003. My biggest challenge has probably been to get a good family/work balance. It's hard being a full-time freelancer working from home and being a mum at the same time. A life with kids isn't very predictable, which is stressful when trying to meet deadlines. I try to add in some extra time when planning a project because I never know what will happen.

Then there have been times when I haven't known where I was going with my art and that is something that is difficult for me. I want to have a clear goal and, being an artist, it is hard to decide what to focus on. Art is my hobby and I try a lot of new things all the time, and it's easy to want to do everything at once. Lately, I have been better at narrowing down and really thinking about what I want to create. I recently wrote and illustrated my first children's book here in Sweden and that has been a dream come true. *Glaskulorna*

(The Marbles) was made using watercolors, but maybe the next time I might use carvings. That would be amazing. I love bringing storytelling into my carvings and to create a narrative would be so much fun.

Q: You have about 185,000 followers on Instagram. Do you have any tips to manage this social account?

A: I started my account in 2015, right about the time I started carving. I was very prolific the first few years, posting almost every day, which gave results. My account grew a lot and very fast, which amazed me. I didn't set out to grow such a large following and I was surprised and delighted with the response I got. I just started the account to show my work that was laying around at home. I felt really shy about showing my work before then and Instagram gave me a lot of confidence. My work consisted mostly of creating art for companies using other people's designs before this.

I would say, be yourself and create the art you want to do, and not think about what others want to see. It's easy to fall into that way of thinking after a while and that can have a negative impact on your works and your energy levels. If you want to have a long-lasting social media account, try to be consistent, but at a pace that work for you and your life balance. Plan ahead and do it fairly regularly. I post less often now, which is better for me in the long run. But I guess my best tip would be to set aside time to work towards your goals and be specific with yourself about what you want to achieve. Create art regularly. It doesn't have to be every day, but keep track of how it lines up with your personal goals. Have fun and don't be shy about showing your art. Your way of seeing the world and what you create is unique to you. Let the uniqueness show.

→ Reading (2020)

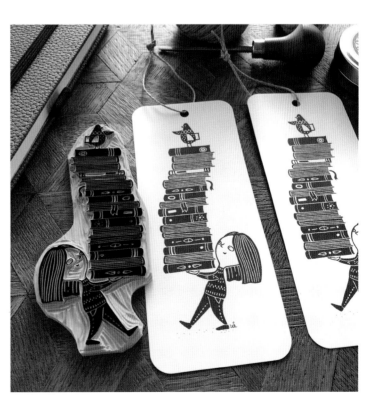

RUBBER STAMP

Esther Elzinga

Esther Elzinga is a fabric printer, printmaker, and pattern lover based in the Netherlands. There are two things she loves most in her profession, fabrics and printing. At her studio called Studio Tokek she makes stamps for her own collection of print fabrics, she makes various items out of the handprinted fabrics, and she makes stamps for various customers all over the world.

"I hope that
I can bring a smile
to people's faces
with my work, just
like thinking
of a little 'tokek'
does for me."

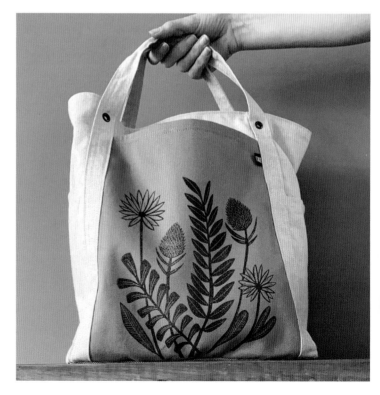

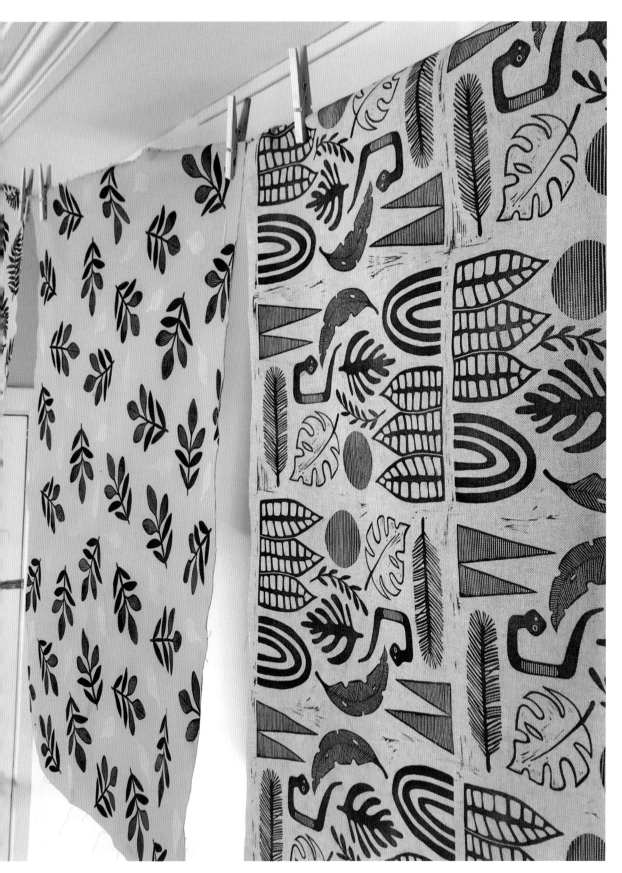

RUBBER STAMP

↑ baby clothes (2021)
→ handprinted shoes (2021)

ESTHER ELZINGA

← pouch (2020)
↙ handprinted fabrics (2020)
↓ leaf pattern (2020)
↓ pouch (2020)

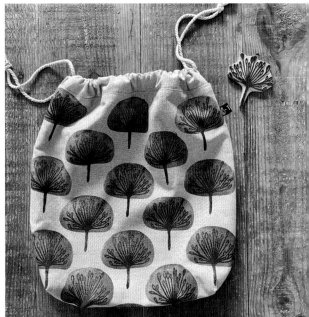

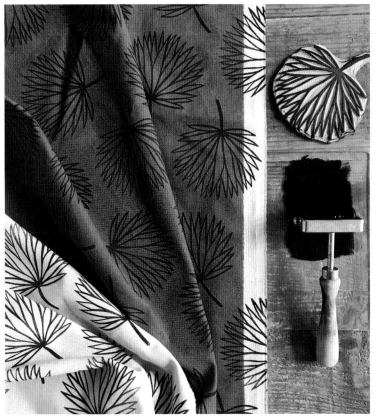

RUBBER STAMP

↑ kitchen (2019)

ESTHER ELZINGA

190

← Beetle pattern on baby clothes (2021)
↙ bird stamp (2021)
↓ beetle stamp (2019)

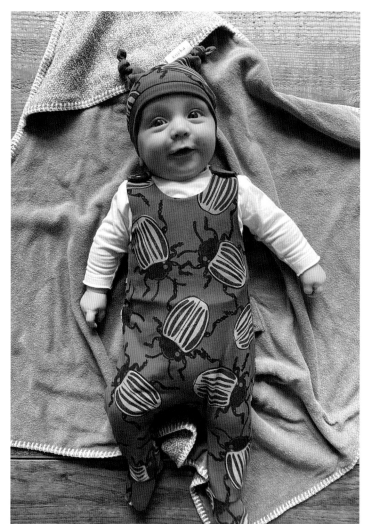

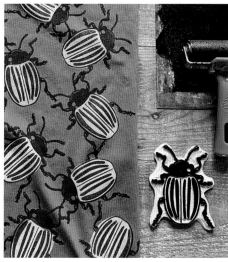

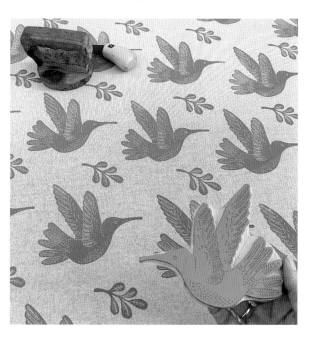

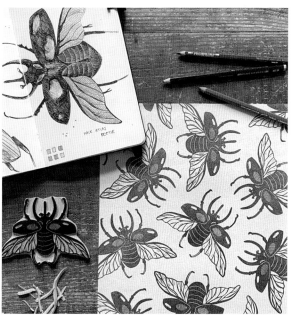

191 RUBBER STAMP

"Making custom
stamps is one
of the nicest and
challenging
things to do."

→ willow pattern (2020)
↓ cat in bag (2021)
↘ pouches (2019)

ESTHER ELZINGA

Q: You have a passion for fabrics and printmaking. At an early age, you studied high fashion at the Fashion and Design Academy, but later you started your career as a printmaker. Did you always know you wanted to be a printmaker? How did you get into printmaking?

A: I didn't know I wanted to be in printmaking when I was younger. As a kid, I was always drawing or experimenting with fabrics. I learned sewing from my mom and grandmother, and I loved to make clothes for myself and my dolls. It was an logical choice for me to study high fashion and I wanted to start my own clothing brand after my studies. But it turned out differently. While I was searching for a job, I became pregnant with our oldest son and I decided to stay at home the first year, so I could take care of him. Long story short, that one year became seven years. And in that seven years, we had five kids. In those years, I have always been creative and I experimented a lot with different materials and fabrics. But even as I really enjoyed our busy family life, I really wanted to set up something for myself. But then life decided different again when a dream came true. We moved from the Netherlands to Singapore for my husband's work. In Asia, the printmaking heaven opened for me. I loved to go to markets where I discovered all the beautiful printed (batik) fabrics. I dived into batik printing and started to experiment with other techniques to print on fabric. And then one day I found soft carving blocks in a small art supply shop and I was hooked! That was the beginning of my love for printmaking.

Q: Why rubber stamping? What are the advantages and disadvantages of this kind of material?

A: I love to work with rubber blocks a lot. Rubber is softer than lino. I can easily carve super-small details and even text in it. This is a great advantage because I make a lot of custom logo stamps for clients with tiny details and small text. Another advantage of rubber block is, in my view, is the lovely print I can make with it on paper and fabric! Compared to lino the rubber is thicker and

that means I can carve a little bit deeper in the rubber. A deeper carved stamp means a crisper print on fabric! And the rubber stamp is easy to use with blockprint ink and an inkpad. Another great advantage of the rubber is the easy cleaning. I rinse the stamps and dry them. Some of my stamps are more than seven years old and still in great condition.

Q: When you got back to the Netherlands from Singapore, you started your own printing studio—Studio Tokek. Why is your studio called "tokek"?

A: When we had to move back from Singapore to the Netherlands again, we needed some time for the kids and ourselves to get used to Dutch life and weather again. When everyone was back on track I started my own printing studio and called it tokek. "Tokek" means gecko in Indonesian. When I think of our time in Asia (Indonesia is especially close to my heart) I see the beautiful nature, the friendly people, the sun, the printed fabrics, and the geckos, of course. All those memories make me happy. I hope that I can bring a smile to peoples face's with my work, just like thinking of a little "tokek" does for me.

Q: As an independent printmaker making stamps for customers all over the world, what kind of difficulties or challenges have you faced over the years? And how did you get through them?

A: Making custom stamps is one of the nicest and challenging things to do. I want to make every custom stamp perfect and that takes a lot of time, especially when I have to design the stamps, as well. I carve all my stamps by hand. Even that carving in rubber doesn't look very challenging physically, but it is. The planning of my day is very important. Carving too long isn't right for me and my body. So, I try to vary carving with printing and sewing. The variation in my work is what I like best in my job and it keeps me healthy.

RUBBER STAMP

Simone Bryant

Simone Bryant, operating under the design studio name of Barneby Fox, is a self-taught illustrator, printmaker, and stamp carver based out of her home studio in Atlanta, Georgia. Using traditional block printing techniques and preferring softer carving rubbers, Bryant is best known for her fine details, vibrant colors, and playful hand-carved stamps.

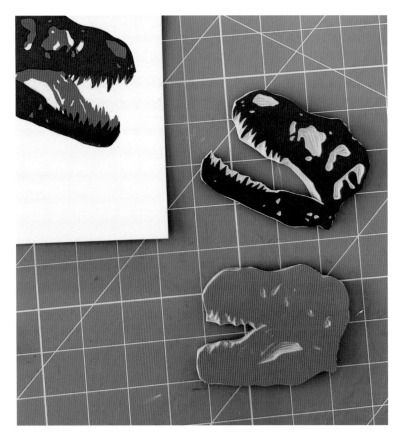

"The delicate details are my favorite because they are such a challenge to carve!"

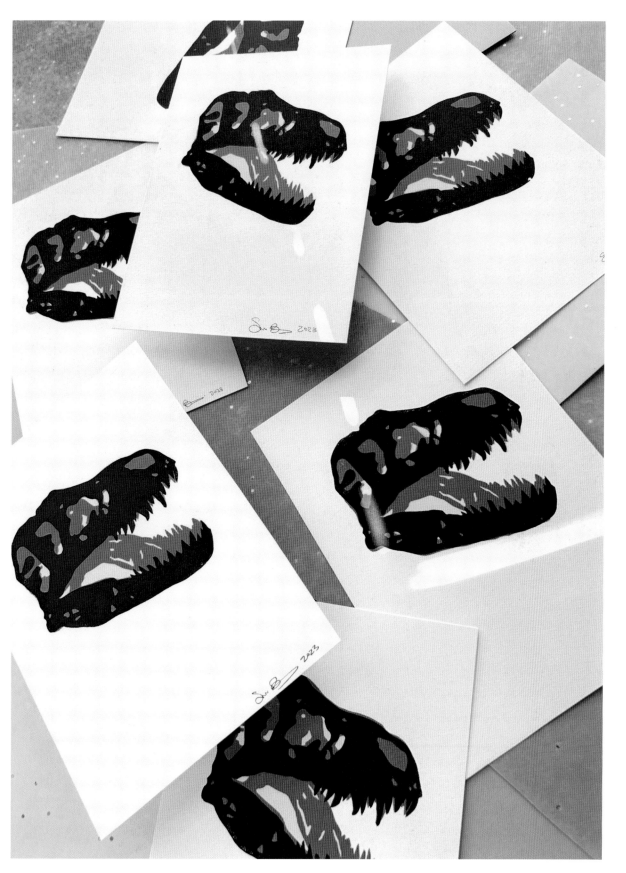

RUBBER STAMP

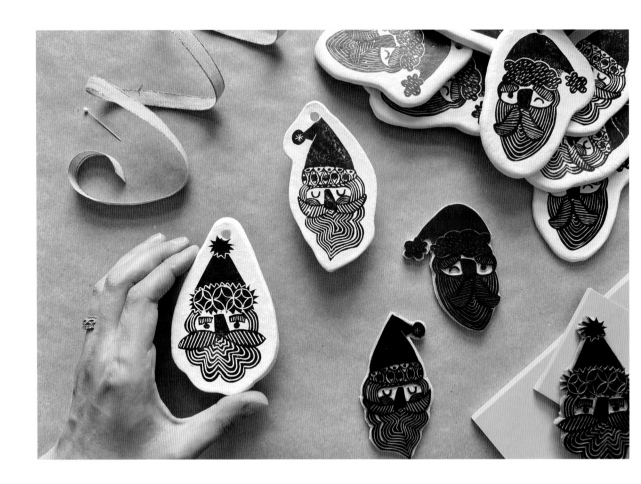

↑ Clay ornaments (2021)
→ Bote Bote Jewels logo stamp (2021)

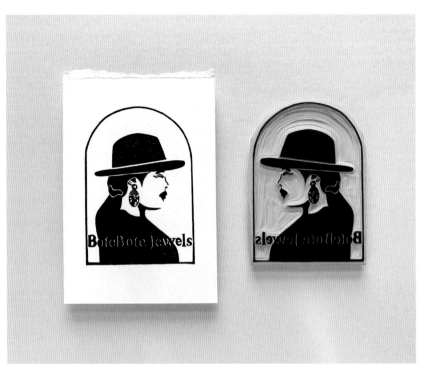

SIMONE BRYANT

"I learn best by just trying new techniques and practicing my skills daily."

← Watermelon rubber stamp set (2021)
↙ Mirrorball block print (2023)
↓ Hazel + Leo Logo stamp (2020)

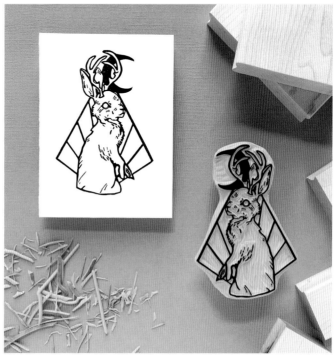

RUBBER STAMP

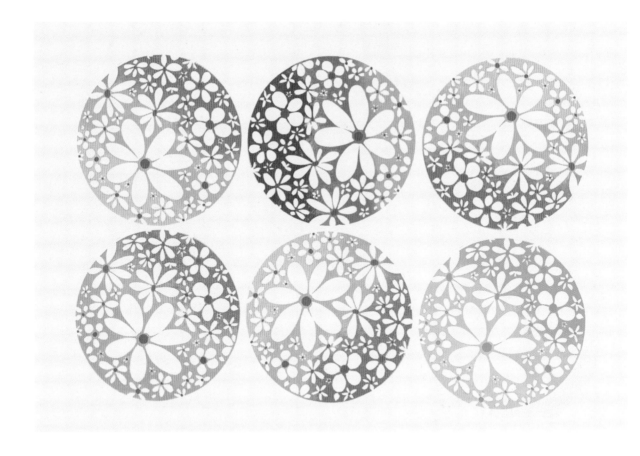

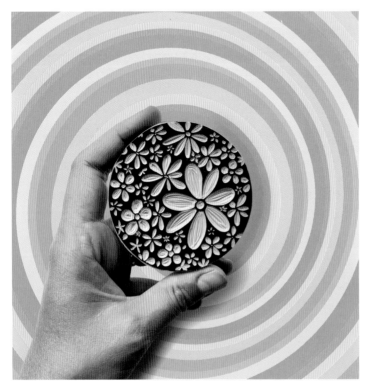

↑ Flower block print (2021)
← Flower block (2021)
↗ Holiday Tree Rubber Stamp (2021)
→ Hot Dog rubber stamp set (2020)

SIMONE BRYANT 198

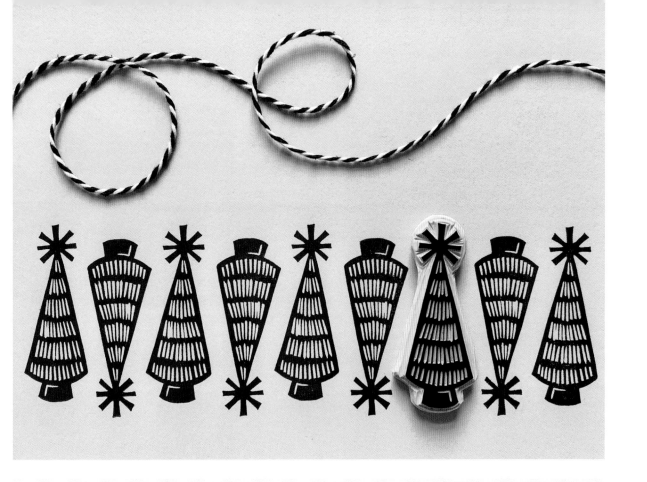

199

RUBBER STAMP

Q: You were a brands and marketing director. What got you into printmaking?

A: Before printmaking, I spent 10 years in corporate brand management and marketing roles for a number of large, global brands. In 2019, I made the difficult decision to hit pause on that part of my life to focus solely on family. I had recently had my first set of twins and just felt like I wasn't present enough, so when they turned two years old, I left my career and became a stay-at-home mom. It only took a few weeks before figuring out that I needed some type of creative outlet. I wanted to still feel accomplished outside of typical parent duties and so maybe it was the shock of such a big life change, or maybe I just missed going into the office each day, but three months into it, I created Barneby Fox—my little at-home print studio above the garage. I spent nap times and late nights practicing stamp carving and block printing, opened a little online shop and use social media to share my passion with others.

With my background in brands and marketing, I was familiar with creating new brands from the ground up, and developing and delivering the customer experience, so it definitely helped when creating my own brand. It was the perfect way to combine my skills.

A few years later, I ended up having a second set of twins! Now, I juggle four kids, five years old and under, while still squeezing in a few hours each day to spend on stamp carving and printmaking. It is a lot to balance but it is rewarding to have found something I am passionate about that still allows me the flexibility to put my family first.

Q: When you first started, how did you learn to illustrate and carve your designs?

A: I have always considered myself a creative person. Growing up, I preferred art club over athletics and was always doodling in my notebooks or walking the aisles of craft stores trying everything from pottery to painting, candle making and embroidery. I have a bachelor's degree in marketing, so I did not go to school for fine arts. Illustrating, stamp carving and printmaking are all self-taught. I learn best by just trying new techniques and practicing my skills daily.

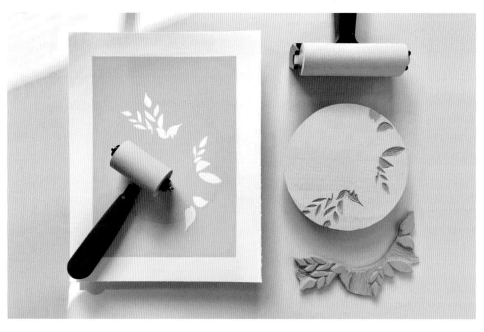

SIMONE BRYANT

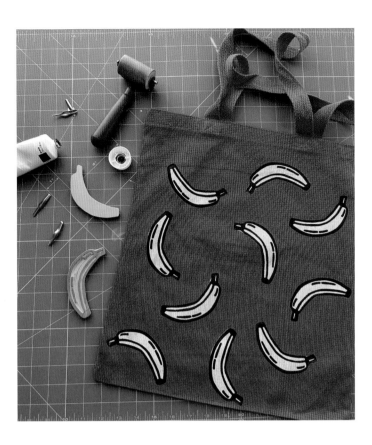

Q: **Your works are full of delicate details. What is the biggest challenge when making such a detailed stamp?**

A: The delicate details are my favorite because they are such a challenge to carve! It takes a lot of patience. The majority of the rubber stamps I carve are custom orders for small businesses, typically logos, to use for printing on packaging materials. When you are hand carving a logo at just a few inches, precision matters. When it is my own design, if I make an incorrect cut, I can usually find a way to cover it up or tweak the design so that no one notices, but with a logo, a wrong cut means starting over. I often have to take multiple breaks so that I don't get too eager and try to rush it. I find the most challenging detail to carve is small text, particularly serif fonts.

Q: **You love to experiment with different materials and media. For example, you print your designs on paper, fabric, wood,** and clay. Is there a different technique to use when printing on different materials?

A: When block printing, there are differences in both what you print with as well as what you print on. For example, there are many different kinds of rubbers and linoleum to use for carving. Some hold better detail, some are easier to cut, some transfer ink better. It's all about trying different materials and figuring how what your preference is. I personally prefer to work with softer rubbers.

Similarly, different types of papers and textiles will all print differently. A heavy paper with more texture might require rolling more ink and using more pressure than a lighter one. For fabrics, I use a specific block printing ink that it will withstand washing. Too little ink and the image will come out light and grainy, and too much ink will flood the details. Again, it is a lot of trial and error and takes practice!

Riyo Kihara is a self-taught hand carved stamp maker and print maker based in Japan. She started "talktothesun" in 2008. Making hand carved stamps has become her passionate work as well as one of the ways to meditate and communicate with people in the world.

Japan

Riyo Kihara

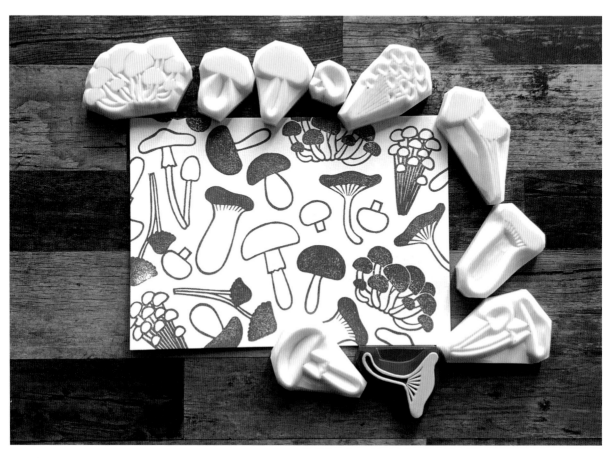

203 RUBBER STAMP

"I want to present something simple, but something that gives you a smile and does not need to be explained with words."

RIYO KIHARA

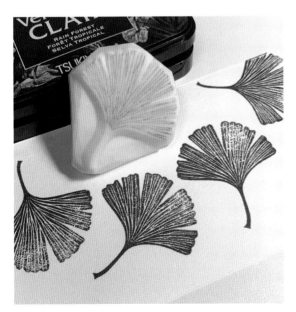

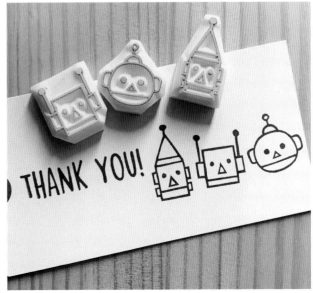

RUBBER STAMP

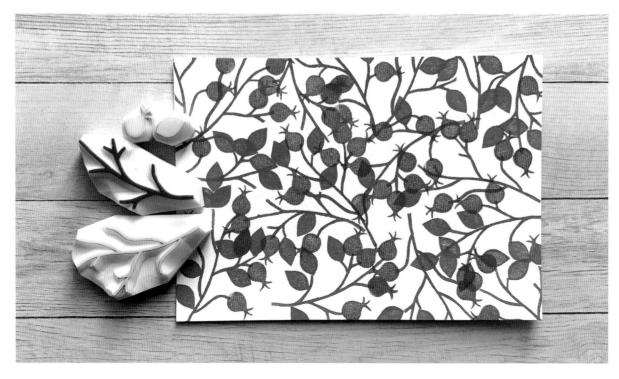

↑ Rose Hip hand carved stamps (2022)
→ Bread hand carved stamps (2016)
↓ Turtle Family hand carved stamps (2023)

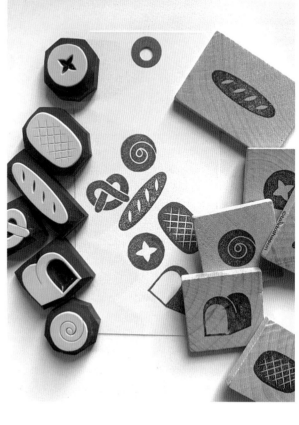

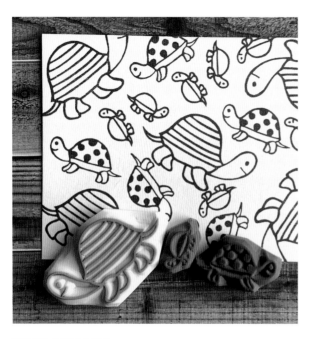

RIYO KIHARA

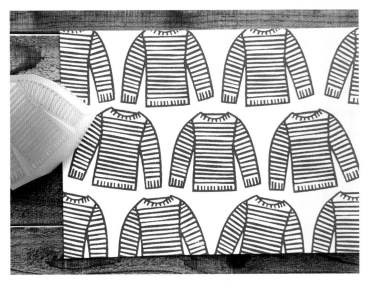

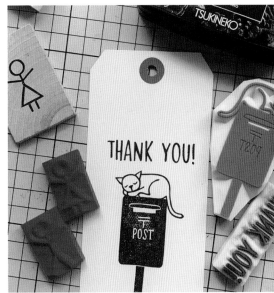

↑ Sweater hand carved stamps (2022)
→ Cat on Japan Mail box hand carved stamps (2019)
↓ Sleeping Cat & Cozy Cat hand carved stamps (2019–2021)

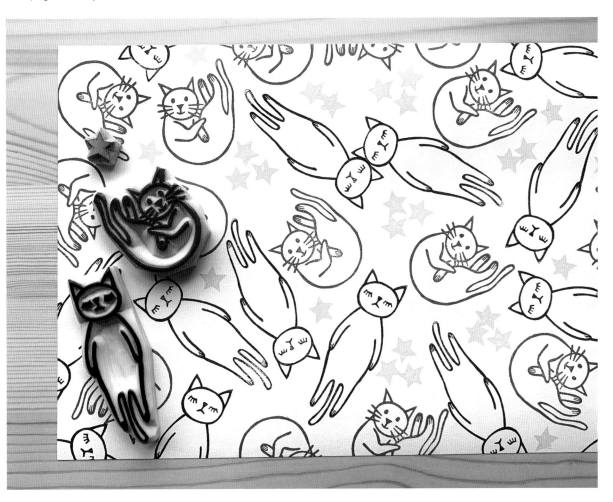

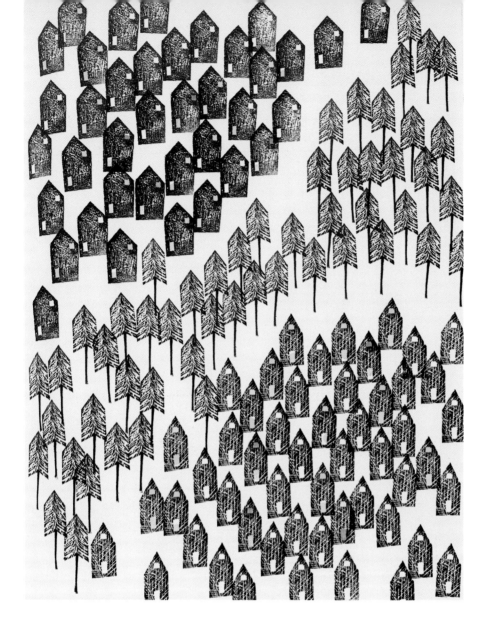

Q: Why did you choose stampmaking?

A: Stamp making was something I did since I was a child after I learned wood block printing and wood carving at elementary school in Japan. I was reintroduced to this childhood craft in 2008 after I got invited to join an artists' fair by an artist friend. In 2009 and 2012, I had some tough times with my health, so stamp carving became a part of recovering from the illness. Apart from that, it is such a fun process to transform drawing into stamps and block prints, so I continued ever since. Stamping is a simple joy that anyone can enjoy like drawing.

Q: You have made rubber stamps for 15 years. What challenges have you faced during those years?

A: Yes, it is always challenging when I get a request to carve something small!

Q: Where does your inspiration come from?

A: My major inspiration comes from my dog since I got her in 2017. She has become a

kind of character who explores the small world of my countryside neighborhood in Japan. Even if she is just sniffing a flower on the street, she makes the scene cute and happy. I also get inspiration from my family photos, Japanese traditional arts and crafts, folktales, travels, and Studio Ghibli animations I grew up with.

Q: How long do you need to finish a print?

A: It depends on the details of the design and the size of stamps or prints. It usually takes about one hour to make a simple design from making a template, transforming it onto a block, and printing on a piece of paper. But others could take several hours or a few days to carve and print.

Q: What do you care most about in print? The material? The carving knife? The color or something else?

A: It is probably not visibly shown in the work. But I am very conscious about carving each block slowly with care. It is same when I make prints. I cherish each process from preparing to cleaning or even

packaging the finished prints. As for tools and materials, I use what I can get locally. I use something that fits in my hands and doesn't make them tired.

Q: What have you been working on recently? Do you have anything you want to do?

A: I have been working on an expanding series of hand carved stamps with Japanese folktales. I would also like to work on larger pieces, of prints which is a bit of a challenge for me as my main work has been working on small hand carved stamps.

Q: What do you want to express through your works?

A: I want to present something simple, but something that gives you a smile and does not need to be explained with words. I mainly offer my work as hand carved stamps. So, it has been my mission to create designs and hand carved stamps that either five-year-olds or 90-year-olds can enjoy and use them as part of their creative activities.

← From My Journal (2021–2022)
→ Doodle Line hand carved stamps (2022)

RUBBER STAMP

Ukraine

Larysa Ahoshkova

Larysa Agoshkova is a stamp artist from Ukraine. She started making stamps four years ago as a hobby and selling them online. Ahoshkova creates all designs for the stamps herself, and each stamp is carved by hand from high-quality Japanese stamp rubber.

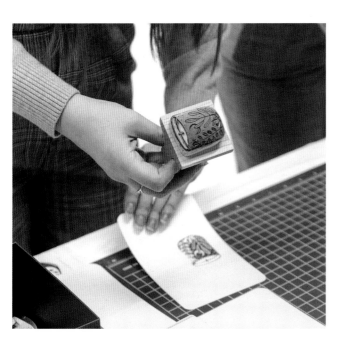

"Each stamp is a
challenge and an
exercise in expressing
my idea with the most
clarity possible."

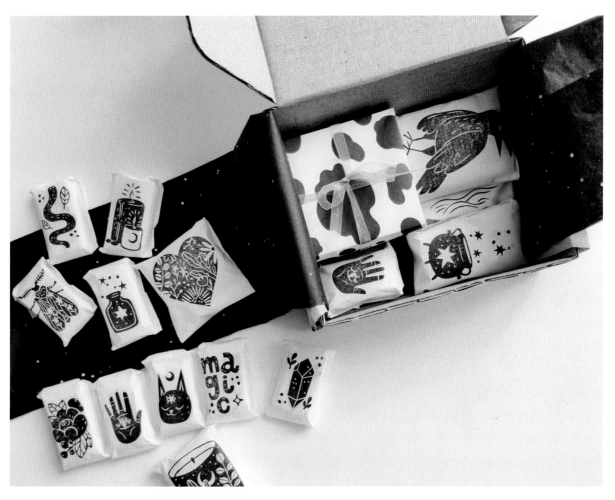

RUBBER STAMP

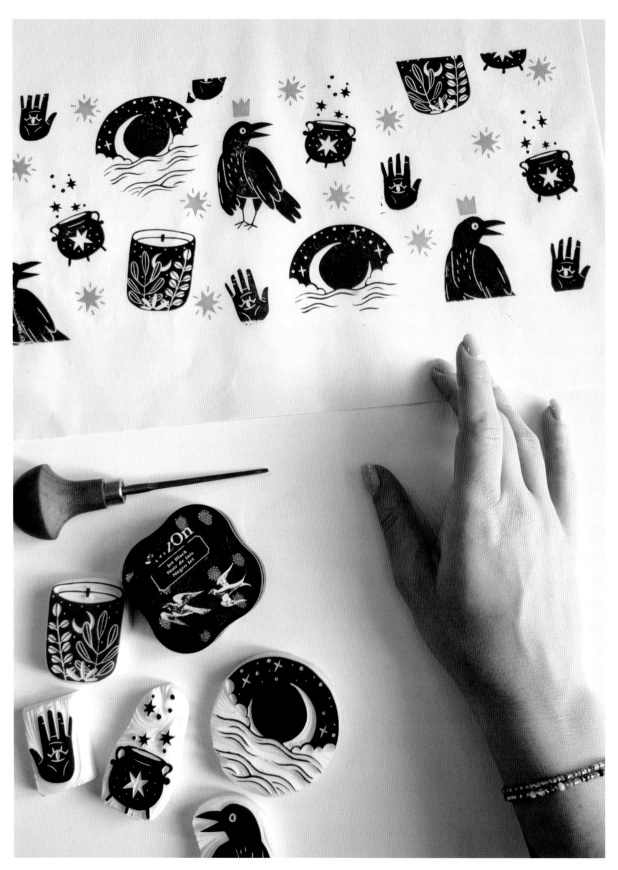

LARYSA AHOSHKOVA

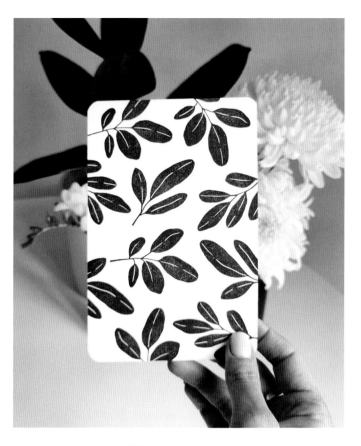

"Every stamp that
I make is a little
reflection on
my current state
of mind, reminders
of the stories I was
living through that
inspired this
or that design."

← top 5 customers favorite (2021)
↑ handprinted greeting card (2021)
→ Foliage Stamp (2021)

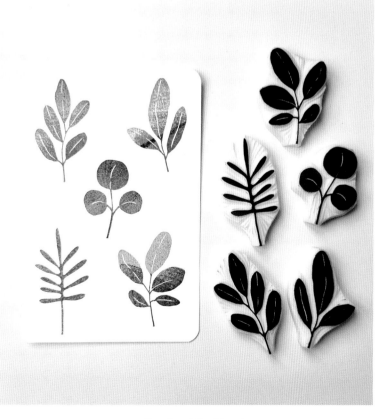

　　　　　RUBBER STAMP

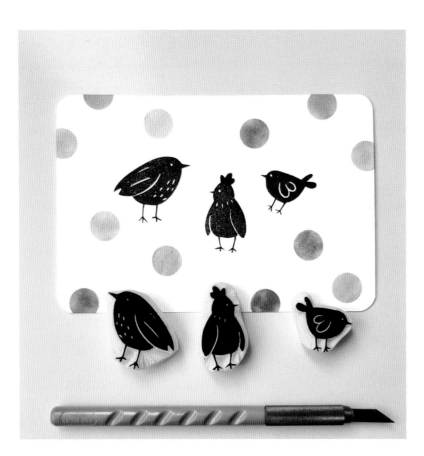

← Tiny Birds stamp set (2021)
↙ top 5 customers favorite (2021)
↓ Reflecting Girl (2022)
→ handprinted Greeting Cards for
 Etsy orders (2023)

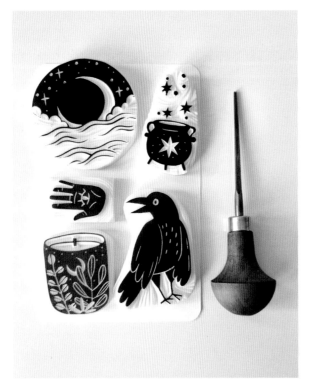

LARYSA AHOSHKOVA

214

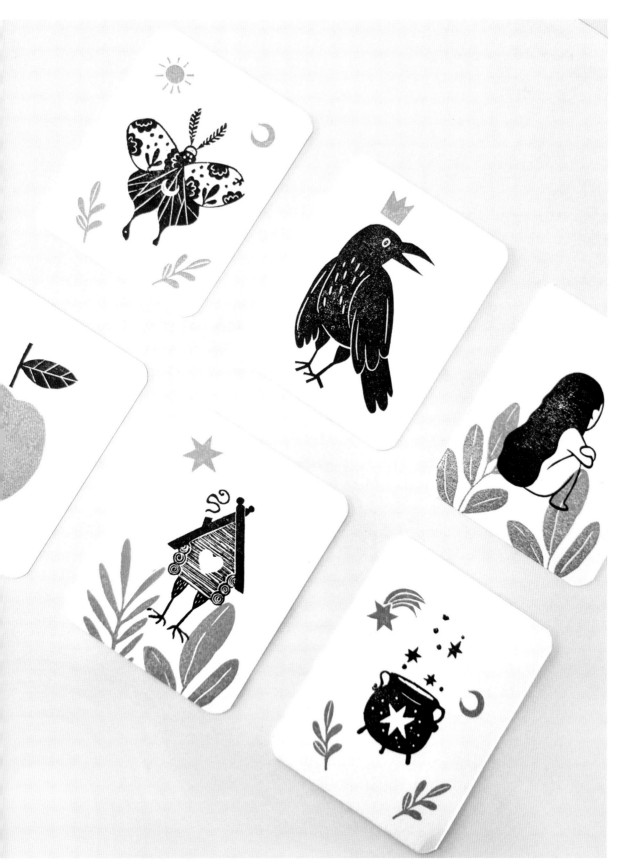

RUBBER STAMP

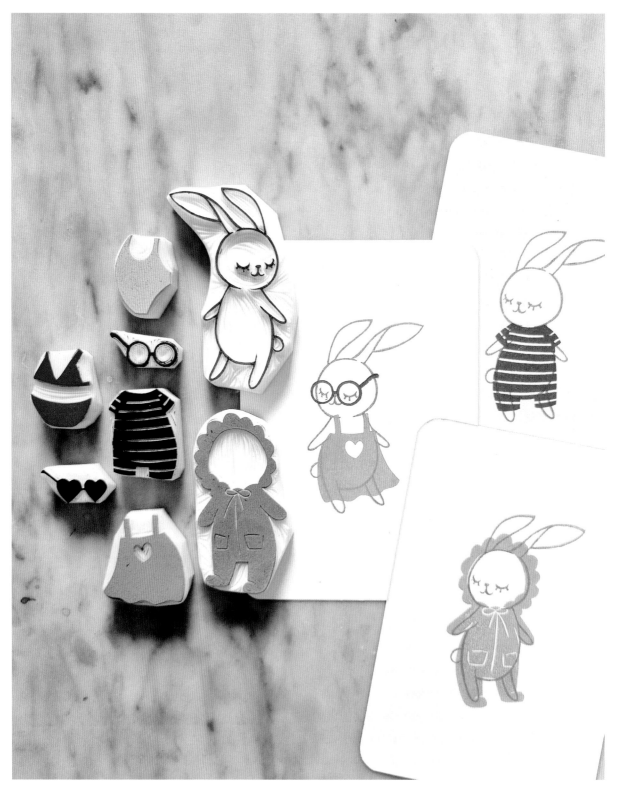

Dress the Bunny stamp set (2022)

LARYSA AHOSHKOVA

216

↑ Mushroom stamp (2020)
↙ Papaya stamp (2020)
↓ Stay Magical stamp (2022)

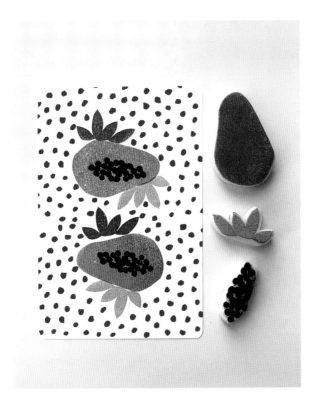

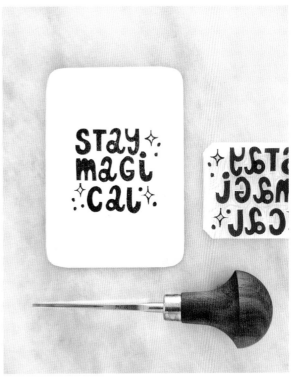

RUBBER STAMP

Q: Why did you choose rubber stamping?

A: This happened by itself. I did not initially think of becoming a stamp artist. One day I ordered a sticker set from an artist I was admiring at that time and when my order arrived, I was completely enchanted by the postage envelope. It was decorated with hand-stamped images and I found a hand printed thank you card inside of it. That's when I knew I totally found my obsession. So, I started making my own stamps and, eventually, it turned into a small business that I enjoy more than anything.

Q: What do you focus on first when you look at a printing?

A: It's all about silhouettes and simplicity for me. Because rubber stamps are quite limiting in terms of artistic expression, unlike watercolor or digital art where you have almost unlimited opportunities, stamps don't allow you to use many details or complicated color scheme. Each stamp is a challenge and an exercise in expressing my idea with the most clarity possible. We have a saying in Ukraine that is very relatable to this: "Complicating is easy, simplifying is difficult."

Q: Where does your inspiration come from?

A: I get inspiration mostly from my personal experiences. Every stamp that I make is a little reflection on my current state of mind, reminders of the stories I was living through that inspired this or that design.

← personal business cards(2023)
→ Moon Moth stamp (2020)

LARYSA AHOSHKOVA

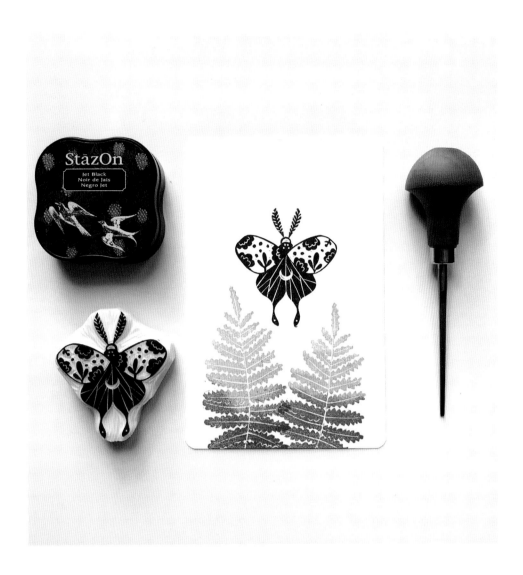

Q: You work with rubber and linoleum. What is the difference between them?

A: I wouldn't use linoleum to make a small stamp as it would be hard to use it. Rubber is thick and soft, perfect for using on paper or packaging. Linoleum is much harder, so it serves better for making large and layered prints in a press or printing on fabric. In general, rubber is better for hand stamping and using with inkpads, linoleum is better for printing on a press and tubed inks.

Q: The colors of your works are lively and bright. Do you have a favorite palette?

A: Black is always my first choice of color. Whenever I make a stamp it should first look good in black. When I want to use color, my favorite palettes would be all shades of autumn, or all pastel shades. Soft or muted, I almost never want to use bright and bold colors.

Q: Do you have any favorite printmaker?

A: There's a bunch of printmakers that I admire for their unique style, sincerity, quirkiness, and creativeness. They are art. zouzeau, solancedesign, lushanglu, and flaviarelli on Instagram.

RUBBER STAMP

United States

Jennifer Zee

Jennifer Zee is a Chinese-American printmaker based in San Francisco. After experience working at nature museums in both research and creative contexts, including scientific illustration, Zee refocused her attention to the fine arts. She now dedicates herself to block printing natural science subjects, often combining organic form with geometry. Zee is an active artist and teacher in her local community, and is passionate about using her art to inform her audience about biodiversity and conservation, as well as social justice with a focus on the Chinese-American experience.

JENNIFER ZEE

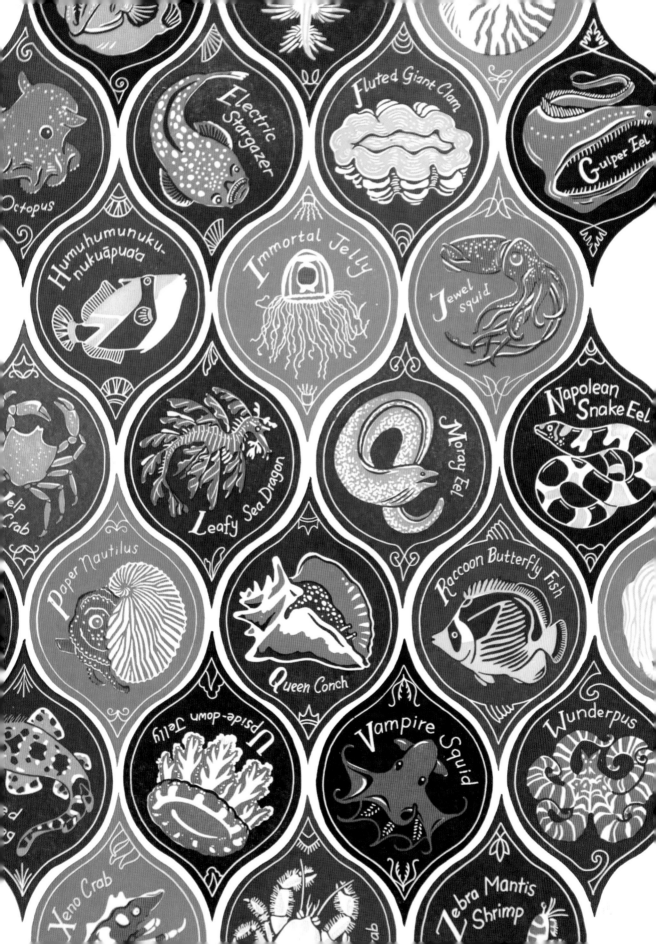

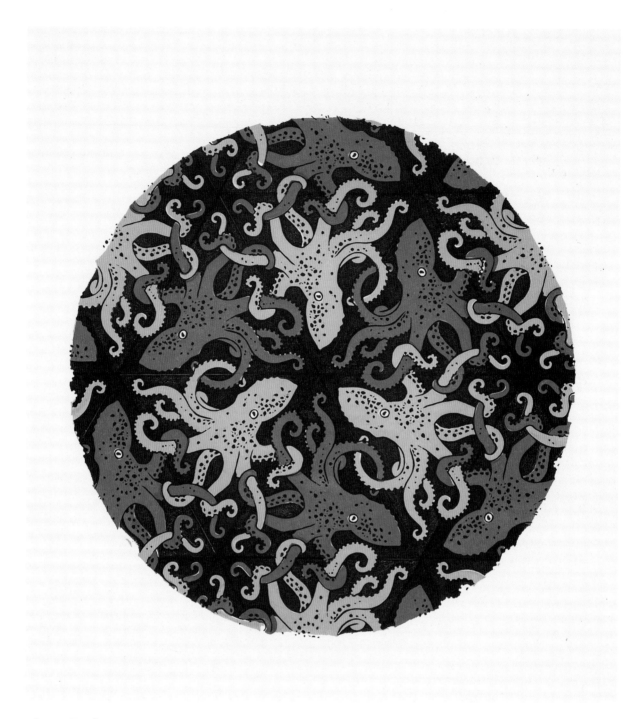

↑ Octopus Tessellation (2021)
→ Lion Dance Mandala (2021)

JENNIFER ZEE

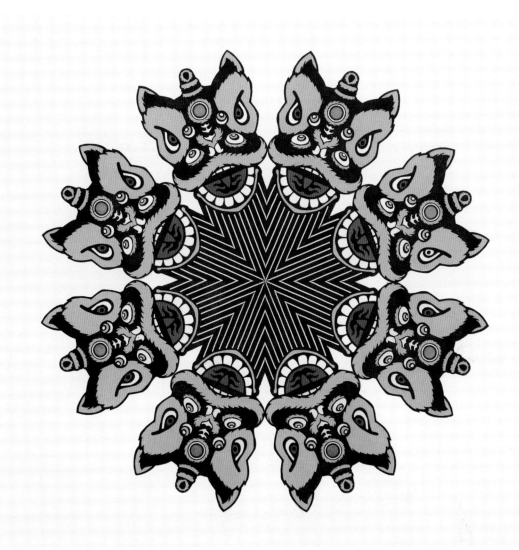

223

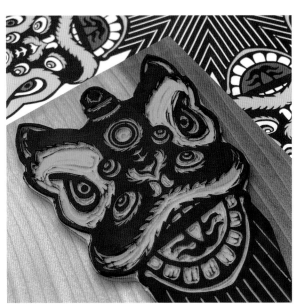

RUBBER STAMP

"Printmaking is an act of generosity;
it is a medium in which I share many genuine
works of art with the world."

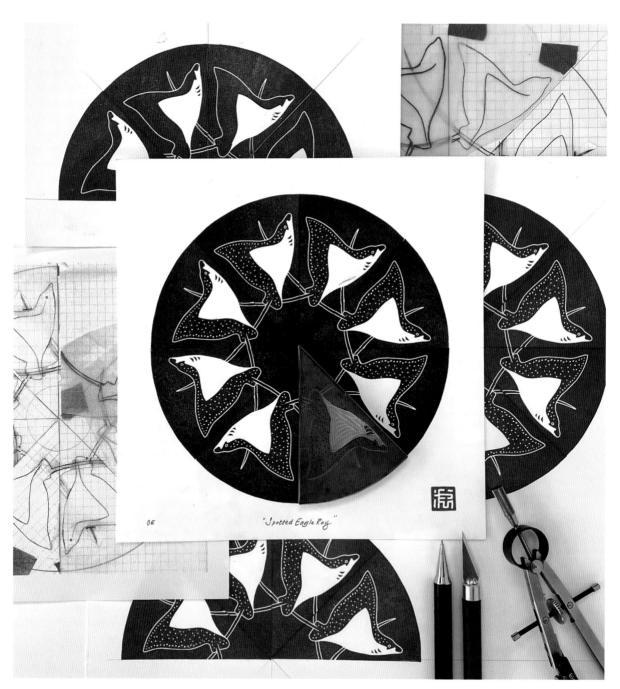

"Spotted Eagle Ray"

OE

JENNIFER ZEE

← Spotted Eagle Ray (2021)
↑ Chinese Zodiac Mandala (2021)

RUBBER STAMP

JENNIFER ZEE

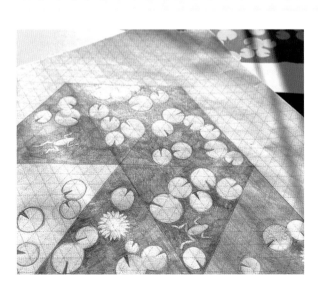

227

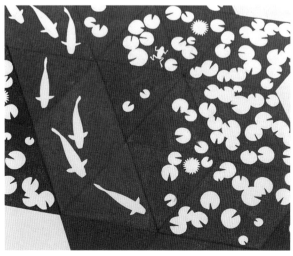

RUBBER STAMP

1. Sketch

2. Tessellation

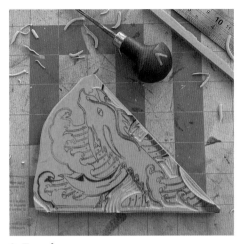

3. Transfer

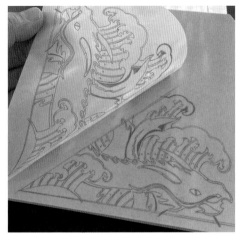

4. Carve

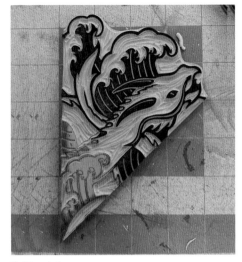

5. Test Ink

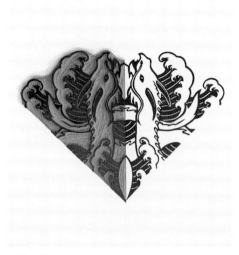

6. Test Print

JENNIFER ZEE

228

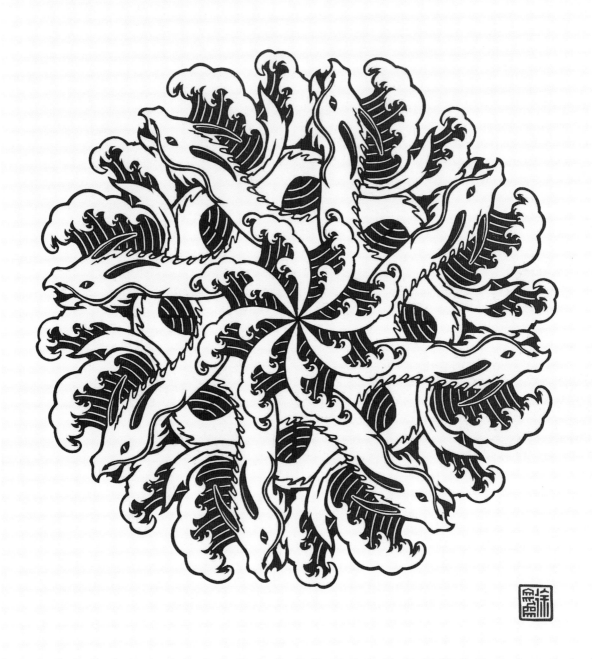

Make Waves (2021)

RUBBER STAMP

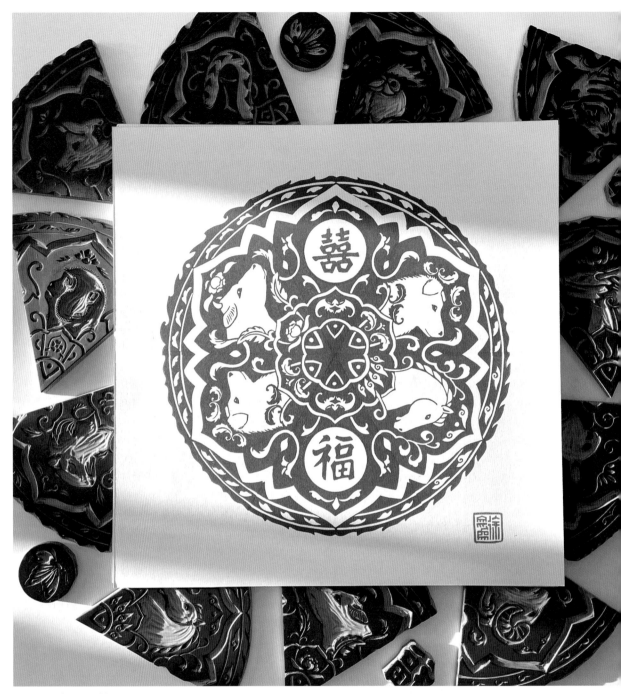

Chinese Zodiac Mandala (2021)

"With greater appreciation for nature big and small, I hope that people become more aware of the importance of taking care of our wild spaces."

JENNIFER ZEE

230

Q: You got engaged with printmaking several years ago. How did this happen and what was the turning point?

A: My first in-depth foray into printmaking was during my master of fine arts work at the University of Michigan, Ann Arbor. I worked with professor and printmaker Takeshi Takahara, from whom I learned the art of Japanese woodcut print. The multi-block process requires painstaking accuracy and carving wood is not easy! Therefore, I jumped into learning advanced techniques right away. That was only a brief visit to printmaking, however.

I worked in other art fields before coming back to printmaking many years later. After 10 years of professional family photography, I felt burned out and I'd hit a plateau in creativity with that medium. Meanwhile, my kids were growing out of toddlerhood and becoming more independent, thus giving me space to make art at home. I re-found my carving tools and found great satisfaction in the design, carving, and printing process. I was so enamored that I have stuck with printmaking ever since.

Q: You are good at many fields, such as fiber art, photography, illustration and printmaking, and writing a graphic novel. How do you develop such techniques? How do you spend your day?

A: If I see a medium I want to try, I will happily buy supplies and give it a go. My parents have always been very supportive of my art, providing me with good quality art supplies since I was a little kid. As a young adult, they gifted me with a DSLR (Digital Single Lens Reflex), which eventually led to my decade long photography career.

Art graduate school introduced many media to me, including the art of the graphic novel. I was fortunate to have Phoebe Gloeckner as my graduate adviser. Graphic novels involve both storytelling and illustration, and that combination really appealed to me.

With block printing, I had the background of Japanese wood cut print. However, wood blocks are hard to find and are hard to cut. When I learned of rubber blocks, I found them so easy to carve! In combination with ink pads, the process fit easily at my desk top. San Francisco homes are small with no way to fit a press. Thus, I worked on perfecting my small scale techniques including tessellation and modular style blocks. I could use small blocks to create large prints.

I spend most of my day being a mom. The demands of motherhood are great and I wear many hats. While the kids are at school, I have precious few hours to work on my art business. I will print orders from my online shop. This also involves cutting paper, cleaning blocks, and packaging prints. Sometimes I need to re-carve old blocks when they become too worn.

The business aspect of being an artist is time consuming. Photographing my art for my online shop, writing product descriptions, and keeping up with social media, which is my main marketing outlet. I try to set aside time each week to work on new designs. It feels like a treat when I find the time to do this.

Q: You have a master of science degree (MS) in biology and a master of fine arts degree (MFA) in art and design. How do these two disciplines combine in your creations?

A: My MS thesis involved the behavioral ecology of invasive and native ants. It was with this research where I learned to watch insects and realized how fascinating they are.

My MFA allowed me to explore many media including painting, sculpture, graphic novels, and, of course, printmaking. Ultimately, I did a thesis on the graphic novel, which involved drawing with pen and ink or brush and ink.

After finishing my two master's degrees, I worked in the exhibits department of an aquarium. This was an ideal interdisciplinary

job, to teach science concepts through visual and interactive media. It was here that my love for ocean life developed, as I explored the aquarium daily before it was open to public and spent much quiet time watching the animals. I also did scientific illustration for a natural history museum's publications.

When I started printmaking, I immediately went for animal subjects. While there was no external need to be accurate as in the case with science illustration, I still made great efforts to depict specific, not generic animals. Also after immersion into the marine animal and insect worlds, I learned about so many fascinating, but relatively unknown animals. I wanted to share these interesting creatures via art so, instead of choosing "charismatic megafauna" such as deer, whales, and wolves, I opted for small, yet to be fully appreciated animals in hopes to open my audience's eyes to the amazing biodiversity out there. With greater appreciation for nature big and small, I hope that people become more aware of the importance of taking care of our wild spaces.

Tide Pool (2021)

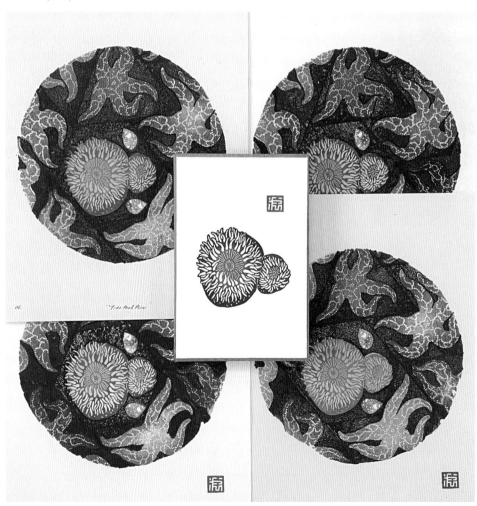

JENNIFER ZEE

INDEX

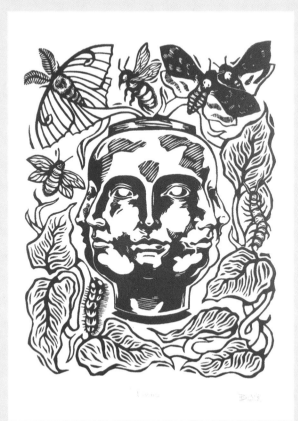

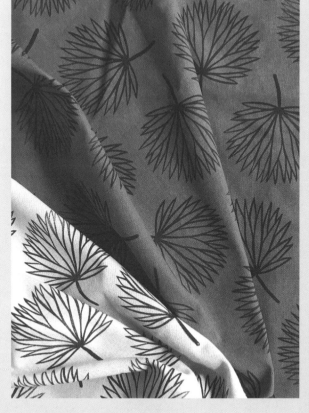

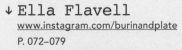

↓ Harriet Popham
www.instagram.com/harrietpopham
P. 046–055

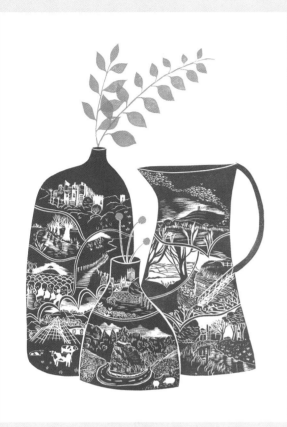

↑ India Rose Bird
www.instagram.com/indiarosebird
P. 102–111

↓ Jason Limberg
www.instagram.com/jasonlimberg
P. 064–071

↑ Jennifer Zee
www.instagram.com/ginkgozee
P. 220–232

↑ John Pedder
www.instagram.com/johnapedder
P. 092–101

↓ JustAJar
www.instagram.com/justajar
P. 120–129

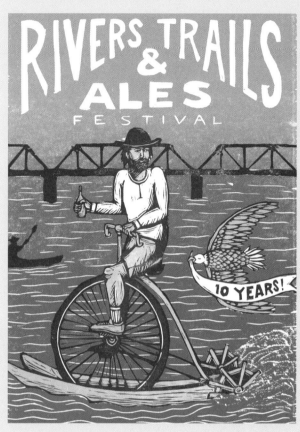

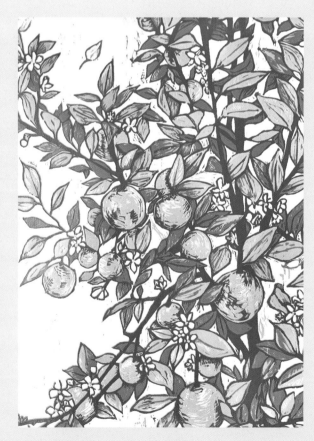

↑ Kristina Hoover
www.instagram.com/kristinahooverfineart
P. 138–145

↓ Larysa Ahoshkova
www.instagram.com/laraahoshkova
P. 210–219

↑ Lili Arnold
www.instagram.com/liliarnoldstudios
P. 080–090

↓ Lim Jia Qi
www.instagram.com/limjiaqii
P. 146–153

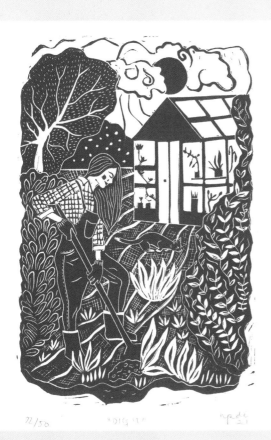

↑ Nicole Revy
www.instagram.com/printsbythebay
P. 036–045

↓ Olga Ezova-Denisova
www.instagram.com/ezovadenisova
P. 018–025

↓ Rachael Louise Hibbs

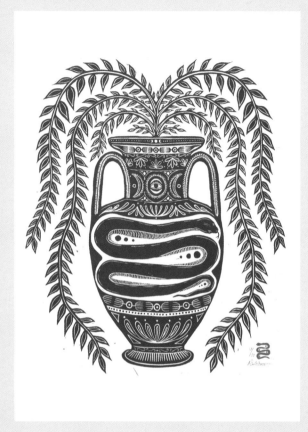

↑ Riyo Kihara

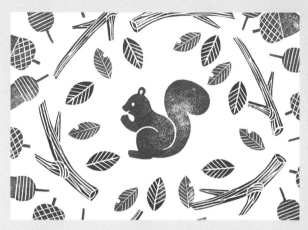

↓ Roman Klonek

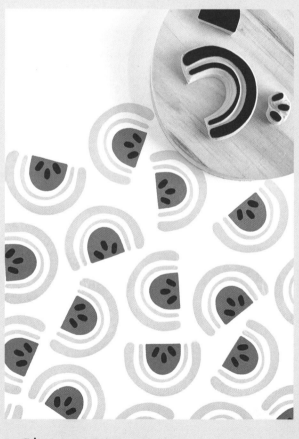

↑ Simone Bryant

↓ T-zuan
www.instagram.com/t_zuan0321

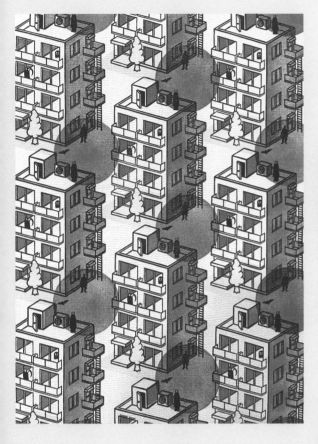

↓ Sofie van Schadewijk
www.instagram.com/sofie.tekent

↑ Viktoria Åström
www.instagram.com/viktoriaastrom

ACKNOWLEDGMENTS

We would like to express our gratitude to all of the artists for their generous contribution of images, ideas and concepts. We are also very grateful to many other people whose names do not appear in the credits, but who made specific contributions and provided support. Without them, the successful compilation of this book would not have been possible. Special thanks to all of the contributors for sharing their innovations and creativity with all of our readers around the world.